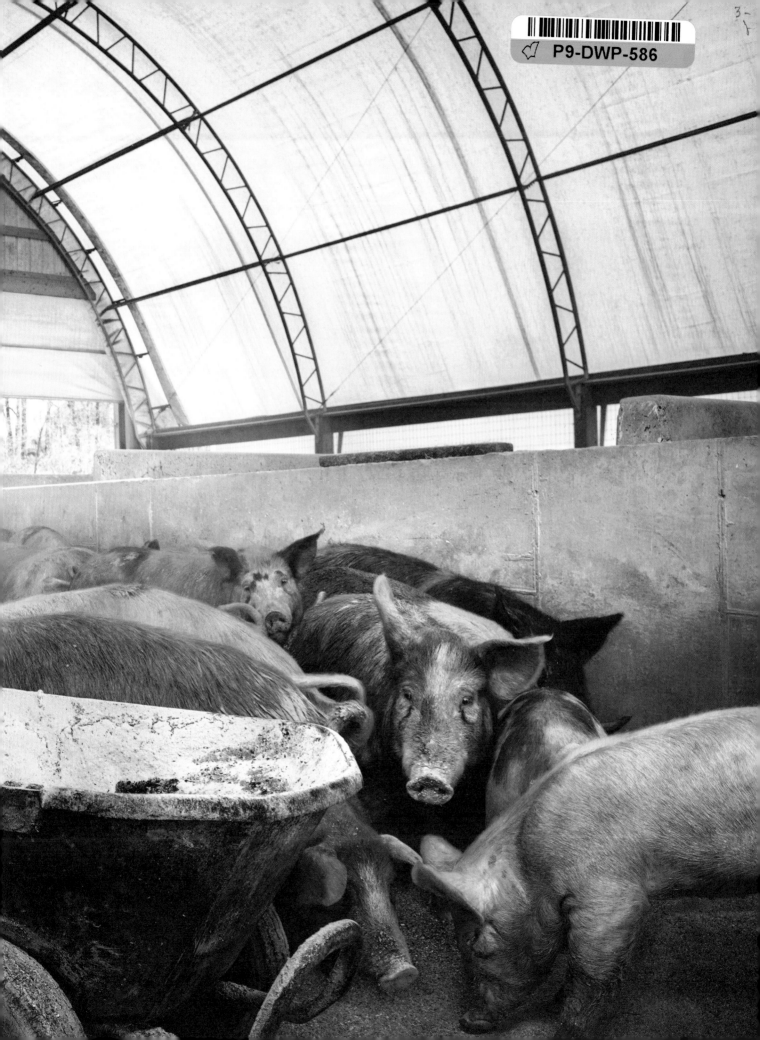

WOMEN'S WORK

STORIES FROM PIONEERING WOMEN
SHAPING OUR WORKFORCE

PHOTOGRAPHY BY

CHRIS CRISMAN

SIMON & SCHUSTER

NEW YORK LONDON TORONTO SYDNEY NEW DELHI

Simon & Schuster
1230 Avenue of the Americas
New York, NY 10020

First Simon & Schuster hardcover edition March 2020

SIMON & SCHUSTER and colophon are registered trademarks of Simon & Schuster, Inc.

For information about special discounts for bulk purchases, please contact
Simon & Schuster Special Sales at 1-866-506-1949 or business@simonandschuster.com.

The Simon & Schuster Speakers Bureau can bring authors to your live event.
For more information or to book an event, contact the Simon & Schuster Speakers Bureau
at 1-866-248-3049 or visit our website at www.simonspeakers.com.

Interior design by Carly Loman

Manufactured in China

1 3 5 7 9 10 8 6 4 2

Library of Congress Cataloging-in-Publication Data is available.

ISBN 978-1-9821-1037-6
ISBN 978-1-9821-1040-6 (ebook)

Julianna, Calvin, and Eliza, you are the reason why. You blow my mind every single day.

Mom and Dad, thank you for all you've done to help me find my way.

THE WOMEN AND THEIR WORK

AUTHOR'S NOTE

Before *Women's Work* the book, there was "Women's Work," the photography project—regardless of the format, the core values and mission have always been personal. I was born and raised in the countryside near Titusville, Pennsylvania, during the 1980s and 1990s. Growing up, my father, Richard, was a steelworker and my mother, Karen—whose photo you will see in this book—was a self-employed dog groomer who ran her business out of our home. The mantra in our house was always "just keep working"; our family way was undeniably DIY. We had three TV stations available to us via rotary antenna, and a washtub but no shower. We grew our own food, we heated our home with the wood we cut ourselves, and we rarely asked for help. No jobs were off-limits in our home.

My father worked the three to eleven p.m. shift at the steel mill while I was in school. He left for work before I got home, and I was often already asleep when he'd return. But I spent countless hours of my youth helping my mother in her groom shop. I witnessed firsthand not only her dedication and work ethic, but also how she balanced the challenges of being a mother and wife with being a business owner. My mother's strength has always been a hallmark to her character. She has taught me to always push forward and to gracefully persevere no matter what life throws at you.

My parents never steered me toward a specific career—instead, they offered me experiences that could open my eyes to new opportunities. Both of my parents always said that when I grew up, I could become anything I wanted to be.

I met my wife, Julianna, nearly ten years before embarking on the "Women's Work" project. I was photographing subjects for a local Philadelphia design magazine that was featuring her work. They asked me to shoot some portraits of Julianna to be paired with stills of her design collections, and her poignant-yet-pointed line of greeting cards, Mean Cards. At the time, she was working out of a modest workspace she'd created for herself in the back of a small wallpaper shop in South Philadelphia. Here was another entrepreneurial woman; I was immediately impressed, attracted to, and engaged with her work, her wit, her drive—qualities I had learned to admire firsthand in my home. Julianna, more than anyone, has shown me the challenges women face in vying for success in a world that is designed by and for men.

We now have two children—a boy, Calvin, and a girl, Eliza. I continue striving to understand my mother, wife, and daughter's unique places in the world as women who have, and will, work to make their dreams realities. In their own ways, they are each the true inspiration for this project. Through my mother and Julianna, I have seen where we, as a society, have been—with my daughter, Eliza, I am compelled to look into the future and wonder what new joys and challenges await her as a young woman forging her place in the world, professional or otherwise. I can't change the adverse struggles of the women who came before her, but I can lend my life toward aiding her on her journey forward.

With *Women's Work*, I have aimed to surround an audience with the most valuable resource from my own childhood: women who imprinted confidence, freedom, and drive onto my own life. In these pages you will read about women who have torn down their perceived limitations—based on gender, race, class—and forged on for the love of what they do. Each story is different, each voice singular. I hope to have captured each woman and her extraordinary presence through my portraits, but it's much more important that you find a story to connect with—stories that you'll see can only be told best in the women's own words.

Chris Crisman
March 2020

WOMEN'S WORK

MINDY GABRIEL

is a firefighter

I have been a firefighter for the past fifteen years. I started in 2002, about a year after graduating from Ohio State University. The testing process for being a firefighter can be long, but for me it was thankfully fairly short. I was hired my first attempt at the process despite the fact that I had no prior firefighting experience. I am a bit of an accidental firefighter. I decided to start the testing process just prior to graduation from OSU. I studied exercise science and was a varsity rower, and I had previously fitness tested. I had also just completed spring racing season and had competed at the NCAAs. I was in top physical condition and was confident I could pass the difficult physical fitness requirements to get hired. I also got to fitness test firefighters during my exercise science labs. I found myself asking them all about their jobs and learning more about how they aid people. I guess if you look way back, I have always had an affinity for the "helper" professions. I knew I wanted to help people and drew inspiration from my mother being a night-shift nurse. Firefighting is a profession of tradition; historically knowledge has been passed down from father to son. Until I met with firefighters during my studies, I had not known a single firefighter personally. I didn't realize it was a career option for me. Discovering it felt good; I have never really felt strongly about being a nurse.

Not knowing any firefighters personally before beginning my professional journey, I would say a few people have been my sources of inspiration to lead me down this path. My parents and my grandparents as a whole were extremely hardworking people. They were all farmers and had other jobs, too. My dad worked building roads and driving trucks during the day and farmed into the wee hours of the night during planting and harvest seasons. As I mentioned, my mother worked the night shift, and I swear she never slept well during her days to recover; she simply had too much to do with six kids in the house (I'm the eldest). My mother's parents owned a dairy farm. They milked at 4:00 a.m. and 4:00 p.m., 365 days a year. They had a huge garden and grew most of their food. I remember going there in the evening to help feed the baby calves, working in their garden till sundown. My dad's parents had a large farm, and we all baled hay in the summers. I recall my grandmother climbing up in the hayloft off the wagon and stacking square bales well into her sixties. I was always told that you don't get anything without working hard. Growing up in a small farming community made it easier to relate to the guys, too, as many of us shared similar backgrounds. Aside from my family and community, another big inspiration

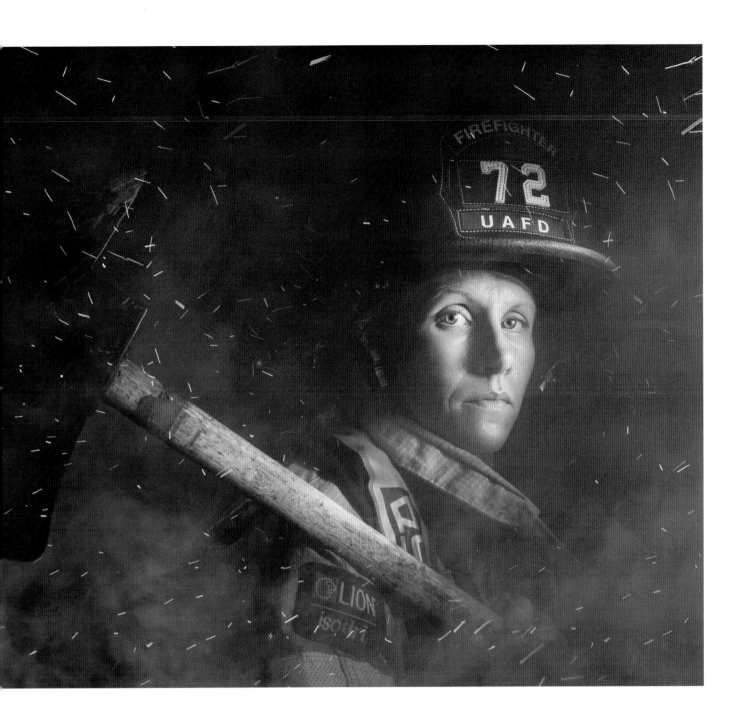

was Lou O'Brien Berl, my first-year rowing coach at Ohio State. I had never met anyone like her. She was tough and beautiful, smart and funny; she taught my teammates and me not to make excuses, to not only talk and complain but to do something about it! She said things like "You are only scratching the surface of what your body can do" and "You can do anything for two minutes." She also asked, when training, "What do you think Michigan is doing right now? Don't let anyone ever be more fit than you; you can always control that." If I learned the value of hard work from my family, I certainly learned from this gal to never give up and to never make excuses. I still use her lines all the time to motivate myself a good twenty years later.

When I was initially being hired as a firefighter, several departments in my area adopted the philosophy that they would find "good people" regardless of their experience level; they knew that hiring someone in this field is a twenty-five-year-plus commitment to their organization. I got lucky. These days, we ask that candidates have more training, usually paid for by the candidate up front.

When I began, I was primed for the job, having been a collegiate rower at OSU. I was essentially an athlete looking for a team, and the fire service is all about teamwork. I was immediately sent to fire and EMT school and then later to paramedic school at Grant Medical Center. About 80 percent of our work as firefighters is medical calls; I wanted to be a part of making those critical decisions by practicing quality emergency medicine. Today I work in a suburban department surrounded by the large urban area of Columbus, Ohio. We work calls in our city and the surrounding areas through mutual aid agreements. I am assigned to a medic and a ladder truck during each shift and rotate between the two. I have always served on our department's fitness committee, with the goal of improving the health and wellness of our firefighters. Lately, I have been working on improving access to mental health benefits for first responders and developing networks to take care of firefighters after stressful incidents. I am working on a community health care model that links firefighters to vulnerable residents, like the elderly population, which is high in our area, to improve their access to care so they may continue living independently. Now feels like an exciting time!

If I weren't firefighting, I would want to be a primary care doctor or working in hospice care. At the moment, I still like the idea of doing direct service with patients, but I would consider opportunities in leadership positions within a health care system.

Even though it's exciting, my job is certainly risky; I can die or get seriously hurt doing it. Also, there has been an uptick of violence toward first responders, due to an increase in violence and rampant mental health problems. We have to be ever more diligent to keep ourselves safe. We have had to do a mind shift to understand that some people may want to hurt us. But I think being able to understand those risks helps you live more fully, too. Firefighters, on the whole, really enjoy their lives. I am a mother of three young children. I would not like to leave them in this world yet. We have many more adventures to take and lessons to learn together.

I would certainly like to see more women join this career. At this point, it doesn't bother me being the extreme minority because I have discovered a network of women across my area. We are scattered about, but we have found each other and there is great support amongst us. This career is not for everyone. You really have to commit to the lifestyle. No matter what is going on in your life, whether you are young and free or nursing an infant at home or are taking care of your aging parents, the job is always twenty-four hours on and forty-eight hours off, usually for twenty-five-plus years. You can't stop for a while and come back to it. You are either in or out. That is no easy task, given all of the obstacles life throws at you. I have been lucky to have a supportive partner at

home to help out. There have been numerous times when my babies were very young that I realized that it was not normal for a mother to leave her kids for twenty-four hours. I think that is hard for many partners to understand because we often build our own families around examples from our childhood. My husband (who is also a firefighter) and I had few examples of families that worked like ours. We felt like we were really making it up as we went. Our kids seem fine. And I have had a lot less negative feedback than you might expect; mostly people have trouble understanding how we work into traditional gender roles. I think all working mothers are doing two full-time jobs with a lot less time to do it. I don't know many women that work outside the home who are not also crushing it when it comes to taking care of their kids and their homes. In the beginning, people assumed I was not going to stay at my job after I had kids. They didn't like that I was filling a spot that a more committed male candidate might want. But there is no use arguing with people who have those opinions. I don't feel like dying on those hills. I have put very little value in stereotypes. I let people speak for themselves.

I love working on my mental health and community health care models. I am toying with the idea of working toward promotion to officer and beginning to think about my retirement job. If it requires schooling, I would start preparing for that soon. I don't see myself stopping working for a very long time.

I think it is important when picking a career to think about what kind of impact you want to make on the world; to figure out your strengths and what kind of lifestyle you are looking for. Never think solely about money. I have found if you are doing something well with passion, the money will come. I probably wouldn't have as much influence if I had chosen to be a tax attorney, no offense to tax attorneys. Your job can open doors for your personal advocacy work. It certainly has in my life.

It has been a true gift to have this profession. I feel that I have seen lifetimes of pain, sorrow, and immense joy. I work with some of the most kind and hardworking people I have ever met. We get to do incredibly hard things in our job—not only tasks that require great physical strength but great mental strength. Our job forces us to feel, to empathize with those experiencing the tragedies we witness. We see the best and worst in people. A firefighter's mind is one that has captured all of humanity; this is both beautiful and terribly sad. We need to take care of one another. I don't think I would have survived this profession without my strong female friendships, three children, and supporting husband. I have my rowing teammates and my book group gals. Strong women helping strong women. My husband is a rock star, too. Women can do anything they put their minds to, but you can't do anything on your own. We owe so much to the people in the fabric of our lives.

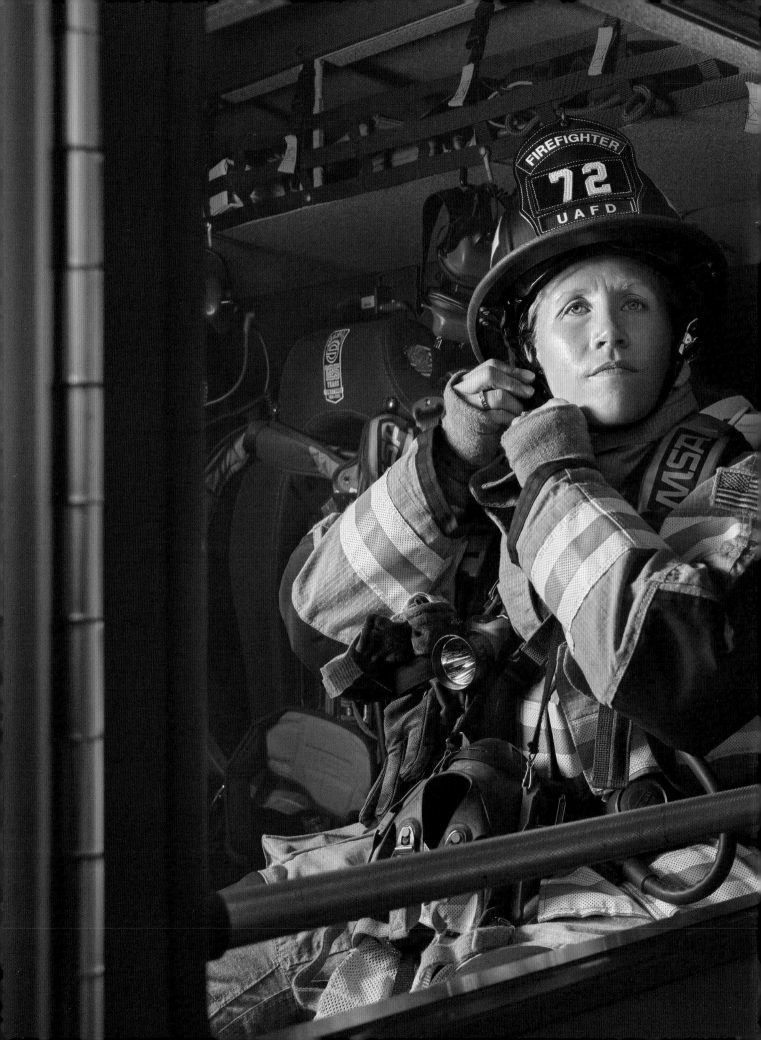

INDRA NOOYI

is a former Chairman and CEO of PepsiCo

I was born and raised in India in a large, conservative family with one brother, one sister, and a lot of extended family living under one roof. It was a wonderful household with an emphasis on education. There was no differentiation between men and women—the girls in the family were all given the same opportunities as the boys and never allowed to be seen as second-class citizens. The men in our family believed we could do whatever the guys could do, and we were encouraged to go to school, college, and follow our dreams.

We were intellectually rich. Love rich. Not financially rich. We were just a middle-class family. That's what helped us understand the value of money and hard work. We learned a lot of good values that guided us as we moved forward.

My sister and I were close in age, and we com-

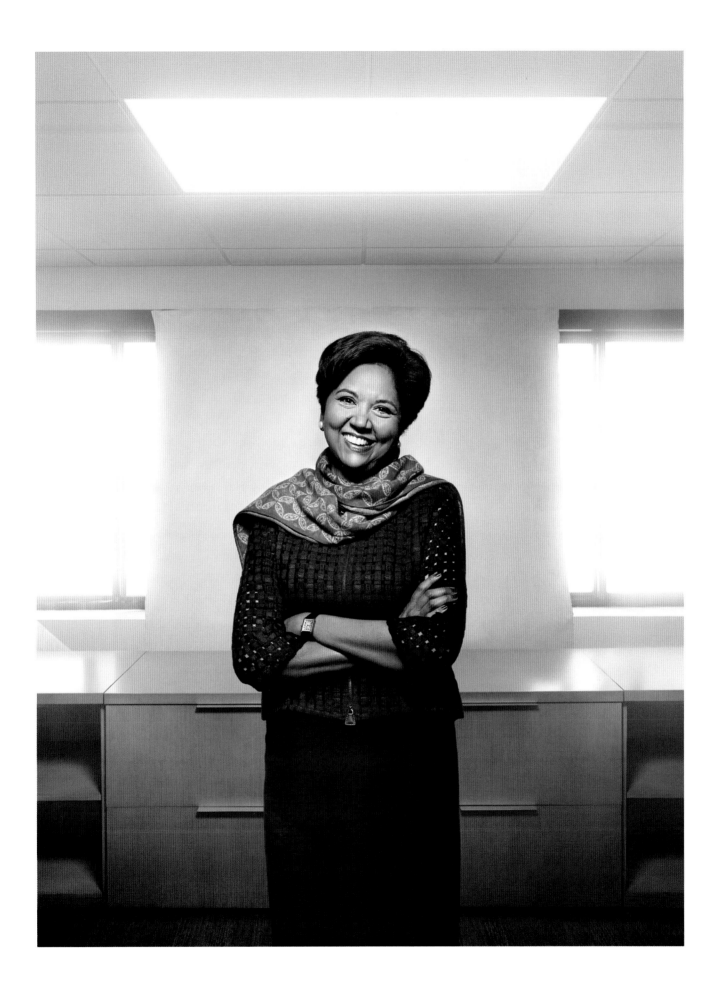

peted with each other a lot. We love each other, so it was always a healthy competition. I was a scientist, and chemistry was my dream. I always imagined myself being in a lab running a big chemical laboratory. My sister went to business school in India. She had majored in commerce and chose to pursue a business career.

At that time, getting into the best business school in India was difficult, but she got in. I had to prove I could do it, too. I took the entrance exam and got in. Once I was there, the business bug bit me, and I've never looked back. It's not that I walked away from science; science has always been part of my life. The scientific way of thinking, the way of analyzing, and the quantitative methods have all been part of my life. I'm grateful for my science background. I feel like I'm a scientist and businessperson, and I'm happy to love both.

Our family is not one of businesspeople. They were accountants, judges, doctors, and lawyers. So my sister and I had to craft our own paths. A lot of mentors along the way stepped in and said, "Let me mentor you, let me encourage you." I think mentors basically come and say, "I think this person has the magic to be successful. I want to be associated with that person." They don't mentor just out of the goodness of their hearts; they do it because they, too, look good by mentoring this person.

I was a very hard worker and very motivated, so a lot of people were interested in mentoring me. I was given a lot of advice that pushed me along and helped me see when I was not doing things right. I was very fortunate to have that advice, and there's not one mentor I walked away from. I'm in contact with most of them. The most important thing I've learned about mentorship is that if a mentor gives you advice that you're not going to take, tell them why you're not taking their advice. Otherwise, they wonder why they're giving you advice in the first place! Explain to them why you decided to do something different. They will appreciate it.

After business school, I worked in India for a couple of years and then came to the United States to continue my education at Yale. I have been here in the United States ever since. After Yale, I went to the Boston Consulting Group, then Motorola, then ASEA Brown Boveri (ABB), and finally PepsiCo. Each job gave me exposure to new issues, new industries, and new challenges. I embraced each job with passion and contributed to the best of my ability. I think at every job I've had—whether at BCG, Motorola, or ABB—my clients and colleagues have said, "We missed her when she left." And that was my only goal.

When I joined PepsiCo, I brought a new sensibility with me. I believed that companies cannot be divorced from society and we had to adopt a stakeholder perspective, not just a shareholder one. At PepsiCo, I always asked my team to walk a mile in others' shoes when tackling a challenge. I'd ask, "What if you were a mother? What products would you feed your kids? What if you don't like plastic bottles in your backyard? If you live in a water-distressed area, would you like an industrial plant consuming a lot of water to make a fun product?"

That perspective was embedded in Performance with Purpose, the philosophy I introduced at PepsiCo. Performance with Purpose was about making healthier products, limiting our impact on the planet, and supporting our people, including helping new mothers balance work and family.

This last issue, in particular, is a tough one. We want young women to get married, have kids, and be in the workforce. We need their smarts. And if they don't have kids, we cannot maintain the population of the country on our own.

So women have a tough set of trade-offs between a family and a career. The journey to balance both is hard indeed. Going forward, we need to find solutions

to enable young people to meet their responsibilities both at work and at home. Companies, communities, families, and government need to come together to devise intelligent solutions to enable this to happen.

When I stepped down as CEO, I wrote a letter to our employees about the lessons I'd learned over the course of my career. The final lesson was an important one: think hard about time. "We have so little of it on this earth," I wrote. "Make the most of your days, and make space for the loved ones who matter most. Take it from me. I've been blessed with an amazing career, but if I'm being honest, there have been moments I wish I'd spent more time with my children and family. So, I encourage you: be mindful of your choices on the road ahead."

KHALIA BRASWELL

is a technologist and the founder of INTech Camp for Girls

Honestly, I started coding through Myspace. I was very intrigued with changing the background color of my Myspace page. I used to have sticky notes with codes on my wall, just to remember how to do things. Being able to control what things looked like using code was fascinating to me. When I went to high school at Phillip O. Berry Academy of Technology in Charlotte, North Carolina, I really learned to code. The first thing I built was a notepad, and I was fascinated by the fact that there was a visual interface that people interacted with despite never seeing the code. There was just something about that that just fascinated me.

I had women teaching my technical courses in high school, and some of them were black women, too. This had a huge impact on me having the confidence to go into tech because I never knew anything different. I saw women of color in tech every day; the

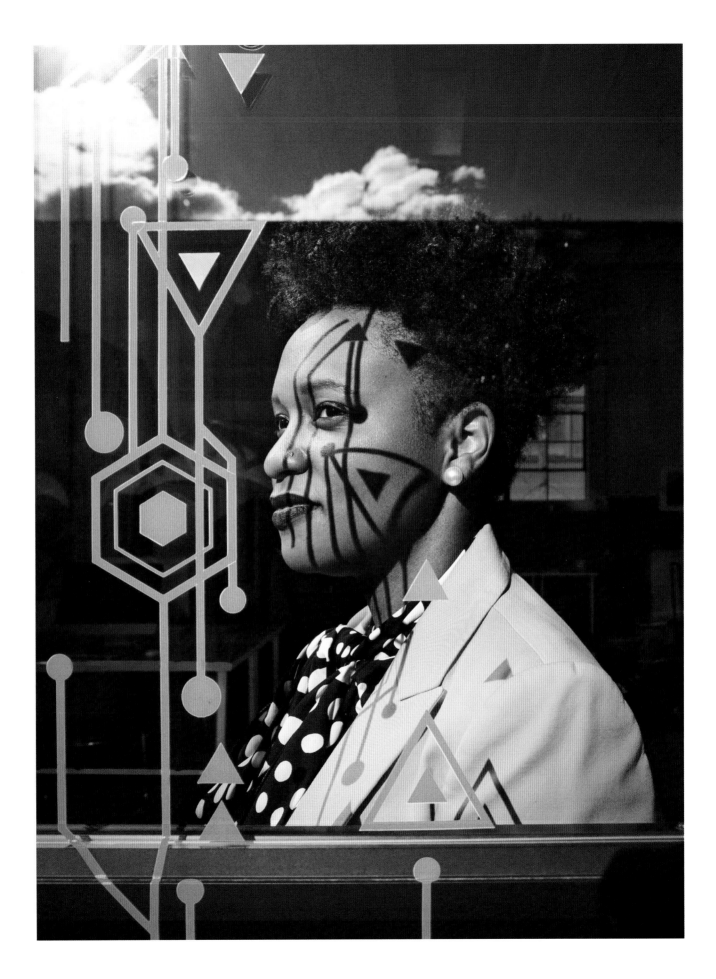

whole story of there not being a lot of women in tech wasn't my reality. I went on to major in computer science in college, got my master's degree, and had several internships to show me what a career could look like in tech.

I didn't intend to create INTech, my coding camp for girls. I had received grant funding to host a camp in 2014, and the response from the scholars, the parents, the volunteers was so electrifying that I had to keep doing it. We never stopped, and we've continuously grown since then. Now we do a one-day camp, a five-day summer camp, and a high school after-school program. At INTech we make sure we have a lot of women in front of our scholars so that they'll know that there are other women—not just me—in tech. I recently wrapped up a role as an adjunct professor teaching computer networking and now I am getting a PhD in computer science at Temple University to gain a deeper understanding of teaching at the higher level and to do research on computer science. I'm also very interested in professional development for teachers. The reality is that a lot of these teachers aren't equipped to teach Python, for example, because they don't know it themselves. I can deepen my impact if I'm able to teach teachers, because they can reach more students than I can reach. I want to get INTech to a place where we are sustainable so that if I decide I want to go back into the industry I can step away from the day-to-day and become only a board member. It's important for me to make sure that I'm doing the work of not only exposing more girls to tech and teaching them but of actually staying in the tech field.

What would I call myself? I usually say that I'm the founder and executive director of INTech. But really, I'm a Jane of all trades.

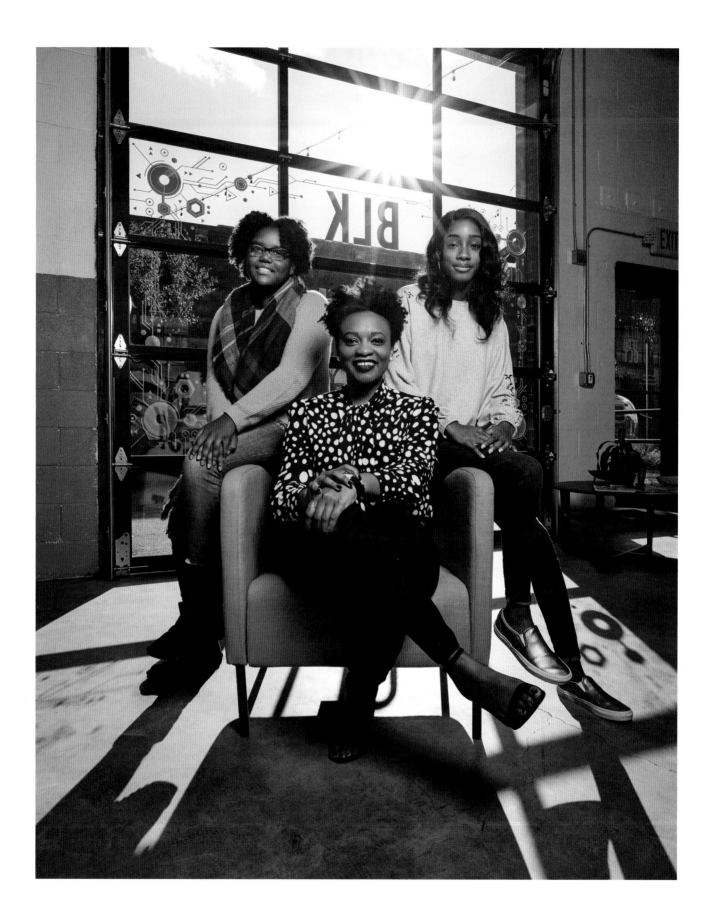

HEIDI & RENAE MONEYMAKER

are movie stuntwomen

HEIDI MONEYMAKER

My sister and I were both extremely competitive gymnasts when we were younger, and we both earned scholarships to college. Renae earned a scholarship to San Jose State, and I earned one to UCLA. I'm older and went to college first. Once I graduated, I met a few people that had entered the stunt business. I would work here and there when they needed a gymnast to double somebody. Eventually I decided to pursue it because the money was good and it was fun. Pretty early on I got a job doubling for Drew Barrymore in *Charlie's Angels: Full Throttle*, and I just loved it. I was hooked. Down the road, I asked Renae if she wanted to be involved because she was a really good height and had the gymnastics background. She wasn't sure about it but ultimately asked if I could

help her get some background gymnastics work on a TV show.

When Renae first got going, it was always "Oh, you're Heidi's sister. You're Heidi's sister." But now Renae's so established and has done such an amazing job, she's now considered one of the top stuntwomen of all time. These days, people I haven't met before will come along and say, "Oh, you're Renae's sister!" So it's full circle.

I've had a lot of great mentors over the years. When I got my first job, the stunt coordinator and second-unit director was a guy named Mick Rogers. He knew that I was brand new and didn't have any real stunt experience, so he asked me to make a tape for him. He liked what he saw and asked me to come work

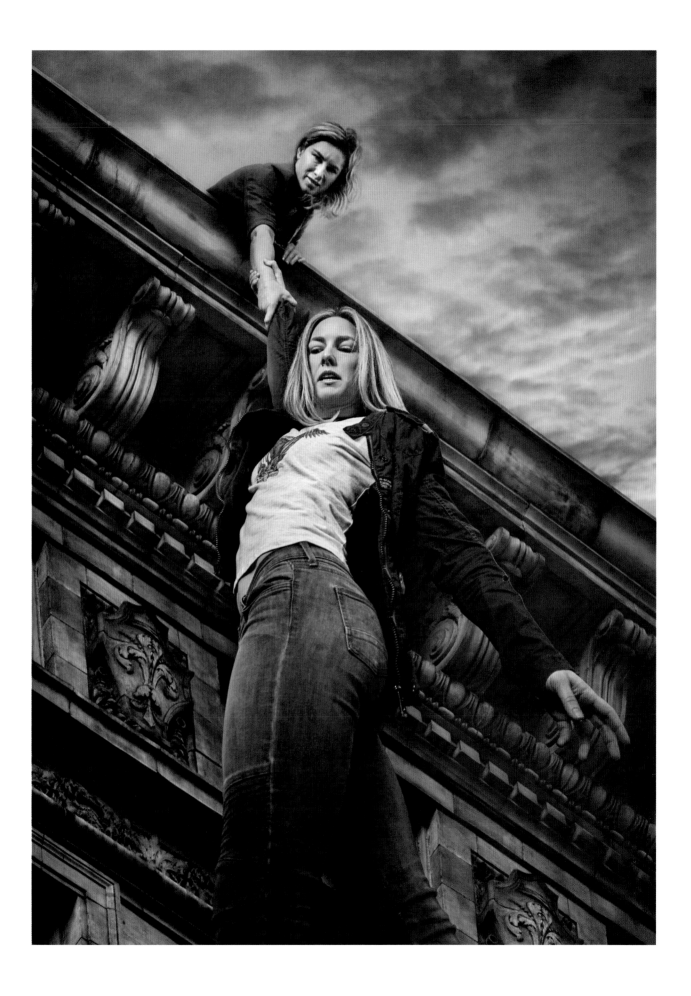

for him. But he also knew that I was new, so anytime I went to do a stunt, like a stair fall or high fall or wire stuff, he would take me aside and explain how the stunts worked and the choices I could make, like falling backwards or forwards, for example. He'd always give me an option. He was a big influence not only because he brought me to big jobs but he walked me through them, too. That doesn't happen very often.

There are also a lot of amazing women who have inspired me. This is going to sound kind of funny, but a huge inspiration was Linda Hamilton in *Terminator 2*. Not her, necessarily, but the character, who was intense, strong, trained for everything. Just a badass kind of woman. I don't know. I still have her on my vision board.

As a woman in the business, I've never felt like some man was pushing me down or prejudiced against me. It's just a fact that this is a male-dominated business; I mean, how many women growing up think they want to get hit by cars? I looked at it like I was entering a man's world, so I needed to figure out what I wanted to do and where my place would be. I looked around, and I saw a lot of stuntwomen who were trying to make their place in this world, too, but they were women in a man's world trying to act like men to fit in. I thought: You know what? I'm not going to do that. I want to be feminine, and I want to be a female. I'm not going to try to be a man, but I am going to work really, really hard so that no one ever looks at me and says, "Oh, she's good for a girl." I want to be good for anyone. The first day somebody came in and said, "Oh, yeah, that's Heidi. She's the best stuntman I know," I was, like, that's what I've been looking for.

We were lucky, though, because of our upbringing; our mom's super-tough, but she's feminine as well. So I think we grew up with a good mentality for moving between feminine and masculine. But other than our mother, Debbie Evans and Donna Evans were huge mentors of mine. Earning their respect was a big deal because they are two of the premier stuntwomen who have gained admission into the boys' club. But they're better than most of the boys at driving and riding motorcycles, for instance. They are the cream of the crop. They are respected by the men but are very, very good—and very humble. I think also, with the rise of Disney and Marvel, that there's a new movement of including women more. We know it's happening, and it's nice. In the past women sometimes had to climb uphill for these roles, whereas now women are getting big opportunities like the men. I think that men and women both bring very integral things to a film. I like what's happening now, but I still want to keep the female/male balance in there because women bring something to the table and men bring another thing to the table. That collaboration can create something much better. I believe that it's my job when I'm running, standing, walking, or doing anything in a shot to mimic the actress as much as possible. To become them. When it comes to the action stuff, I'm never probably going to get enough training time or somebody who's potentially able to move like I move, so I don't worry about that. When it comes to the action, I'm just trying to make them look as badass as possible. But as far as the simple stuff, I try to mimic them.

If I had to give advice to any young person trying to become a stunt double, I'd say: Be humble. Work hard. Ask a lot of questions. Be prepared, and never do anything that you're scared to do. If you're nervous or something's intense and you're excited and you have adrenaline, that's one thing. But if something scares you, if you're afraid, don't do it. Once I was doing a car turnover scene, I was flipping a car. The location they chose had a cliff with a two-hundred-foot drop-off into a canyon. There was likely no way I could have reached this cliff even if I'd tried, but for days it plagued me. If, by some horrible miracle, I was able to reach that cliff, that was game over. But I pondered it for a couple of days. I finally said, "There has to be another spot." The team was very cool about it and moved it down a little way to where there was

no drop. I was very lucky I had a team that respected me and was willing to fight for a location change. But I'm confident now. When you're first getting started, it's really hard to tell somebody no because you feel like you're going to get blackballed. But it's just not worth it. It's really hard. But you can say, "You know what? I'm feeling somewhat uncomfortable with this. Is it possible to . . ." You never know: sometimes if you're just suggesting a small change, it might set in motion a series of changes that can actually fix things.

RENAE MONEYMAKER

When I was still in college, I remember thinking "Oh, it might be fun to work on that show for a summer!" So I came to Los Angeles, and once the show was picked up, I matched one of the girls really well. It was called *Make It or Break It* on ABC Family, where I worked pretty regularly for about a year. After about a month and a half I was in love with it. I told Heidi I wanted to get more into stunt work. We started training together and with a team called 87eleven. But it all started with gymnastics. And now I'm Captain Marvel and Heidi is Black Widow. It used to be a compliment to be called a stuntman, as a woman. It created this weird sense of making it. I rose up through the industry with a lot of that, too—feeling that it's a man's world. You've got to be able to hang with the boys.

My biggest influence was definitely my sister. She had been in the business about six or seven years before I started. She was already one of the best stuntwomen in the game. Everyone knew who she was, so anytime somebody learned my last name they were like "Oh, you're Heidi's sister." Heidi taught me everything from the ground up. I had never thrown a punch in my life. Never been in a bar fight. Never been in a street fight. Never been boxing. She really helped me along through my career—and still does today.

I love being on projects where there is a lot of prep leading up to the shoot so you get to train with an actor a lot; you have a part in training and grooming them for this part, but you also get to work together on creating the action. I try to study someone from the first time I meet them: how they stand, how they walk, maybe how they would run. When I'm doing their action, I try to take on some of those characteristics but enhanced, more dynamic.

I wouldn't say there are a lot of times where I've been told I couldn't do a stunt because I was a girl. But there are sometimes conceptual issues. Someone might suggest more girls in a fighting sequence. But, well, most people don't really want to see a girl get punched in the face or thrown into a wall. In the past action films were mostly filled with men and a token girl as the love interest. Now we are entering an era where we are seeing more women in leading action roles.

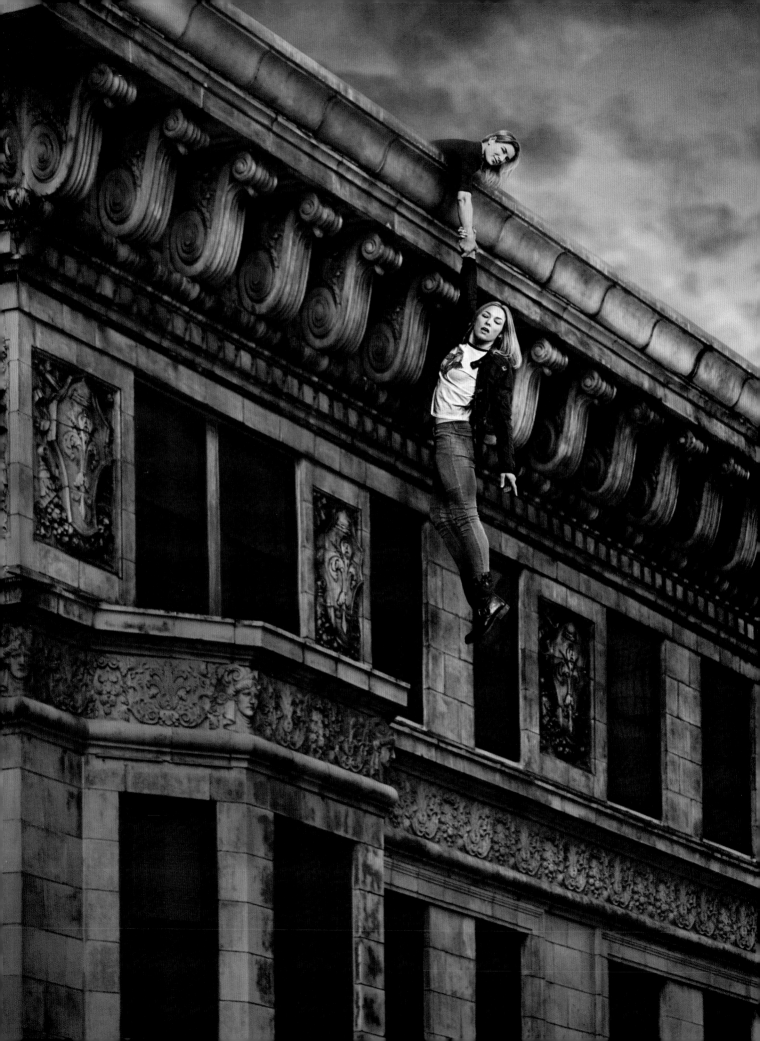

DORIS KEARNS GOODWIN

is a presidential historian

My name is Doris Kearns Goodwin, and I am a presidential historian.

My love of history began when I was a young girl. My mother suffered from rheumatic fever as a child, which left her with a damaged heart. She had only an eighth-grade education, but she loved reading. She would read to me every night. I would go to the library and get passes for the adult reading room to bring books home for her to read. The only thing that I loved more than listening to her read me stories was listening to stories about her childhood. I became obsessed with storytelling. I would say to her, "Mom, tell me a story about when you were young," so I could think of her as a young girl again, running up the steps or jumping rope, which she could no longer do. I never realized how peculiar it was until I had my own three sons, who never

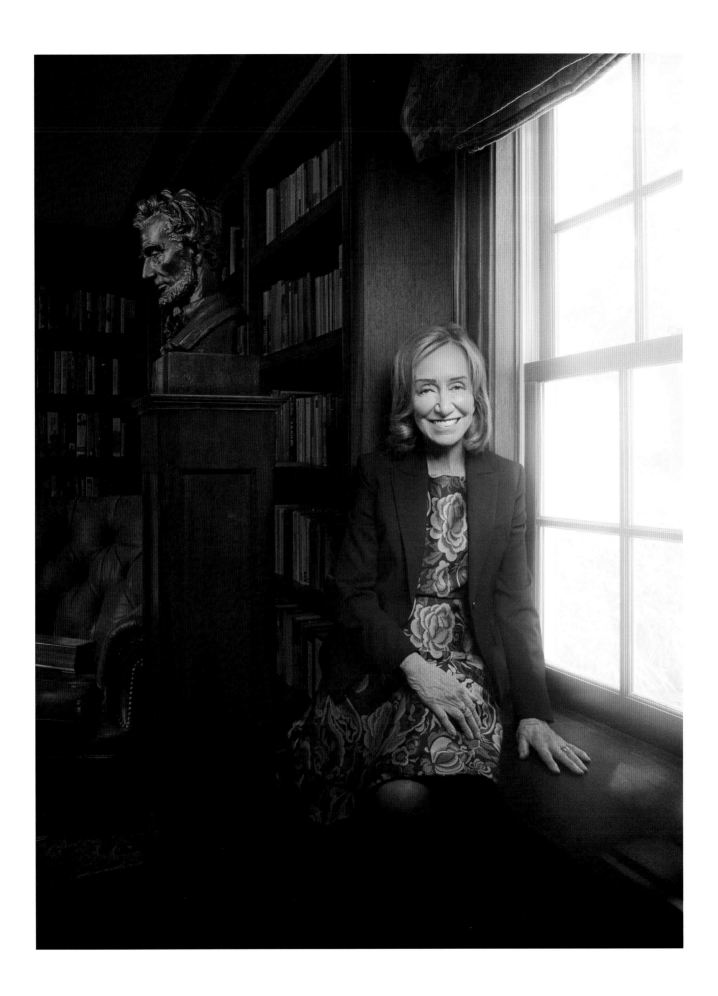

once have said to me, "Mom, tell me a story about you when you were young." I think I just became interested in the stories of history, because it was a way of bringing me back to a time before my mother became ill. She died when I was fifteen. Those stories that she told me have become, in some ways, the anchor of my life.

At the same time, my father loved baseball. He taught me that mysterious art of keeping score while listening to games, so I could record for him the history of that afternoon's Brooklyn Dodgers game. When he'd come home from work, I, with my miniature symbols, could tell him everything that happened in the game. It made me feel that there was something magic about history to have kept my father's attention during the hours it took to tell the story—from beginning to middle to end.

I think of myself as a storyteller who happens to focus on presidential history and leadership. People remember stories more than facts and figures. When you tell a story, it takes on a life—it illustrates something, and then people can tell it to someone else. In the old days of sitting around a fire, one generation would tell a story of the people who had lived before them, and even before the written word: that's how memories became preserved.

And like many people, I was also influenced by a great teacher who loved history, Miss Austin at South Side High School in Rockville Centre, Long Island. I remember that when she talked about Franklin Roosevelt's death, she was almost crying. I thought, Oh my God, a teacher is feeling that emotional about a person who's not alive. Through her storytelling, she brought him to life. Then when I was in college, I read a book by a female historian and great writer, Barbara Tuchman, called *The Guns of August*. It's about World War I, and it's stunningly beautiful. If she could understand war and history and explain it to others in a way that makes us feel as if we were there, I realized that there was room for female historians. As a young woman, she made a big impact on me, and much later in life when I met her, I was so excited to tell her how much her work really mattered to me.

When I was twenty-four and in grad school at Harvard, I was selected as a White House Fellow, a wonderful program that still exists today. There was a big dance to celebrate, and President Lyndon Johnson danced with me, which wasn't that peculiar as there were only three women out of the sixteen Fellows. As he twirled me around the floor, he told me he wanted me to work directly for him in the White House. But it wasn't to be that simple. In the months leading up to my selection, I'd been active in the anti-Vietnam War movement, and had written an article with a friend of mine that we'd sent to *The New Republic*. Having heard nothing, it was suddenly published a few days after the dance. It was entitled, "How to Remove LBJ in 1968." Yet he said, "Oh, bring her down here for a year, and if I can't win her over, no one can."

I did end up working for him in the White House, and then accompanying him to his ranch to help him on his memoirs in the last years of his life. That's how I became a presidential historian. My first book was about him. I then wanted to write about another president, and I chose John F. Kennedy. Then there was Franklin Roosevelt, Abraham Lincoln, Theodore Roosevelt, and William Howard Taft. I wake up with them in the morning, and think about them when I go to sleep at night, all the while learning from them—on personal as well as political levels.

I never imagined myself becoming a presidential historian. I knew I loved history, and I knew I loved storytelling, but my direction came from working with LBJ, an experience that changed my life. Had I known

him at the height of his power, he could never have spent so much time talking with me. But hour after hour, day after day listening to his stories, I developed a great understanding of him and had empathy for him in the end.

For five decades now I have been living with dead presidents. There's something about the perspective of being thrown back into another time, where you feel like there are layers of life that are coming alive. Writing about the past has allowed me to live through the Civil War, the Great Depression, World War II, and the turn of the twentieth century. Although LBJ and I were alive during the same time period, we were a generation apart. Today I'd have a much harder time writing about a current president. I appreciate the significance that comes with the perspective time offers, plus I need diaries and letters—a little different than emails and texts.

The perspective of time also allows us to feel we're part of a continuum—that we know what people experienced and thought during the Civil War, for example. I think it is so important today to realize that although we feel like we're living in such a difficult time—and we are—looking at history gives us a certain sense of solace. We can look back on these times like the Civil War, the Great Depression, World War II, and the civil rights struggles and know that we got through those times as a country, that people got through it, and their circumstances were more difficult, perhaps, even than what we're living through now. We can have hope that we'll come through this.

I also find hope today in the rise of women studying history. When I meet young women, there's nothing that matters more to me than when they tell me they loved what I wrote and it made them want to study history. I think one of the reasons women may not be going into the field of presidential history right now is that our presidential field is male

dominated. There are so many burgeoning fields of history—the studies of the rights of women, LGBTQ communities, and immigrants, to name a just a few. Women are growing those fields of study, and I hope that more and more women will also study our presidents— especially as we have female presidents in the future.

Even so, when I'm writing about a president, I'm really not just writing about a male—they have wives, families, colleagues, and friends. They, too, have lives that are much broader than just a male perspective, and the lessons we can learn from them are universal. It's why the wives are a huge part of what I write about. In the presidential biographies of the nineteenth century, sometimes there would be no mention of the wife, except maybe Mrs. Harrison, or Mrs. Somebody, in the index, because historians didn't think these women mattered much. But each one of these presidents could not have done the job without a team around them, both when they became leaders, and beforehand; people who encouraged them along the way, who supported them—family, friends, teachers, mentors, and colleagues. I am as interested in their path and journey to get to the White House as I am in what they did when they were actually there.

When I first went to graduate school, there was a problem in that not very many women would finish their PhDs, as we were pointedly told by the men who headed the department. It's impossible to imagine such a conversation today—leadership saying to young women that the chances statistically that they'll finish are not great because they'll get married and have children. You couldn't imagine this today, right? As a presidential historian, my colleagues are mostly men, but we're buddies. I guess growing up loving sports, loving baseball, I've always had male friends. I never have felt that sense of being an outsider.

Of course, it would be more fun if there were more women. Sometimes when I look at young women who are studying history, I think that if I were fifty years younger, how great it would be to have them as my colleagues. It makes me happy that they have one another, and I hope they will help and support one another.

I think the most important thing to remember is: If you've found some vocation or some cause that you really want to be a part of, that desire will take you through. That passion for what you're doing is going to help sustain you. You may not find your calling right away, and that's okay. The philosopher William James said: "Seek out that particular mental attribute which makes you feel most deeply and vitally alive, along with which comes the inner voice which says, 'This is the real me,' and when you have found that attitude, follow it."

It's a wonderful time to be young as a girl. Everything's opening up in a way that it wasn't when I was young. There are more women graduating from college, more women running for office and making their way into Congress. It's very inspiring to each of us, and it exponentially inspires others. If you see someone in a field you are interested in who looks like you, it helps you realize that you can get into that field, too. Eventually, they'll be everywhere, women.

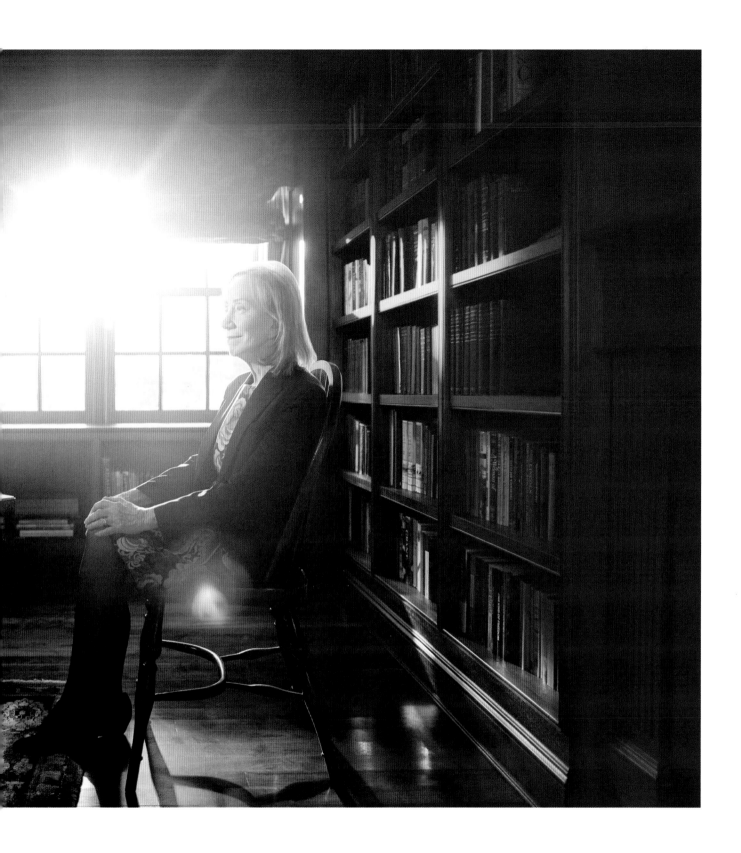

KAREN CRISMAN

is a dog groomer and small-business owner

I grew up in Titusville, Pennsylvania, and then went to Harcum College, an all-girls school, before moving on to Bryant & Stratton College, a business institute. After, I worked as a secretary; I worked as a fashion buyer for LL Burgers in Buffalo. I wore many professional hats before marrying my husband, whom I met in high school, actually. We've been married forty-four years now.

I'd thought about becoming a dog groomer for quite a long time. A friend of mine had been in the business; she married and had to move out of town, and I kept saying to myself that I wished I could just go and do what she had done.

I had just been laid off, and my husband said, Why don't you go for it? I'd have my own business, I wouldn't have to worry about getting laid off, I'd be at home. That's what started it. My husband has been so supportive—and talented. He's put on three additions and a garage, a full basement, everything. He built my work area so it would flow more efficiently; for example, he built the tub up higher so I wouldn't have to keep bending over. He made sure that I got a vacuum system installed. He just did everything he could think of to help me. But before all of that, I found a dog-grooming school over in Sharon, Pennsylvania, about two hours away—I did the drive every day to get the training done. That was forty-three years ago. I never looked back.

One of the best parts about my career has been the ability to schedule my time around my husband's schedule and around my son, Chris's, activities when he was growing up.

Chris was a big help, too. He'd do things like brush the dogs out or dry them. It saved me a lot of time, and I paid him well. But the greatest thing was just spending time down there with him. We spent a lot of one-on-one time together, really talking—about his day or school or something happening in sports.

This industry is filled with both men and women; the questions I get usually aren't about me being a woman doing dog grooming. There's so much support for people, for women, now than ever before. It's just amazing. There are so many people that want to help get you to the right place. So no, I don't often get questions about being a woman dog groomer.

They're more like, "That's a career?" But despite that, I've been blessed to have many great clients, both two- and four-footed, over the years. They've all treated me so well. Many had been sent to me because other groomers refused to deal with unruly dogs. Spending time with them, calming them down, could turn them into some of the best dogs I ever groomed. But you have to take time and patience. And it seems like I had more patience with dogs than I did with anything else. They're good listeners; they don't judge. I couldn't have asked for a better job.

At one point, after I got into grooming, I did find myself wondering if I should have just studied to become a vet. But there's so much schooling. And for me, it's sometimes hard enough just to deal with older animals as a groomer. Some of these dogs I've groomed since they were puppies all the way through old age. To see them deteriorate to that point, it's hard. When people would call to say their pets had passed, I would just cry like a baby, because they were part of me.

Some of that has to do with my grandparents, who were big influences for me. They were always so good to me; they taught me to be kind. Kind to people and

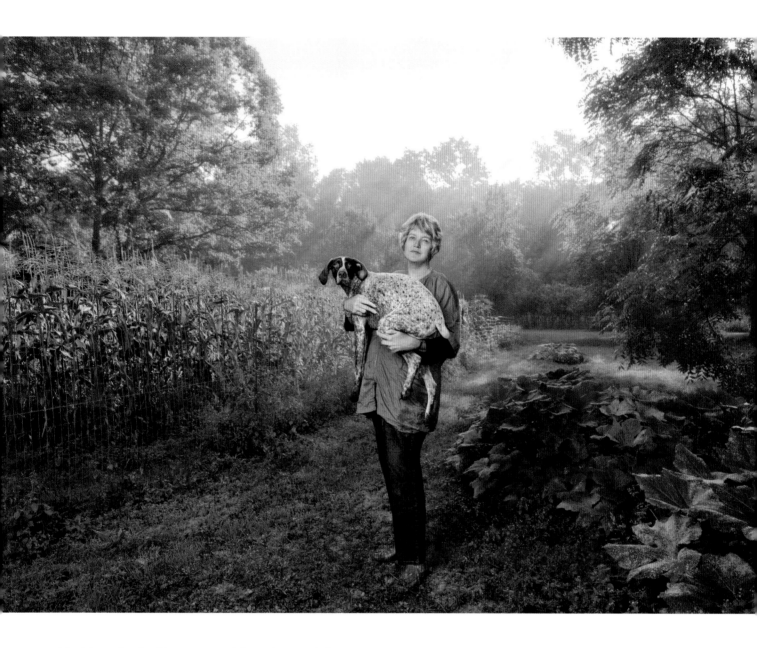

kind to animals. They were avid readers and they really believed in education, even though they'd only gone through the third or fourth grade. I think that helped me a lot. My grandfather at one point raised rabbits because I had once said, as a child, "I love rabbits," so he started raising rabbits. I was very lucky to have the parents and grandparents I did.

I'm a grandmother now. So to my granddaughter—and other young people—I say: If you have a dream or something you want to do, don't let money or your situation hold you back. In the end you're going to be giving yourself the gift of happiness and the joy of loving your own work. That's priceless.

CONNIE CHANG

is a chemical and biological engineer

My father is a chemical engineer, and my mother studied agricultural chemistry; however, I am the only one of three siblings who became a scientist. Growing up, I was not sure what I wanted to do. I enjoyed music and writing but also loved math and science. I went to a women's college where I had a wonderful mentor who inspired me to study biophysics in graduate school. During my graduate studies at UCLA, I focused on soft-materials science and the physics of viruses. I then went to Harvard for my postdoctoral studies in the area of experimental soft-matter physics. I am currently an assistant professor at Montana State University in chemical and biological engineering. I am passionate about my research—I examine tiny microorganisms such as bacteria and viruses at the single-cell level. I use a powerful technology called microfluidics to manipulate fluids in channels the width of a human hair. This allows me to test these microorganisms very quickly. I am interested in increasing the speed of clinical diagnostics and translating basic research findings into new therapies for patients and would like to see the biomedical technology in my lab commercialized.

I love my job: teaching students, interacting with diverse colleagues, making scientific discoveries, and engaging with the scientific community and the general public. Teaching engineering has been a great opportunity to connect with my father—who has a traditional chemical engineering background—to ask him about engineering classes and options for engineers after graduation and to borrow all his old undergraduate and graduate textbooks. My father always encouraged me to enter engineering and was a major influence in my becoming an engineering professor. Both my parents are inspirational, hardworking, and supportive. In addition to my parents, other important influences came from my mentors: from undergraduate, graduate, and postdoctoral training. The most valuable things I have learned from them include how to conduct experiments, how to apply the scientific method, and how science can benefit society and change the world for the better.

In terms of changing the world for the better, I always try to raise greater awareness of recognizing biases and inequality in higher education. This may involve efforts like ensuring that underrepresented speakers are invited to conferences or emphasizing equity, diversity, and inclusion in my classes. I am passionate about being a role model for younger women in science, and I am therefore involved in a lot of outreach within my community, including Girls for a Change and Expanding Your Horizons, which are outreach organizations to encourage young women to pursue STEM-related fields. I have been fortunate to have had fantastic mentors, both men and women, who have been supportive of women in science. I am also fortunate to have attended a women's college where there were many examples of women in leadership positions. That certainly has shaped who I am today.

I have two little girls, and one of the books I read to them regularly is *She Persisted* by Chelsea Clinton. It starts off, "Sometimes being a girl isn't easy. At some point, someone will probably tell you no, will tell you to be quiet and may even tell you your dreams are impossible. Don't listen to them. These thirteen

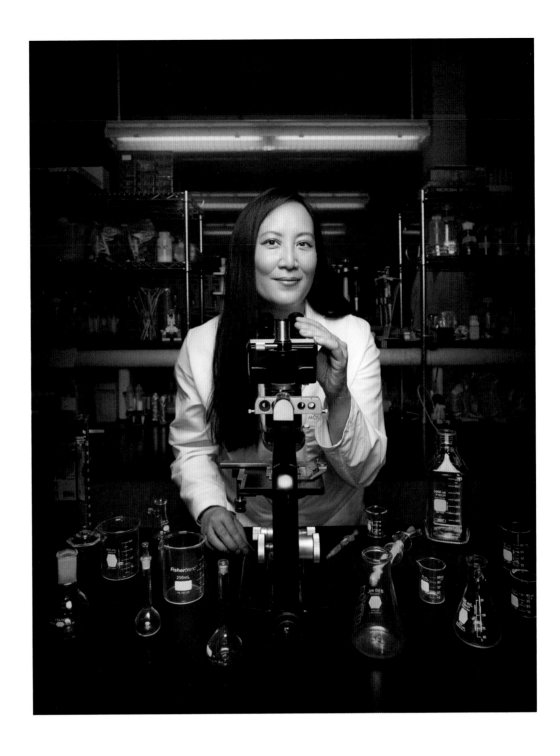

American women certainly did not take no for an answer. They persisted." As a woman in science, there were many difficult times—making it through graduate school, having a baby during my postdoctoral fellowship, seeking a two-body solution in the academic job market, securing a tenure-track position, and obtaining research funding for my laboratory. Forging a path as a woman in science is challenging, but each experience has helped me to grow and gain confidence in my abilities.

I think it is important as a woman in a male-dominated field to provide mentorship and advice to make sure the next generation of women are given a chance to reach their potential. The main advice I have for young women is to have grit. Have a goal, and keep working toward it.

PAT SUMMITT

was an award-winning basketball coach

THE FOLLOWING WAS WRITTEN WITH THE PARTICIPATION OF THE PAT SUMMITT LEADERSHIP GROUP

Pat Summitt was an American treasure. Growing up on a farm, she learned an amazing work ethic from her father. Summitt often quoted him on the subject of hard work: "Cows never take a day off." As a coach, Pat rarely took a day off. In fact, one of her key parcels of advice on success, simply put, was "Make hard work your passion."

After a stellar basketball career in high school and college, Patricia Summitt (née Head) took her passion for basketball and transitioned into an astonishing coaching career. At the young age of twenty-two—nearly eight years before the NCAA acknowledged women's basketball as a sanctioned sport—Summitt surely made hard work her passion. She was paid a mere $250 per month for coaching, taping her players' ankles, driving the team bus, washing the team uniforms—all while pursuing graduate studies. But through it all, she became a sponge for learning the fine art of basketball. She was a highly committed student of the game. She disciplined herself and her team. In her formula and model for success, her "Definite Dozen," as she called it, she wrote, "Discipline yourself so no one else has to."

Summitt prided herself on being an educator first and foremost. In her thirty-eight years of coaching, she graduated 100 percent of her players—a feat unexcelled by any major coach, male or female, in any sport. Over her career she was named Coach of the Year multiple times; National Woman of the Year; Mother of the Year; and Coach of the Century by the NCAA. She won eight national championships and 1,098 games. She coached Team USA in the

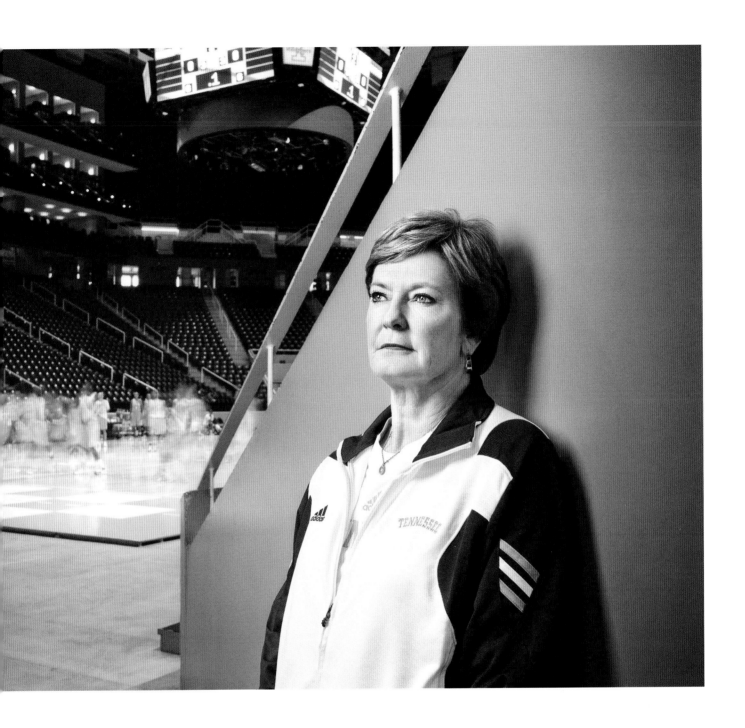

Olympics to a gold medal, won multiple international championships, received the Arthur Ashe Courage Award from ESPN, was honored by three US presidents with the Presidential Medal of Freedom, and wrote three *New York Times* best-selling books—*Sum It Up* being a number one bestseller.

Coach Summitt was a champion for women and gender equality. She was an extraordinary coach, teacher, mentor, and friend. Those who knew her—many of great fame such as Robin Roberts, Reese Witherspoon, Peyton Manning, Samuel L. Jackson, Garth Brooks, and others—still remember her great pieces of advice over the years, including "Nobody cares how much you know until they know how much you care."

What can we learn from this amazing iconic coach? It's all in the **Definite Dozen**: "Respect yourself and others. Take full responsibility. Develop and demonstrate loyalty. Learn to be a great communicator. Discipline yourself so no one else has to. Make hard work your passion. Don't just work hard, work smart. Put the team before yourself. Make winning an attitude. Be a competitor. Change is a must. Handle success like you handle failure." These twelve seemingly obvious pearls of wisdom are what made Pat Summitt historical, a legend, and a legacy. They're what led her to be the Coach of the Century.

Read them. Reread them. Put them up on your wall or on your desk. Share them with others. And as Coach Summitt said, "Take full responsibility."

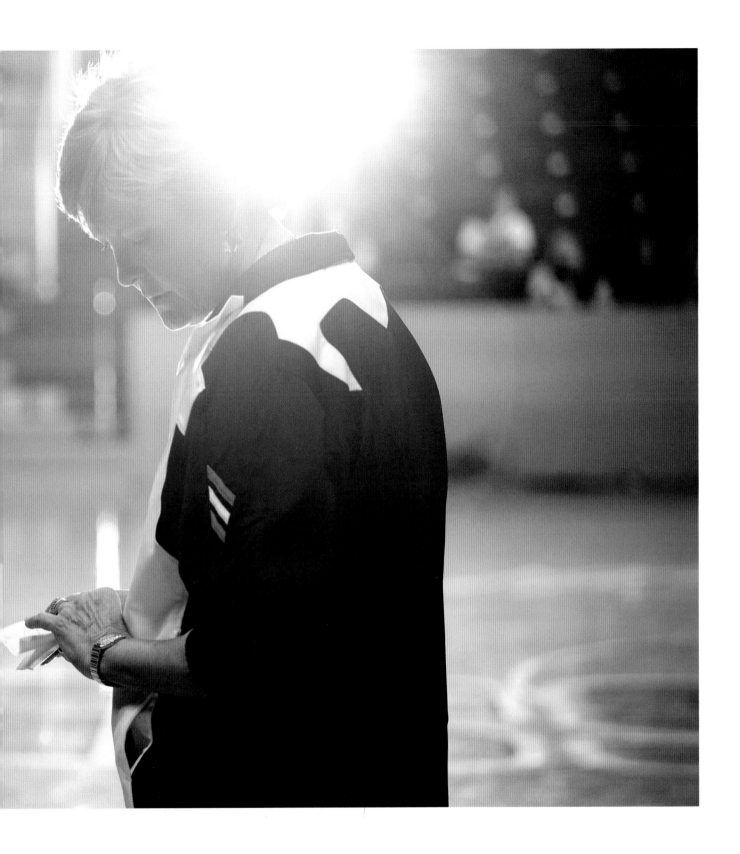

HEATHER MAROLD THOMASON

is a butcher and the founder of Primal Supply Meats

My entry into butchery started with farming. I was inspired to learn the trade in order to become a resource for small, sustainable livestock farmers. When I was unable to find an opportunity to apprentice with a butcher, I sought out a farmer to take me on instead. I spent a full season, from April through November, apprenticing at a pasture-based livestock farm, North Mountain Pastures, in central Pennsylvania, where we raised animals from birth to slaughter, harvested chickens weekly, made sausages and other products for farmers' markets, and worked with a local butcher to process all of the other meat we raised to sell to customers. Towards the end of the season, I finally connected with a butcher, the owner of the Local Butcher Shop in Berkeley, California, who agreed to take me on as an apprentice. I showed up every day for five

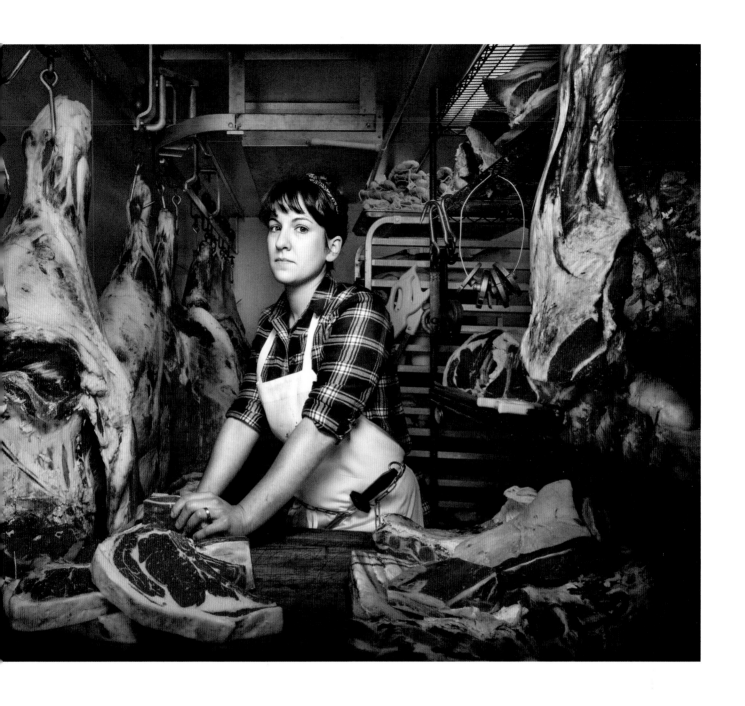

months to train in all aspects of meat cutting; by the end, I could break whole hanging beef off of a rail. That summer they hired me on as a butcher and I stayed there, continuing to practice the craft of whole animal butchery. I eventually went back east to help open a new butcher shop within a restaurant called Kensington Quarters in Philadelphia. I became the head butcher and shop manager there; in my work I started to build a network of farmers and processors who would eventually become the foundation of my own business.

In 2016, I started Primal Supply Meats, a butchery and local sourcing company committed to providing sustainable, pasture-raised meat to Philadelphia. It has been an actualization of what brought me to butchery in the first place. I am working directly with local farmers to build up a supply chain and market for sustainable meat in Philadelphia. Chasing my goals as a butcher brought out the entrepreneur in me. Now I am dedicated to growing my business, training more butchers, educating the chefs and home cooks we supply, and creating lasting connections in my local food community. A perfect workday for me looks like getting everything done! But that never happens. Connecting with people about food is what I love, and I get to do that every day at work, whether it is talking to customers over the counter about what they're cooking for dinner, visiting a farmer and walking the pastures together, or meeting with a chef to talk about how we can source local meat for their menu. I do love the art of butchery, but these days I spend more time running my business than I do working in it. So when I get to spend a quiet morning cutting meat to set a beautiful case in my shop and then open the door for the day's business, it still feels like a dream come true.

I spent my twenties working as a graphic designer in New York City. I loved the work, but my personal passion was always food and I was developing deep connections with my local food community through involvement with my neighborhood food co-op, CSAs [community-supported agriculture], and farmers' markets. As I entered my thirties, I grew tired of perpetual deadlines and staring at a computer screen all day. I had grown close with a local farmer raising pigs and became interested in the challenges he faced growing his business because of the limited resources for slaughter and butchery available to small farmers. At the same time I saw a whole-animal butcher shop open in my Brooklyn neighborhood that immediately filled a need for the community. I believed that if I could learn the craft of butchery, I could become a restorative link in a broken supply chain connecting sustainable livestock farmers to local customers. I suddenly identified an opportunity for a career change, despite the fact that it seemed like a crazy idea to some people at the time. I am fortunate to have grown up in a supportive family that encouraged me to believe I could do or be anything. As an adult I am a determined person who has never hesitated going after the things I believe in.

During my time training as a butcher, I was never really bothered or deterred by the lack of women around me. Some of the men I worked with—farmers, butchers, slaughterhouse owners—would not always take me seriously at first. I often had to work harder than the men around me just to prove myself. But I always did, and that made me better at what I do. Once I worked my way up to being a head butcher and manager, I started to hire and train other women, so that now there are more and

more female butchers in our world. I really loved working as a livestock farmer, but it's a tough living and I like that my work now supports farmers in making their ends meet.

I would encourage every young woman to chase her dreams. Work hard, be patient, and believe in yourself and the long game. Anything worthwhile will take time and dedication to achieve. The road to becoming a butcher was not always smooth or clear, and it taught me to be patient, but I kept looking and moving forward. My work has taken me farther than I ever dreamed it would.

ANGELA DUCKWORTH

is a psychologist and the best-selling author of
Grit: The Power of Passion and Perseverance

The first time I took a psychology course, I was sixteen years old. I had signed up for a summer program at Yale and paid for it myself; my parents are immigrants and didn't believe in paying for summer activities. So I used money I'd saved up from birthdays and Christmas and jobs. For my two classes, I chose psychology and writing. And here I am: I ended up becoming both a psychologist and a writer. But it took me until I was thirty-two, which is exactly twice the age I was when I went to that summer program, to actually have the self-awareness to say, "I want to be a psychologist, and therefore, I need to get a PhD, and therefore I need to go to graduate school."

So I came to the field a little bit later than most psychologists. I was already married and pregnant with my second child, so there were some limitations on my time. But the reason I decided to pursue psy-

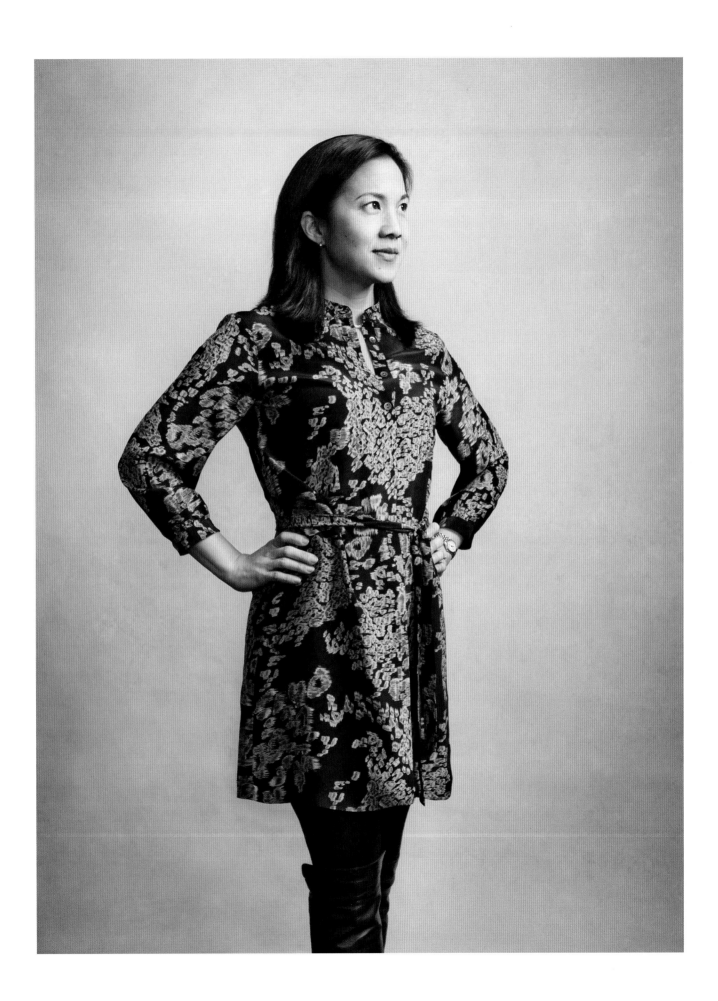

chology is that I really want to help kids thrive. And I realized that my way of doing that—though not the only way and maybe not even the best way—would be to understand how kids develop and then help everyone help them. In other words, help teachers do a better job teaching, help parents do a better job parenting, and so on.

Before I became a psychologist, I spent several years as a classroom teacher, trying to help kids that way. I think teaching offered stories and relationships that inspired my current research. Back then, I was frustrated by my own ineffectiveness in motivating kids to do what I thought they were capable of. In that sense, teaching shaped everything that I do as a psychologist today. If I hadn't gone into teaching, would I still have become a psychologist? I don't know.

In terms of my writing life, I am not working on another book. I may or may not write another one. I never thought of myself as a writer in the book-writing sense. In fact, when I was just starting to write *Grit*, I thought, "Who can write a whole book? They're so long!" I mean, I would go into airport bookstores and think, "Oh my God. These books have so many words!" So I'm a bit in shock that I wrote a whole one myself. And it's the hardest thing I've ever done professionally.

What I really hope to do next is take the principles of my book and apply them practically. I want kids to develop grit but also self-control and other capabilities that will make them happy, healthy, and helpful people. And it's really hard. I will tell you that almost all of my experiments fail. I work with some of the best scientists in the world, and a lot of their experiments fail, too. In other words, human behavior change is a really hard nut to crack. It very well may occupy me to the end of my days, and I think there's a reasonable chance that I won't make any progress. But that's what I'm working on.

I won't speak for all psychologists or all women psychologists—I can only speak for myself—but I have been very lucky that, at times, the world has rolled out the red carpet for me in ways I don't understand or feel are really fair. It's like, "Why did my current university, University of Pennsylvania, even give me a job?" Because I got my PhD here, and you're not supposed to get a job at the school where you got your PhD. It's sort of a norm that you don't do that. So I've had unusual advantages in my path through my profession.

But I do think there are real gender differences in how hard it is to get through, all the way through, the system as a woman. I know that women are more likely to feel like they should be doing a lot of work that's not central to their own personal research agendas. For example, women are much more likely to sit on committees when asked; men don't feel as bad about saying no.

In most of my own work on grit, I haven't felt pushback that has had much to do with gender. I think that when people push back against grit, it's actually for a very good reason, which is that a lot of people worry that if you focus on grit, you forget about other things that matter. I think it's a good thing to remember that grit's not the only important character strength. As a mom, I can say that my kids being gritty is not the highest priority. Of course they should be honest and nice and curious people before they're gritty.

I also don't want grit to overshadow structural factors like income inequality, prejudice, and other ways in which the world is not yet an even playing field. The message of grit is that no matter who you are, there are no shortcuts to achievement. That's true, I think, but some people have roadblocks and trapdoors and many more obstacles to achievement than others.

What advice do I have for young people? Here's a hack—or you can call it a strategy—that works for me, my husband, my closest collaborators, but not everyone realizes its power: you should copy other people. I sometimes jokingly call this "personality plagiarism."

You could also call it "copy and paste." It works like this: when you're trying to do something and you can't do it because you've never done it before, or maybe you have tried to do it before but you just haven't done it very well, you should take the best possible version you can find and copy it.

I'll give you an example. In my first year of graduate school, I had to write papers, just like many of my students do now. I'd never done it before. But I took a great paper, actually a few great papers, and I laid them out. I took a pen, and I tried to understand them. They started here with a short sentence, or they used active verbs, things like that. I copied the form. Start looking for these patterns. Ask yourself, which friend has the most reliable workout schedule? Ask them how they do it. Just copy what they do. I hear from a lot of people who feel like that's cheating. They don't want to copy. No, it's not cheating. In the school of life, it's okay to plagiarize.

I'm often asked how to find a passion to pursue professionally. The writer John McPhee says that when he started out writing, he thought he might want to be a poet. Writing poetry made him think he might want to try short stories. And he didn't stop there. He kept trying different genres until he wound up spending most of his time writing what became his specialty, long-form nonfiction. McPhee believes you can only learn to write through experimenting. In other words, learning what you want to "be" is not a cerebral exercise. You cannot reason your way to decide "Oh, I must be a novelist." You must experiment and experience to learn.

This is why I think anyone who is trying to find a passion needs to have patience. As long as you're tasting and experimenting with intention, though it is hard, take comfort in knowing it's the only way. Yes, it's very inefficient, but there is no efficient way to develop a passion.

JUDITH VON SELDENECK

is a C-suite executive searcher

I was born in North Carolina. My father worked for 3M, and when I was young we moved to northern New Jersey. (Though by then my accent was already ingrained. A southern girl for life.) My father's aspirations for me were not, shall we say, progressive. He thought I would make a fine secretary, get married, have a family. In fact, I did make a fine secretary, get married, and have a family. But that proved to be just the beginning of my aspirations.

I have always enjoyed, and been attracted to, the company of smart, interesting people who either were successful or wanted to be. And the most interesting to me were in politics. So it wasn't a surprise when I ended up working as the personal secretary to Senator Walter Mondale in the 1960s. Mondale was everything you could hope for in a politician: brilliant, champion of the underprivileged, open, honest, a man of great integrity, great sense of humor, and charismatic. And it was such an incredible time to be in Washington; John Kennedy was president. I attended Dr. Martin Luther King's "I Have a Dream" speech, which I will never forget, ever.

Of course, I had no business even getting the job in Mondale's office. When I went in to interview, I needed to take a shorthand test, and I didn't know anything about shorthand. But a friend of mine convinced me to sit there in front of Mondale as he dictated letters; my friend stood outside the door, taking it all down. So I sat there, scribbling nonsense in my notebook, as Mondale dictated, "Dear Lyndon" and "Dear Hubert." I then got the transcribed notes from my friend and typed the letters. (Flawlessly, I might add.) It wasn't until my going-away party that I found out that Mondale knew all along I had bluffed my way through the test. We were all able to laugh about it ten years later.

Mondale was, no question, my biggest influence in becoming an executive recruiter years later. He taught me how to manage time, which is one of the most undervalued skills around. You need a sense of urgency to your work, an underlying sensibility that problems need not only evaluation and solutions but also decisive action, which may require some risk taking—not everyone's cup of tea, but mine.

Mondale was also personable, outgoing, and down to earth. You wanted to be around him. He treated the Senate pages the exact same way he treated his fellow senators. If people like you and respect you, they will work hard for you. I realized the intrinsic value of bonding, of getting people to buy in and feel ownership. We were all very close in the Senate in those days—it wasn't like it is today,

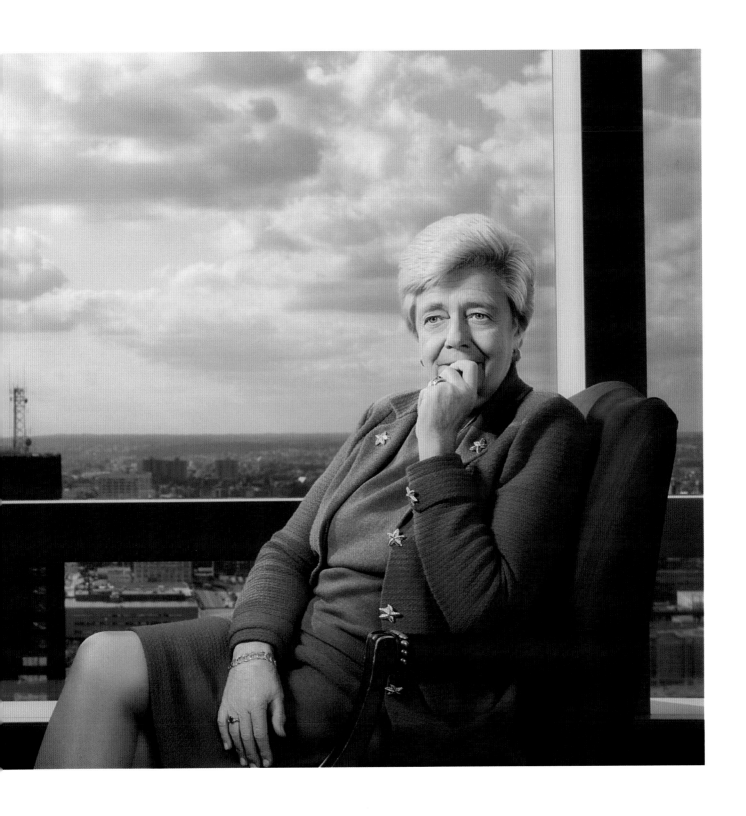

this sort of *Game of Thrones* "I am out to get any-one who disagrees with me" stuff. We understood the importance of passion and the importance of the work we were all involved in, genuine and inspiring leadership, and fighting for the greater good despite the odds. Mondale also symbolized fairness and the concept of equal opportunity for all. I feel lucky to pay taxes. I truly do. There is a sense of altruism he not only taught but lived. I fear there is a deficiency of it today in our culture.

Later, becoming involved in executive search was opportunistic rather than something I planned to do. It just evolved. I didn't even know what "executive search" was. So I sort of backed into it. The only thing I did know for sure was that I didn't want to work for someone else. I always had an entrepreneurial spirit. Given my strong interest in politics, which has never abated, I probably should have run for office. But back then? Heaven forbid. Women didn't do that. Espe-cially southern women.

When I moved to Philadelphia in the early 1970s, I needed a purpose. I found it when I met a few other women like me and we together started a job-sharing business for women. At this time, women were begin-ning to show up in the workforce in more substantial numbers, but in my neighborhood, I was still the only mom carrying a briefcase and taking the commuter train into town with the boys. I wasn't sure the busi-ness would work. But then we began finding people for government jobs, and at that time there was a big push in government to find female and minority can-didates. That was sort of a light-bulb moment for us, and we began telling people, "Just tell us what open-ing you have, and we'll find the people, for them." And we did.

It was tough going in the early years, as it usually is when you are building a business. Our first placement in 1974 was for a market research position that paid $13,000 a year. We were ecstatic! We kept our records on three-by-five cards in shoe boxes. Women were

not allowed to be members of private clubs in Phila-delphia in the mid-1970s. I called the private club my husband belonged to and made a reservation for sixty in his name without telling him. This was to become the Forum of Executive Women, which today has 450 members and includes some of the most powerful women in the region.

I actually don't really like the name "headhunter" or any derivative. I personally feel it cheapens what we do, which is to find great leadership. That's a term used by people who don't understand what we do. I don't much like "recruiter," either. A headhunter goes out and puts heads on the walls. That is not at all what I do or what my firm does. We do not find jobs for people—we find people for jobs. We work for the companies and organizations who want the best and the brightest. Our duty is to locate and place the most extraordinary leaders we can find.

I am an early riser. I get up early in the morning and read three newspapers: the Philadelphia *Inquirer*, the *Wall Street Journal*, and the *New York Times*. I read them thoroughly. And of course I love my coffee. So I drink my coffee and read my papers and curl my hair.

I always have a to-do list. I review that, look at my day, put stars next to the important stuff. A great day for me includes someone calling me and asking, "Can you find me a board member or CEO?" And then having lunch with someone who is really interesting and who can provide insights and cares about what is going on in business or the world.

I am not easily intimidated—it is death if you are a woman who runs her own business—so I don't listen to anyone who speaks negatively about what we do. I know what we do. We look for people who have the right set of skills but who also have the right set of val-ues. Our firm has a set of tentpole values we live by: truth, integrity, respect, goodwill. Those are the qual-ities we look for in our candidates as well. As for the number of females in search, we certainly have many

at our firm. And I think our number is growing. I think it's a sign that women often see attributes differently and that they can bring a unique and important point of view to leadership initiatives. You're beginning to see this with this push to get more women on corporate boards and in the C-suite. Many believe if we had more women at the top rungs of government, we would all be a lot better off.

I can't imagine not doing this. I am proud of what we have done and what we continue to do, and I don't think anyone could have wished for a better career than the one I've had.

If I hadn't done this, I think I would have liked to run for office. Somewhere in Congress perhaps, but back in my day this was unheard of. I went to law school briefly in the late 1960s and was one of only two women in the whole class, which tells you something.

I will never retire. I am always looking for what's next: the next search, the next board, the next initiative to support. A lot of my peers are retired or near being retired, and they want to talk about their gardens or their golf games. I'm happy for them, that they are loving life as they take their victory laps. But I want to be where the action is. I love politics. I want to be in the mix and to talk to people. I love talking to people who disagree with me. I get bored when there are not problems to solve. Pressure gets my juices flowing. I thrive on it. I'm interested in supporting more women entrepreneurs and supporting more women running for office. I want to support more scholarships, create more opportunities for people to get an education who can't afford one.

In the way of advice for young women, my favorite quote is from Eleanor Roosevelt. She said, "You gain strength, courage, and confidence by every experience in which you really stop to look fear in the face. You must do the thing you think you cannot do." From a young age I was driven—to be seen, to be heard, to excel. You can't teach that. It has to come from within. You have to look at yourself in the mirror and take stock: What have you got that you can bet on? Figure out what is unique about your talents, and build on them and go for it. Don't be afraid. Fear is a killer. Confidence, energy, and hard work will carry you far—and they will attract other people who will help you on your journey.

I feel blessed! Truly blessed by the life I have led and continue to live.

SADIE SAMUELS

is a commercial lobster fisherman

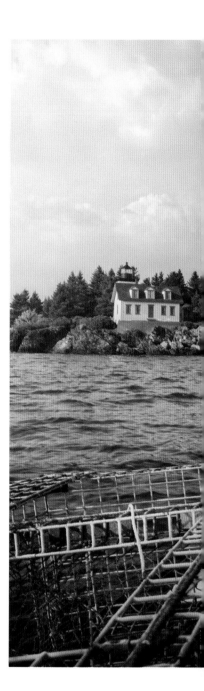

My name is Sadie Samuels. I'm a commercial lobster fisherman from Maine. I plan on fishing for the rest of my life.

The ocean is everything to me. When I feel really stressed out or unhappy or anything in my life is going wrong, I go to the ocean. When I need inspiration, I go to the ocean. I sit by the ocean. I listen to the waves. It's calming. It reminds me that there's something bigger than myself. It's both bold and soft and delicate; I think these dualities are really beautiful.

In my line of work there is no on and off season. It changes from harbor to harbor, mostly due to the way lobsters move. I'm stationed way up in midcoast, like in the bay. In midcoast, where I'm at, the water gets colder sooner, so I'm done fishing here generally by mid-December. But it's a soft done; I like to say that I'm done for the season when I stop catching

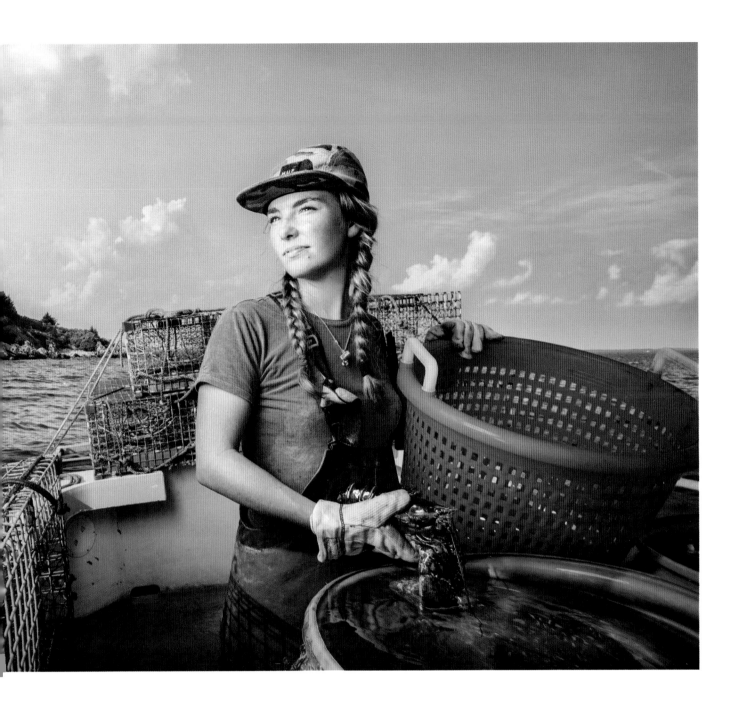

enough lobsters. But it's generally because the water temperature got cold enough for them to move out into deeper water.

I haven't really been able to work with many other fisheries because I've been doing this since I was a little kid as a family business. When I was growing up, my dad was also a lobster fisherman. He was always working from before sunrise to after sunset. The only way for me to get to spend time with him was to grab my boots, get next to the door, and be there at 4:00 a.m., when he left the house. At a certain point, by the time I was around seven years old, my dad decided to get me a student license, a couple of traps, and see what happened. Once I started fishing and I got my first hundred-dollar check, that was it. I was hooked. I pretty much wanted to fish since then.

I am pretty proud that I was raised by a fisherman and that I've continued on that legacy. My goal in life is to be happy. I want to have a family. I want to continue fishing. I want to be able to share all of the knowledge and all of the history of what I do and where I came from with them. That's what's important to me. That's what makes me happy. What's the point in not being happy?

I did go to college, and a lot of my family members are scientists, so we do have interesting conversations about environmentalism and our work. There is often a big disconnect between fishing communities and scientists. It's a huge issue and a struggle to connect our worlds, though there will always be people who think what I do, because I harvest live animals, is inherently bad. But I've grown up in this community, and I've seen firsthand what an incredible job it can be. I couldn't be more proud to do what I do or to be a part of my community. There's a legacy component to it, too, which I think is so important and has such a huge part in protecting the environment.

In terms of being a woman in my line of work, I'd say my immediate community is super-cool, super-supportive. The majority of them are older, salty fish-

ermen who are male, but they have always treated me with the same pay-your-dues mentality that they would any other guy. They see me as a younger person, rather than a woman. I feel like I've earned and gained their respect. But I do face gender discrimination like any other woman might. When I go to an auto shop, for example, where the owners don't know me and I need help getting a certain tool or buying a transmission or an alternator, I'm often ignored or unacknowledged. And that stuff really, really bothers me quite a bit, still.

The other thing about lobstering is that because it's an isolated business—we have strict territorial guides that we have to follow—I haven't really interacted with many other women who do what I do. I started getting involved in some projects and meetings in order to meet other women in the industry, hear their stories, and such. I feel like a lot of them have had it a lot harder than I have, in comparison, which makes me feel lucky. It's a challenging environment, and I think if I hadn't grown up in the business, I'd probably take the jokes and criticism a lot differently. I usually just give it back to them. I treat the guys like equals, and they treat me like an equal in turn. I often say, "Well, you don't think I can do this? Whatever, I'm doing it."

That attitude has changed people's minds, but I don't often pay attention to anyone who isn't outright supporting me. When you're on a boat, it's often just you and your boat and the lobsters. And when I come back with lobsters, I can still sell whatever I've caught, the same as a guy. I sometimes am uncomfortable being called a fisherwoman, because I feel like I've worked so hard to be as impressive as any guy. I don't want my gender to be relevant or surprising. I think just being a woman, you know from the time you're a little girl that there can be some public aversion to being anything outside of the norm. And that's the change I'd like to see made. I have faced incredibly frustrating situations, but I just try to remind myself

that I am the captain. This is my boat. I own this, and I do know what I'm doing.

Honestly, I've really wanted to find a woman to work closely with, but the only woman I've ever had work with me is my little sister. I've never found another woman who wanted to. And I've asked a lot. But I'm hopeful I'll find another woman sometime soon who can kind of step in, step up, become my stern man. I know women can do this work. Other women know women can do it. Yet still, often people will come to my boat and ask my stern man, even though I'm clearly driving, "Oh, so what kind of engine do you have? You let her drive the boat?"

I just think it's great how shocked people are to see a girl throwing traps around the boat. It should not be shocking; I'm super-passionate about my work, so why wouldn't I be the one doing it?

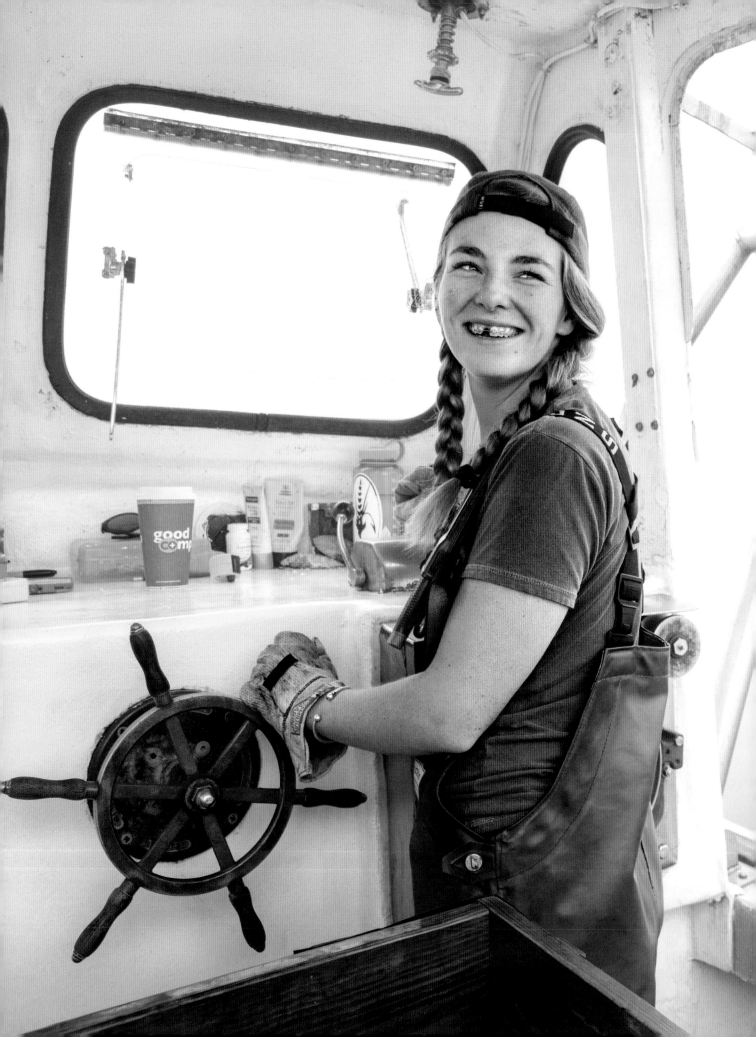

ANNA VALER CLARK

is a ranch owner and ecological restoration practitioner

When I was born seventy-eight years ago, the education of women was different than it is now; the expectations of women were different than they are today. My family expected that I would raise a family of my own in or around the New York area. They did not envision me living in remote areas restoring watersheds. Nothing in my previous life had prepared me for this new lifestyle. Fifty years ago, higher education did not focus on environmental issues. When I moved west, Nature became my teacher and I started to observe how water moves and how vegetation responds to moisture.

A series of life experiences took me from a plush residence in New York City to a mobile home in southeastern Arizona, miles up an unpaved road. When I arrived at this remote ranch, my first question was, "What do the cows eat, rocks?" The land was very dry and barren. My first shock came from the scant amount

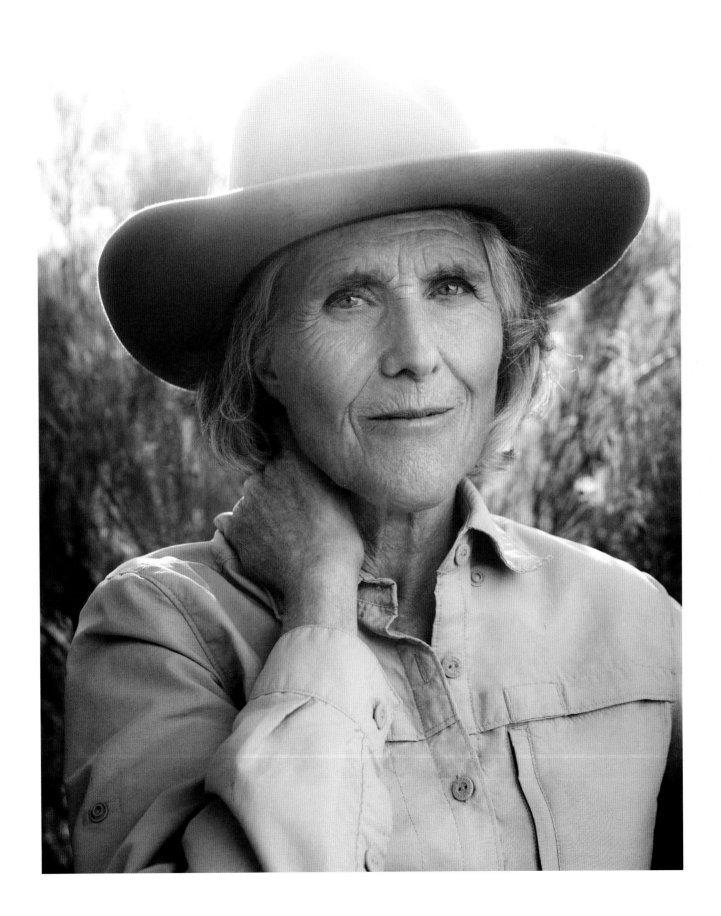

of rainfall, and the second shock was observing the monsoon flooding and severe erosion. It seemed unnatural to me that Nature should treat herself so harshly, and indeed it was unnatural. A century of poor management, overgrazing, and logging in the hills had created a problem. The earth could no longer absorb rain. I realized that it would be possible to heal erosion and capture water in the hills by putting rock dams, also called gabions, across places that had eroded. At times the experts were skeptical about the way gabions could work on a large scale, but time has proven that they are effective. I knew these places would fill in with dirt and remain damp, and over time the seeds that are present in the soil would start to grow. Thousands of rock dams later, the earth absorbed the rains and the hills became covered in grass. The hills were literally "weeping water" long after the rains had passed.

My life has been a continuation of applying these same principles of harvesting water, revegetation of the land, and the restoration of water to dry areas. Even though I was told by experts that what I had in mind couldn't be done, I went ahead and did it. Now the reality of what I have done has convinced people that it is possible to bring running water back to streams and revegetate the land.

These restored habitats sparked the interest of scientists. Now ranchers as well as state and federal agencies have shown interest in learning from our success. My mission has been to take severely degraded land and restore it. If one can accomplish this under seemingly impossible conditions, one can do it anywhere.

In my mind, this is the future. Where there is water, there is life.

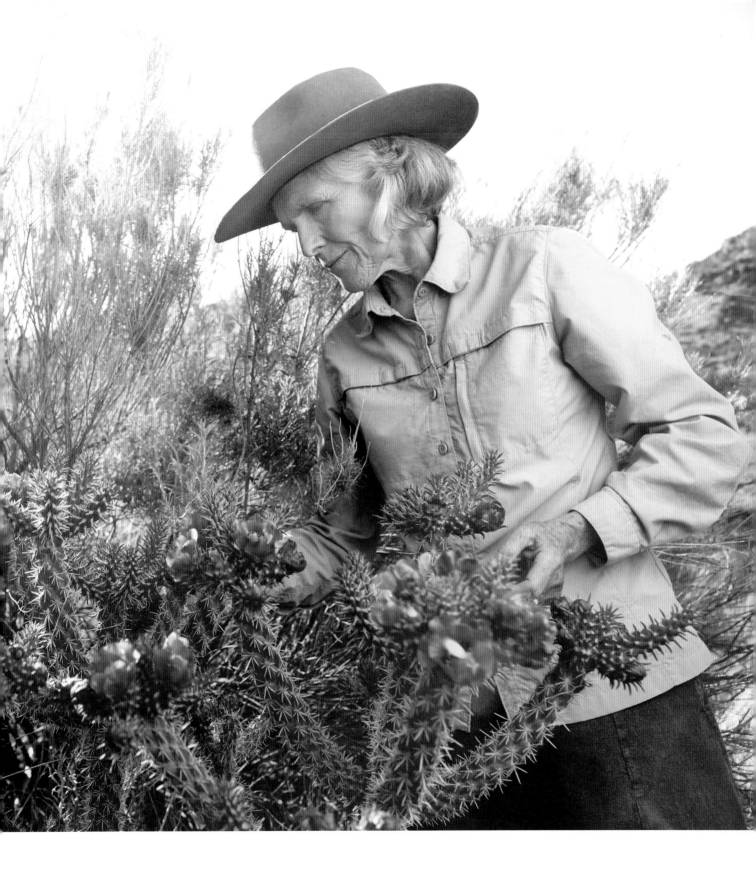

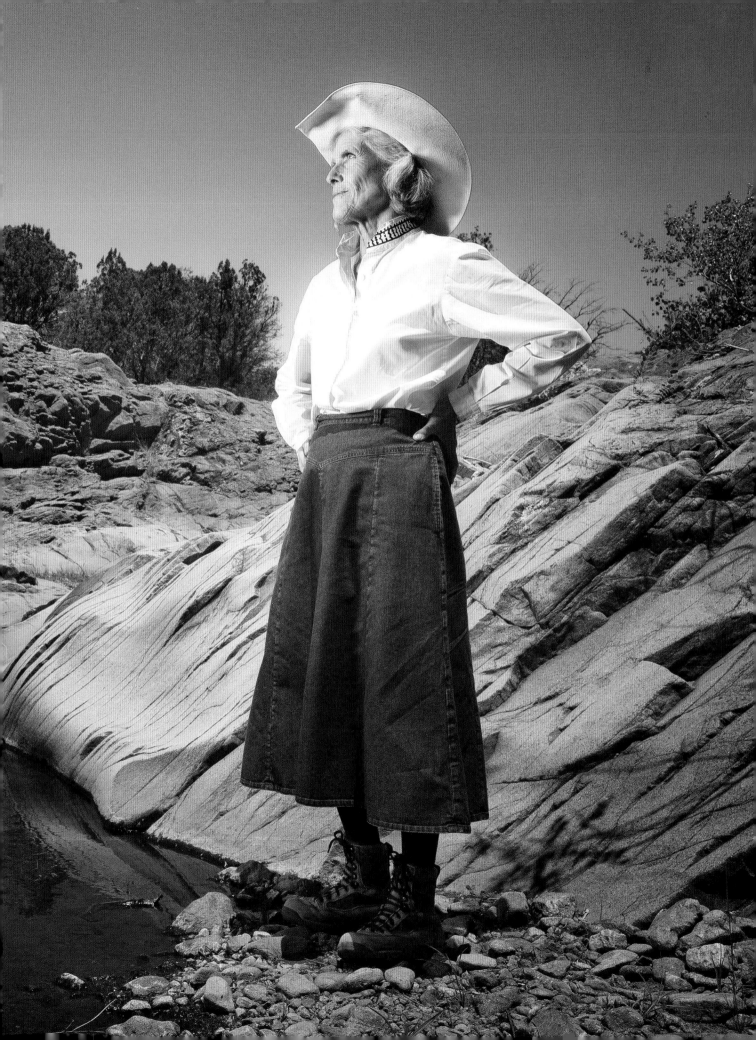

MEEJIN YOON

is an architect and the first female director
of the architecture program at MIT

I wanted to become an architect from a pretty young age. I was always quite impressed by unusual buildings. I grew up in the Washington, DC, area. I remember one of our school field trips to the Hirshhorn Museum—a concrete doughnut building designed by the renowned architect Gordon Bunshaft. I also remember visiting the National Gallery of Art's East Building, designed by I. M. Pei. I thought these strangely shaped buildings were quite special, inside and out. The volumetric scale of the East Wing atriums were really amazing. I remember all the sharp corners and defined edges of the space. I did not know much about architecture at the time, but I wanted to learn more about these buildings that seemed like such anomalies.

Throughout my youth, I continued to find inspiration in museums and their collections. There were

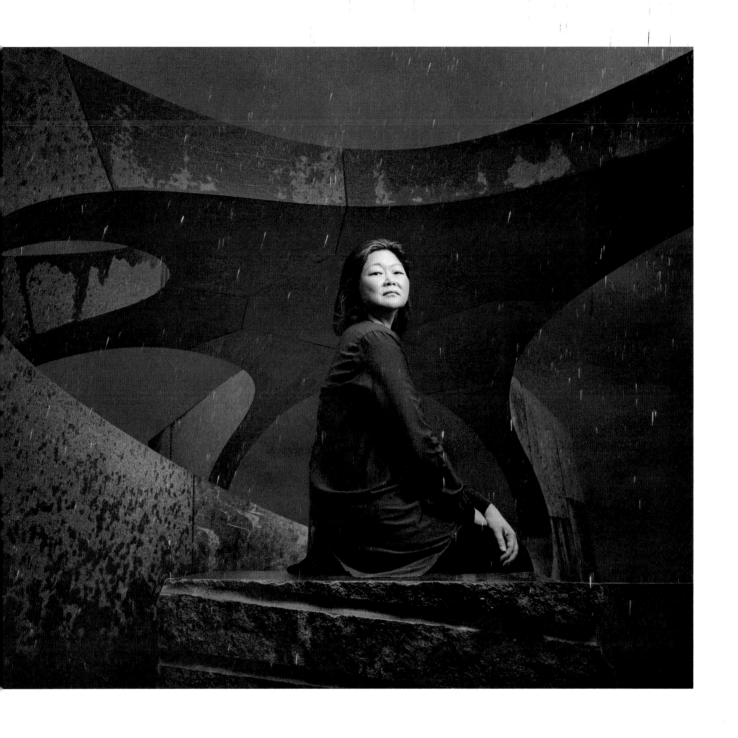

many artists whose work I found really inspiring: Rachel Whiteread and her plaster castings of architectural space and motifs; or Gordon Matta-Clark, who would carve into buildings geometric shapes through walls and floors; and then Walter De Maria is another whose environmental art projects, the Lightning Field or Broken Kilometer, were powerful and beautiful in their interventions in time and space.

No one in my family was an architect, but I was fortunate to discover that Cornell had a five-year bachelor's of architecture program. I could not imagine doing anything else with my life, and that is why I went into a five-year program at Cornell. I loved it. I loved every aspect of my architectural education. The studio time combined creative imagination with rigorous exploration—I relished the fact that there were so many different approaches to a design problem. I realized that form, context, and content could come together.

On graduating from the architecture program, I felt like I needed to learn more about the expanded building context, cities, and urbanism. For graduate school I studied urban design at Harvard to learn about urban form, urban networks, infrastructure, and ecological landscapes. But a year into the program, I longed to work at the smaller scale. I missed designing highly tangible spaces and places that were highly experiential. And so from the beginning, my work has moved across scales, from the tactile details to the territorial mark.

I did not have many women professors in architecture school. Though I served as MIT's first female head of the architecture department and Cornell's first female dean of the College of Architecture, Art, and Planning, it feels strange that it is only recently that women have taken up these roles. For the first time, in many architecture programs, women students make up 50 percent or a slight majority of the student body, yet the number of tenured women faculty and licensed practicing women still trails significantly behind. I think it's really important to have more women

teaching and more women practicing in the field. The change in gender balance in architecture schools is very palpable. Women students bring different and critical perspectives to the table; it's essential to have a variety of vantage points to understand the built environment and approach a design problem. Students have a fresh, critical capacity that you can lose sight of when you've been practicing over many years. But what I cherish most about teaching is that you are constantly challenged and reminded of your values. I would like to spend the next period of my life thinking about how design and architecture can be used to address questions of dignity, equity, and the environment. To that end, the UVA Memorial to Enslaved Laborers is a project I've been working on and have found extremely weighty but meaningful. Architecture brings communities together; it can expose hidden histories and give a physical place for voices that have not had one before.

Early in my career, when I was looking at different places to work, I concluded that there were very few women practitioners and there were even fewer women solo practitioners, and there were even fewer women in leadership. I sought out a firm that was a husband-and-wife partnership. I think it was important to me to be in a small firm, where a female was a strong force both in design and construction.

Looking at female architects, like Zaha Hadid, Liz Diller, or Jeanne Gang, they seem to be the rare exceptions to the norm. The generation of women architects my generation looked up to typically were superwomen who did not typically have children. Early in my career, it felt like you couldn't be a woman and have it all; professional success and children seemed mutually exclusive if you wanted to pursue an intense architecture career. It felt like you had to make a choice, but that has clearly changed. There are many female architects of my generation doing excellent work, leading professional offices or schools, and raising families.

There's no one path. I made a conscious choice, early in my career, to pursue architecture. I thought that meant I would have to sacrifice many things. Financial stability, because the early years of being an architect are pretty tough, and compensation is low. Family, because there would be no time to have a child. I did make those decisions consciously; I believed succeeding in architecture required sacrifices. I gave up on the idea of having a child for a long time, focusing instead on the work. Then later, when I was thirty-eight, it felt like maybe it was possible to do what I loved professionally and also have a family. Today I can't imagine life as an architect without being able to share that with my daughter.

I now believe it is more than possible to have the career you want and the family you want and the personal fulfillment that comes from both. It might happen over time and in unexpected ways. You have to just be open to that. Try not to feel like you must choose—that you have to sacrifice one thing to get another. I hope the next generations never feel their career comes with required sacrifices. Now more than ever there are many models for young women to see how one can navigate life while still pursuing the work they love and want to do.

ABINGDON MULLIN

is a pilot and the founder of the Abingdon Foundation

When people ask me how I got into flying, I tell them it was free food.

In high school, at John Burroughs High School in Burbank, California, we had a career center that held monthly career lunches. They would have Subway or pizza or something delicious, and they'd bring in someone to talk about what they did for a living. I never really cared about the topics, but I always knew that I had to be at the career center the first Wednesday of every month because I got free lunch. One Wednesday I was both early and the only girl in the room when two pilots from a flight school at Burbank Airport walked in. They said two things that really struck me. One was: you don't have to join the military to learn how to fly. I was like, really? Because I had thought all pilots came from the military. They told us about going to universities and aeronautical colleges and flight schools like where they worked. You could join the military if you wanted to do that, but there were other paths. The second thing they said was that you don't have to join an airline after you learn to fly—there were other jobs out there. You could work on relief aid in underdeveloped countries. You could work on traffic watch in the mornings when news stations fly helicopters to report on traffic. You could fly banners over beaches and stadiums. You could even fly corporate executives and celebrities, who I was told tip well. There were so many types of flying that I really had no idea existed. You would get paid to travel? At fourteen, I was sold. That night I went home and said, "Hey, Mom, I want to be a pilot." She said, "That's nice, pass the peas," and I just held on to that dream for a long time.

My first demo flight was through the same flight school that came to talk to us. I was driving down Hollywood Boulevard, and there was a sandwich board outside of Burbank Airport that said $15 INTRO RIDES. I didn't even have $15 with me. I had to call my mom and ask her to come meet me with the cash. She did, and that was my very first flight. I absolutely loved it.

But my parents insisted that I go to university. They didn't really understand vocational schools. I was their oldest child, and they were adamant that I go to college. I went to the University of California San Diego for four years, got a degree in psychology and film, and started my flight training after college. I worked over the summers to save up money to pay for flight school. That's what led me to the American Flyers Flight School at the Santa Monica Airport. But before that, I actually walked into five different flight schools in Santa Monica and asked them all the same three questions. I really, firmly believe that you have to be smart enough to be dumb enough to ask. This means asking all the questions, even if you don't always get the answer you want. The three questions were: One, can you teach me how to fly really, really fast? (I needed to start getting paid to work.) Two, do you have any jobs available? (I had just graduated.) Three, will you pay for my flight training? Some people might find it odd that I asked a flight school to pay for my training (a question that might not lead to an answer you want). But there was one flight school, American Flyer, that said yes to all three. It had, and still has, an internship program where you work as an intern in exchange for flight training.

I started the next day. I got my private rating

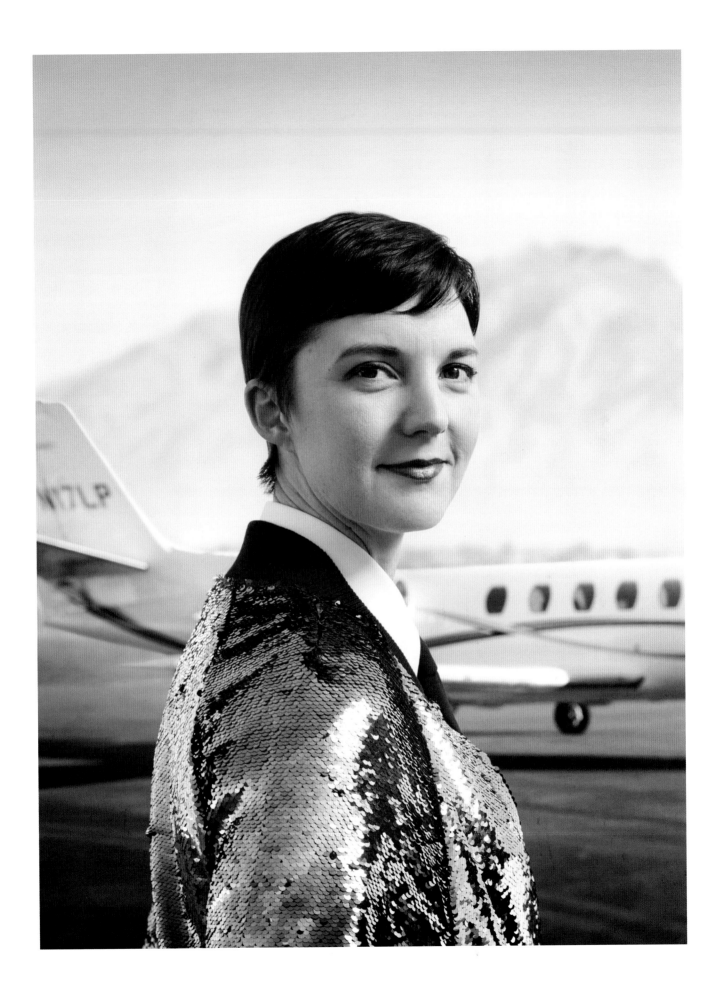

(essentially my certification) in thirty-four days, and then I began working on all of the other ratings I needed to get a job, which I did over the next year while staying on as a paid intern. It was absolutely perfect. I haven't left the airport since.

Though I could have skipped the whole four-year college part of my journey, I do see value in a college degree. Had I not gone to college, I wouldn't have found the southwestern door-to-door sales job I worked over the summers, where I made great money. Because of that, as a college student, I was able to save up quickly and was prepared to pay for all of my flight schooling, which can cost up to $60,000.

Having that cash on hand in order to start the flight training and get through it as quickly as possible without incurring more student loans was key. The internship helped with this, and having a college degree was a hiring prerequisite. It also led me down the path toward my first official job, combining flight and sales. Basically, I was hired on November 3, the day I graduated from my commercial training, and was given the keys to a brand-new Cirrus and a credit card to use for gas. The company said, help us sell airplanes, so that is what I did. But that same day I also launched the Abingdon Company, a watch company that I had been working on after getting my private rating. I really wanted a pilot's watch, but they didn't make any for women. So I took my spare time, outside of my studies and my internship, established the watch company, and launched it on November 3.

Which brings us to the subject of women in the field. It totally bothers me that there aren't a lot of women working as pilots. There's definitely something missing by not having women in the industry. There's something missing by not having minorities in the industry. When you look at aviation, it's an old-boys' club.

It's all old white men, and I don't say that as someone who doesn't appreciate the variety of backgrounds that the old white men can have. Think

of it like a boardroom. So if everybody is coming to the boardroom and they're all discussing how to improve the industry or what we can do or inventing products, well, if everyone around the table is the same, then we're only ever going to get one perspective. So when you start diversifying that table with minorities, women, youth, elders, then you're going to get different perspectives. You're going to make that industry much stronger. So I really do feel that women only making up 6 percent—or less—of the aviation world is detrimental to the industry. The industry is going to die if it just ends up being the same group of people.

It's easier said than done, of course. I have been called every name in the book. I have been accused of sleeping my way to the top. I have been accused of not being as qualified as my male counterparts. It happens regularly.

But my motto is: Water off a duck's back. I couldn't care less. Most women, at some point in their career—it doesn't matter what field—grow thick skin. One might even be in a female-dominated field and still suffer. Every industry has women who have been slighted at some point. It hardens you, it callouses you, and it makes you stronger. And I don't mind it. Besides, an airplane doesn't know if its pilot is a man or a woman.

I am always available for women in this industry. I didn't have all the answers. I didn't come from an aviation family. I really didn't know where to start, so I just kind of found out things as I went and it took me a long time. But that's one of the reasons why I created Abingdon Foundation, which is for helping women find their starts in the industry. We provide resources, training tools, organizations to join, community outreach, like coming to schools and speaking, sharing knowledge, and helping people find their starts.

Many years ago a young woman said to me, "You know, I don't know if I want to design and build airplanes as an aeronautical engineer or if I want to be an actual pilot and fly them." I said, "Okay, well, you and I need to go to the Women in Aviation Conference. I'm going to introduce you to some aeronautical engineers, I'm going to introduce you to companies that need pilots and need engineers, and I'm going to introduce you to some professional pilots that fly corporate, that fly for airlines, and that fly private." By the end of the weekend, she knew exactly what she wanted to do.

That is the whole reason why I started the Abingdon Foundation: to help women figure out where they want to go. Sometimes that doesn't even lead to recruiting more women into aviation. Sometimes they want to be scuba divers or explore maintenance or become a mechanic. All we're trying to do is be a nucleus of information and provide resources to get started in any of our tangential industries.

And we're growing, steadily. We'd love to reach nationwide as quickly as possible, within the next two years. Speaking at every school, having presentations lined up by different women all dressed in their uniforms. Because it's just as important to see a woman in a firefighter uniform as it is to hear her. And it's not only important for the young girls in the classrooms; it's also important for the young boys.

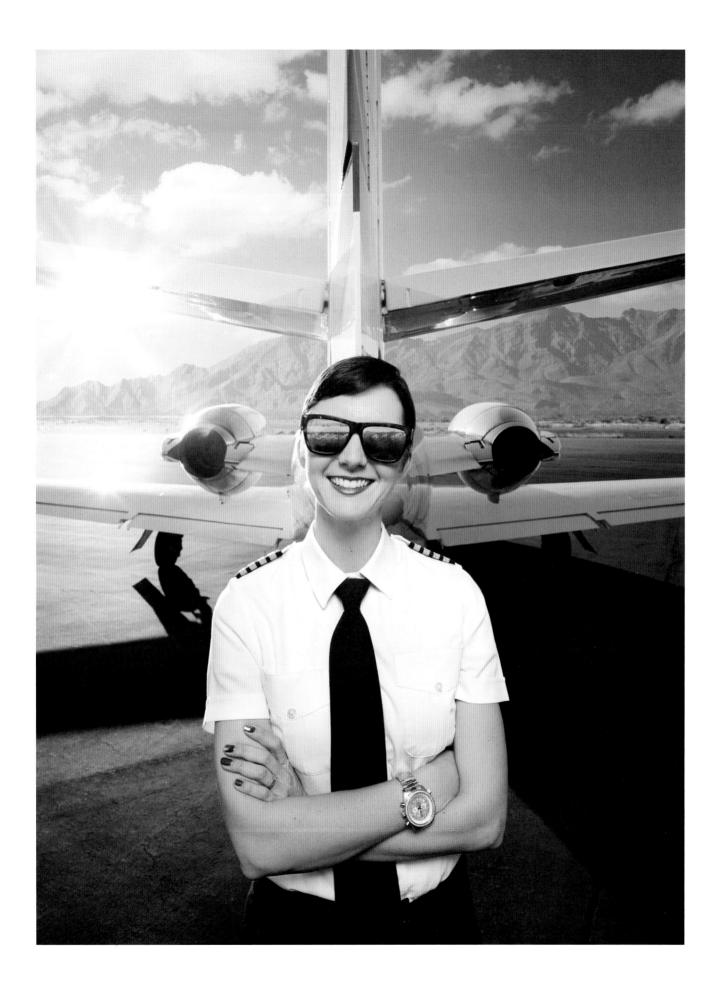

DIANE CRUMP

was the first woman jockey to compete in a sanctioned pari-mutuel horse race in the United States

I was the first female jockey to ride in a sanctioned pari-mutuel race (meaning a race you bet on) in America. My experience being the first woman to ride was kind of crazy. The tension that day was high. Everyone—whether jockeys, trainers, or fans—was so against a woman riding. I didn't exactly understand it. I guess it's like any other tradition. It can be so hard to break from the norm! For some people it just took seeing it happen for them to know it was all fine. They moved on.

But the day itself was wild. I had to be kept somewhere else—they wouldn't let me into the jocks' room. They had to figure out how to weigh me. The crowd around the saddling area was so large—like five thousand people—that they had an armed guard lead me from my little makeshift jocks' room—a repurposed racing official's office—to the paddock. Here's the thing: I don't care about stuff like that. I'm not the nervous type. The thing that excited me was finally getting to do what I loved. I wanted to be a jockey; I wanted to ride races. It was so important to me to get to ride. It was my life—I loved it. I loved racehorses, I loved riding them, I loved working with them. I just loved the sport. I was oblivious to all the anxiety and the crowd and the hoopla.

For me, there were no other female jockeys; I had no influences. My family didn't know anything about horses. So the biggest influence, for me, was the horse itself. And the passion I had for them. It motivated me to keep going. Since my first race, there have been more women riders. There are plenty of very good ones out there. I certainly would like to see more. The only thing I am grateful for is that now, if a young woman has the same desire and passion I did, there's nothing blocking her path. The opportunity is available to them. So someday, I'm sure, there will be more professional competitors. But until then, at least there are women out there riding. Some of them are doing just fine.

These days, I still work with the horses almost every day I can, whether it's out showing horses or selling them. My business is like a real estate company for horses. Working with horses is a labor of love. You work hard doing what you love, and none of it is easy—it's a lot of physical labor. I love working with the riders because they're hard workers. They bust their butts and they struggle, and I enjoy it. If I can help them, I love it.

I try to just go with simplicity. I want to find the good things in life. I want to find what makes me happy. I want what brings me closer to God. For me, it's helping people, it's being out, it's loving animals, it's just being able to spend time out in nature. I feel closer to God when I'm there. Like everyone else, I still have to make a living. You bust your butt seven days a week, year in and year out. But if you love it, there are no regrets. I've learned so much about life. The ups and downs—you appreciate it more.

Since I love animals and helping people, for a few years now I've been doing some work with a therapy dog program at a hospital. I take my dogs there and work with people of all ages. Maybe it's the oncology center for a couple of hours, and then after that I'll go to the behavioral health. I've seen the dogs making a huge difference everywhere they go; if they didn't, I wouldn't do it. But I know the difference an animal can make. It's important. It's important to me.

Animals, whether horses or dogs, reflect how they're treated by how they behave around you, riding or otherwise. I've never had a dog that wasn't friendly; it's a reflection of how I treat them. I love the way my dogs are when they go to visit people. They're just so friendly. They wear a little vest with little pockets, and I put prayer cards and little crosses in there for the patients. So if anybody's feeling really bad or down or whatever, I just say, "Potter or Pippy, there's a little gift in there!" I just love it—nothing makes me feel better than being able to help somebody.

Once I got my little guys certified to come to the hospital with me and I saw how much people appreciated him, I knew I had found my niche.

To that end, my advice to young people is that whatever you love, whatever that is, whatever your dream is: you follow that. You don't let anyone dissuade you. You pursue whatever you love. You try to make a career or living out of it. If you follow what you love, I believe you're acting out God's will for your life. God put that dream in your heart for some reason. When you love something that much, if people tell you it's not good or no good for you or the wrong thing, you cannot listen to people who try to point you in another direction. What's in your heart is your direction. If you follow that, then you'll have happiness; you'll have peace. That's what I believe, anyway.

MARY LATA

is a fire ecologist with the US Forest Service

My only exposure to wildland fire before college was watching retardant being dropped from air tankers in Glacier National Park in 1967 and again in 1987 while working at a Girl Scout camp in central Idaho; there were a lot of fires in the area, and they took the counselors up in a plane to see them. A quick introduction to my work is that fire ecology is a special field; it straddles firefighting, research, and most other disciplines needed in land management (wildlife, range, recreation, silviculture, forestry, etc.).

I didn't get serious about college until I was in my early thirties, and I knew I wanted to find a way to make a living spending time outside. My undergraduate, and later graduate, adviser had been involved in some fire research in California, and I thought it was really interesting. He and I put together a special project for me that focused on geomorphology and fire. For three summers, while working on my bachelor's, I was awarded a scholarship internship with the Nature Conservancy, working in four states doing prairie restoration. It was hard physical work, but I really loved it and learned a lot about land management and ecology: fencing, invasive species, pesticide use, seed collection, and of course prescribed fire. I was intrigued. Wildland fire is critical in many ecosystems; I'd never had the opportunity to use it before, so this was a "new shiny thing" for me that became the rest of my life.

I worked my way through my master's program working two summers as an interpretive ranger in Badlands National Park; I managed to focus all my programs on fire, even my geology program. At Badlands, I discovered a position called a fire effects monitor. After speaking with some of them, I knew that

was what I wanted to do next. I wanted to work in fire, but at the ripe old age of thirty-nine (in 1999), I was already too old to be hired as a full-time firefighter. Fire ecology was a perfect fit. The following year, I got a seasonal job as a fire effects monitor at Bandelier National Monument in New Mexico and loved every minute of it. We spent almost every day out in the field in New Mexico and north Texas evaluating the effects of fire and working on prescribed fires. I went to Montana with the Bandelier Fire Use Module and was excited to work so closely with wildfire in a situation where we were using a wildfire to restore ecosystems instead of putting it out. It felt so very right!

In the late 1990s, I was wavering between looking for a permanent job and getting serious about a PhD. I admit that I was leaning toward the job, but I was offered, and accepted, a full-ride fellowship to get a PhD and to complete the research I'd begun as a master's student. In 2002, before I was done with my PhD, I accepted a permanent job with the US Forest Service working as a fire ecologist in the northern Great Plains. Eventually, I did finish a PhD in geoscience from the University of Iowa, focusing on the thermal dynamics of grass fires.

Despite all the formal schooling, I felt, in many ways, that my "real" work as a fire ecologist started when, as a land manager, I was in a position to apply what I'd studied and begin learning from my experiences. That has never stopped. My work in various positions and capacities over the years has helped me understand the responsibilities of fire management, as well as the impact of the choices we make as fire managers.

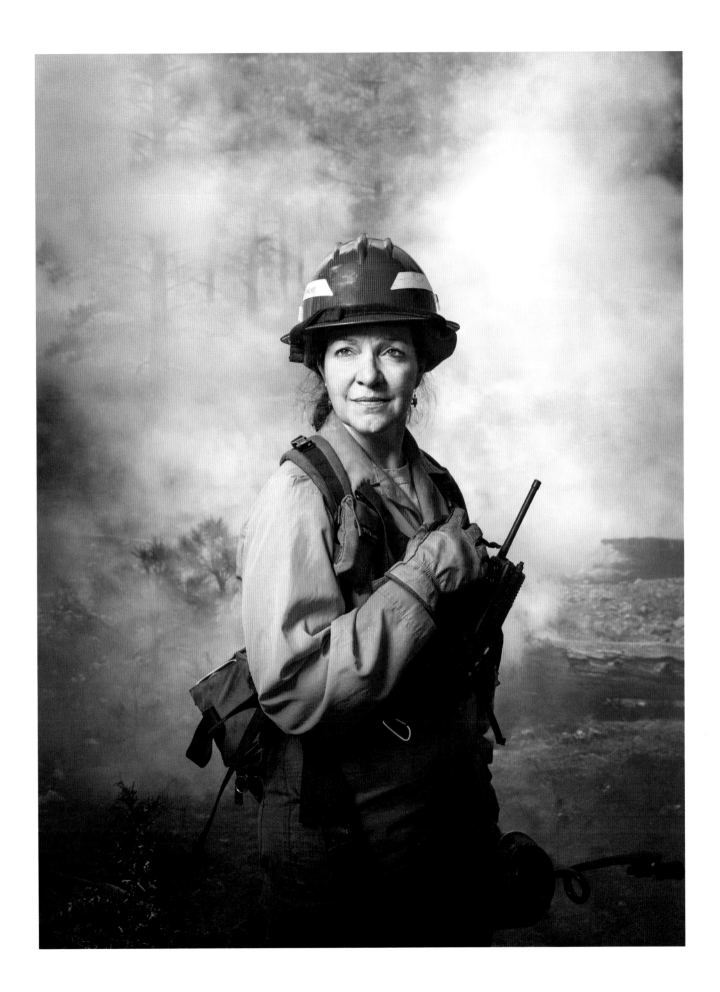

For example, a mentor of mine, Dr. Lon Drake from the University of Iowa, would take an entire class out to different field locations every weekend for an entire semester and always asked the same questions: What was here this morning, and how do you know? What was here yesterday, and how do you know? What was here last week, and how do you know? And so on up to fifty thousand years or even a million years, depending on the location. I still use that technique when I'm in a new area to help me figure out the local ecology, and I teach it to trainees and students who are learning how to interpret new ecosystems they find themselves in.

I'm unsure of the ratio of male versus female fire ecologists, but I don't think it's an overwhelming difference anymore, not as much as in the wildland firefighting world (though there is certainly an increasing overlap). Needless to say, there are a lot more men than women in fire management (fire management includes fire ecologists), but I think the ratio of men to women in fire ecology is probably a lot different than for the fire management community as a whole. Wildland fire has been a man's world for most of the time it's been an established profession, but it is slowly, and painfully, shifting. I don't so much receive negative comments about being a woman in my field as I do about the work itself. For example, when I am contacted by the public about the impacts of wildland fire emissions on air quality, my response depends on who I'm talking to, to some degree. Some folks just want to know that we do understand the impacts of smoke, some people actually do yell at me and blame me for the smoke. Many people simply don't understand the role of fire on landscapes and are often intrigued.

As an older woman in wildland fire, when I go out on fire assignments, I notice that initially, I'm often given assignments that are physically easier than other firefighters who've been brought on for the same jobs. After a few days, that stops, but I feel like I often have to prove myself to people who don't know me. I don't know if it's age, gender, or both. But at this point, I have so many years invested in fire ecology—research, management, planning, wildfire/prescribed fire—it's hard to imagine a life that doesn't involve working outside with fire and natural landscapes. I think the concept of public land is and was genius—and it was pioneered by the United States. It's part of what makes us unique in the world.

I would say that one secret of life is to find a way to make a living doing something you love. Be creative about how to make that happen, and never give up or settle for less—don't get stuck in a daily grind doing something that doesn't let you thrive.

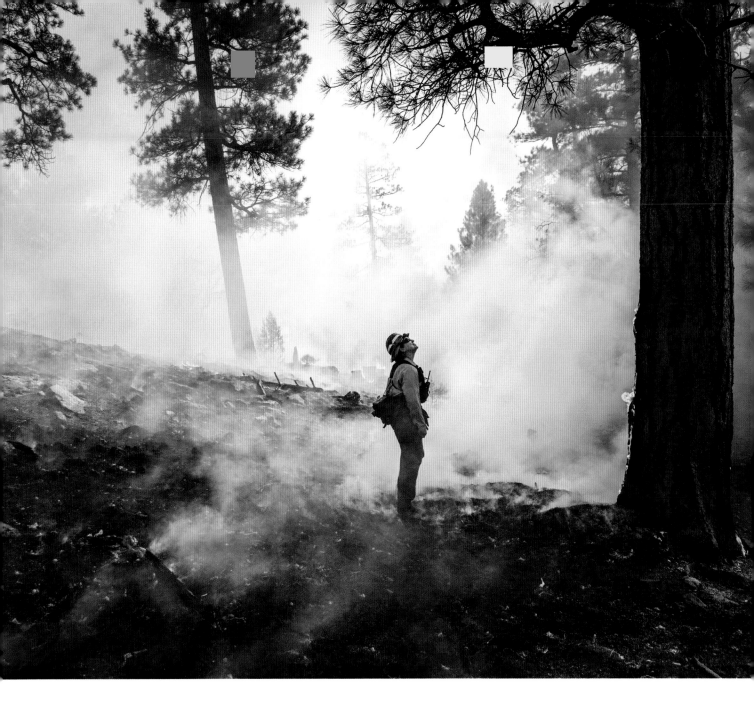

MIRA NAKASHIMA

is a woodworker

When I was growing up, women were not allowed to do woodworking and not many studied architecture either, but I studied architecture as an undergrad at Harvard and earned a master's at Waseda University in Tokyo nonetheless. I returned to work with my parents in 1970, helped my mother in the office, helped my father with design, and got to work in the shop when I was finished with my other work. I was always more of a designer than a woodworker and was my father's design assistant for twenty years before he died in 1990.

He was certainly my biggest influence. He convinced me to major in architectural sciences, introduced me to his friends in Japan who taught architecture, got me into school there, and then provided me a job at his shop when I finally returned home. Architecture was as extremely good training for me as it was with my father. Not only can you visualize shapes and volumes on paper, engineer the structure, visualize the piece in a given space, but training in Japan and with my father also sharpened my eye for proportion both visually and structurally.

After my father died, it was a struggle to convince the public that I was not just making reproductions of what my father had done—that I could actually design and make something different from him. It took several years of "flying solo" before people began to believe I could actually continue the work he had begun.

Surprisingly, I never received any negative criticism because I was a woman, even in Japan. There are now several women woodworkers making themselves known, finally being accepted into the largely male woodworking community.

A perfect workday for me begins with waking up refreshed, followed by exercises and meditation, and then having the time to accomplish all the tasks that need to be done. Before bed I'll play or listen to some music. Usually it takes me a week to get through my to-do list, due to constant interruptions, visitors, phone calls, and meetings. If I can sift through emails, oversee projects in the shop, find wood for projects, and do drawings for them all in one day, that would be perfect, but it hardly ever happens.

Without woodworking, I honestly do not know what I'd be doing. It's a bit late in my life to start thinking of another career, but my heart has always been in music. I suppose I should start thinking about retiring, but it's too much fun to stop now. I would like to develop a workable plan so that our work continues beyond my lifetime, but this has been my life for so long I am having a tough time letting it go and imagining what it would be like without me.

Sometimes doing what you think you want to do is not the best thing. One should respect the past and the wisdom of our elders and be good at improvising and making the best of what life throws in our paths.

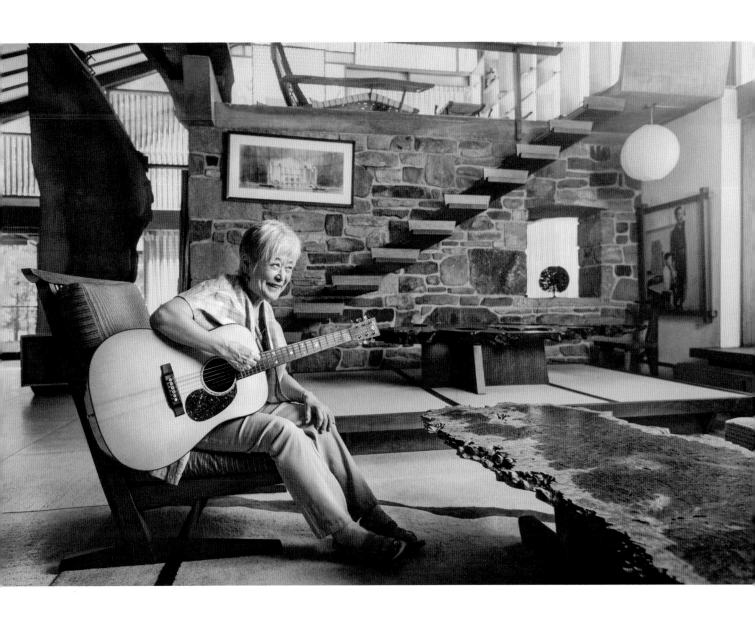

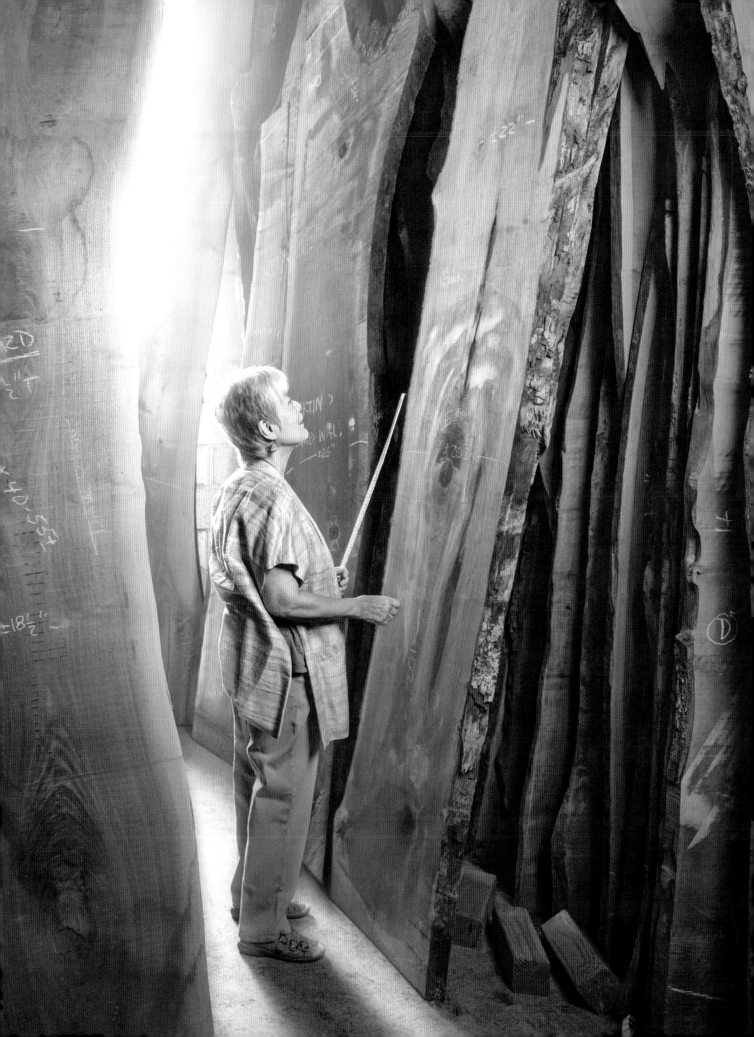

NERI OXMAN

is a material ecologist, as well as an architect, professor, and designer

Material ecology is a design philosophy and a technical framework that offers a set of principles and technologies enabling designers to create relationships between artificial structures and their environments at the resolution that matches and possibly outperforms nature. In simple words, it is the field of ecology (i.e., the branch of biology that deals with the relations between organisms and their physical surroundings) applied to all things artificial.

Mediated Matter is the name of my group. Material ecology is the name of the field/research area I pioneered. I coined the term in early 2005.

As an architect, I believe in the synergy between the buildings we design and the environments they form and inhabit; as a designer, I believe that the products we design are extensions of and for the human body; as a scholar of nature and a medical scholar,

I believe in the integration between buildings, products, and the environment. This holistic approach to design, which considers all environments—the built, the natural, and the biological—as one postulates that any designed physical construct is, by definition, an integral part of our ecology. A practicing material ecologist will therefore engage multiple disciplines—computational design, digital fabrication, synthetic biology—the environment, and the material itself as inseparable and harmonized dimensions of design.

In the biological world you find that structures are optimized for a multiplicity of simultaneous functions across scales: structural load, environmental pressures, spatial constraints, and so on (consider a living tree). But in the designed world, due to the limits of man-made materials and the technologies to create them, it is as yet impossible to match the resolution and sophistication of the natural world. Bricks are dumber than cells, and synthetic fibers have yet to fire electrical signals into the textiles they inhabit. Biology is still far more refined and sophisticated than material practices dealing in polymers, concrete, steel, and glass. But what if we can change that by creating new technologies that can vary the physical properties of matter at a resolution and sophistication that approach that of the natural world? If bricks were smart, buildings would likely weigh less, generate less carbon, and function more like a body than a building, accommodating multiple functions rather than one.

From a material ecology perspective, we are approaching a "material singularity," meaning a state in which there will be little to no distinction between "natural" and "artificial." Designed objects (and the technologies to create them) will exhibit functionality and behavior equivalent to, or indistinguishable from, naturally derived ones. Imagine an entirely artificial heart digitally printed and biologically augmented that perfectly matches its host and even outperforms it. In this respect I find the discourse involving bio-mimicry and sustainable design overrated and possibly boring. Why would we invest in sustaining things as they are?

Those whom I admire have always inspired me: [Pablo] Picasso, [Susan] Sontag, Beethoven, [Ingmar] Bergman, [Leonard] Bernstein, [Charlotte] Perriand, [Virginia] Woolf, [Ludwig] Mies [van der Rohe], [Maureen] Dowd, and [Maria] Popova, also a dear friend. Every member on my team. Gershon Dublon. My sister, my parents, my close friends, Edgar Allan Poe, Isaiah Berlin, Uber drivers who care about what they play.

On the topic of there being few women in the sciences: When I have little patience for reflection, I turn off that sense of awareness; I go about my day and my work, and when faced with gender-sensitive positions, I say to myself, "Just get on with it." But on good days, I tune in and I listen, inviting qualities about myself often associated with femininity, male or female, and how that enriches my group's work and our way of being. Most of the time, though, I find that acknowledging the gender divide gets in the way of letting it go. And letting it go is best served, for me, by carrying on meaningful work that celebrates positions binaries on a continuum. It is only through hard work, awareness, and humility that we can truly own our identity, not by shoving it under a round table of tailored suits.

Although I often find that the feminist rhetoric—not feminism—can come across as simple minded, self-regarding, nuance averse, and reductive—biology to physiology, history to psychology, procreation to genecology, and so on—I have come to realize that we should all be feminists. Gender is more of a continuum than we are willing to admit when we hit the restroom. We must pursue social equality, confound label-based gender norms, and embrace complexity.

I loathe categorization, I cherish my independence, and I treasure chivalry. I live just fine with ambiguity, and I welcome a good quarrel about all

things designed or grown—except for when men confuse "confident" with "poised" and "passionate" with "feisty." I work hard.

The Mediated Matter group is antidisciplinary by design: computational designer; computer scientist; systems biologists; microcinematographer; materials engineer; microenvironment engineer; synthetic biologist; biomedical engineer; computer scientist (artificial life); apiculturist; beekeeper; apiculture artist; textile designer; architect; industrial designer; graphic designer; interaction designer, product designer; designer; spatial designer; biological systems fabricator; computational designer; mechanical engineer; planner; executer; and enforcer. Our projects necessitate that we invent the technologies to create them. In that sense, the relationship between our design ambitions and the technologies that enable them is, well, "nonplatonic." There is a rather intimate transfer of content across product and process, artifact and technology, technique and expression.

A 3D printed-glass pavilion, for example, cannot be designed, nor can it be built, without a glass printer; our biomaterial structures could not have been designed or constructed without designing a robotic platform to design and build them; the Silk Pavilion would have not been constructed without a robotically woven scaffold on which to spin silk; the Wanderers would have not come to life without high-resolution material modeling of macrofluidic channels and the ability to print them. And so on.

I am excited about our transition to the architectural scale as much as I am provoked by the notion of revisiting altogether what it means to set up a different kind of architectural practice, one that considers the environment as its main client and the client as its enabler. This entails building a new kind of practice that is less concerned with objects and more with systems: technological, organizational, social.

The ability to digitally fabricate or construct at nature's scale (mechanics, optics, etc.) will enable archi-

tects to overcome the existing dimensional mismatch between physical matter (e.g., sheet glass, homogeneous concrete, single-property metals) and environmental forces (e.g., variable load, variable heat) by offering methods and technologies for digitally designing and fabricating variable-property structures (e.g., variable-optics glass, variable-density concrete, variable-strength metals).

In a system view there is little room for categorical delineation: achieving world peace, eliminating poverty, or curing cancer. Rather, the designer authors systems to address manifold issues, across scales and disciplines, from curing malaria to populating Mars. Now, that is real scale.

One of our more recent projects, Vespers, is a collection of masks exploring what it means to design with life. From the relic of Agamemnon's death mask to a contemporary living device, the collection embarks on a journey that begins with an ancient typology and culminates with a novel technology for the design and digital fabrication of adaptive and responsive interfaces. We begin with a conceptual piece and end with a tangible set of tools, techniques, and technologies combining programmable matter and programmable life.

The project points towards an imminent future where wearable interfaces and building skins are customized not only to fit a particular shape but also a specific material, chemical, and even genetic makeup, tailoring the wearable to both the body and the environment which it inhabits.

Imagine, for example, a wearable interface designed to guide ad hoc antibiotic formation customized to fit the genetic makeup of its user; or consider smart packaging or surface-coating devices that can detect contamination; finally, consider environmentally responsive architectural skins that can respond to and adapt—in real time—to environmental cues. Research at the core of this project offers a new design space for biological augmentation across a wide

breadth of application domains, leveraging resolution and scale.

The collection includes three series. The first series features the death mask as a cultural artifact. The final series features a living mask as an enabling technology. The second series mediates between the two, marking the process of metamorphosis between the ancient relic and its contemporaneous interpretation.

The living masks in the final series embody habitats that guide, inform, and "template" gene expression of living microorganisms. Such microorganisms have been synthetically engineered to produce pigments and/or otherwise useful chemical substances for human augmentation such as vitamins, antibodies, or antimicrobial drugs.

Combined, the three series of the Vespers collection represent the transition from death to life or from life to death, depending on one's reading of the collection.

We end with efforts to keep commerce at bay: Look, we haven't gone this far to sell printed-glass light fixtures on Amazon. We are here and remain committed because we are able to design an architectural "skin" as an optical lens, thereby opening up possibilities for harnessing solar energy on urban scales. These amongst other enabling technologies developed in my group should not be trivialized for entertainment purposes alone, though potentially profitable solutions such as a biodegradable San Pellegrino bottle may well help us cut down on plastic! One has to start somewhere without compromising soul.

LAUREN KESSLER

is a writer

Like all writers, I started first as a reader, a voracious reader, a little girl who lost herself in books. I did the high school things someone who imagined herself to someday be a writer did (yearbook editor, newspaper editor, bad poetry), went to journalism school, took a job as a newspaper reporter that I hated with a ferocity that surprised me, went to graduate school because I didn't know what else to do, earned another graduate degree because I fell in love with history, and I still didn't know what to do—and then started writing seriously.

I am the author of ten works of literary nonfiction, including immersion reportage, biography, narrative history, and essay. My focus these days is on immersion projects, combining in-the-trenches reporting with deep research to explore everything from the gritty world of a maximum-security prison to the gru-

eling world of professional ballet, from the hidden world of Alzheimer's sufferers to the stormy seas of the mother-daughter relationship.

My newest book is called *A Grip of Time* (prison slang for a very long stretch behind bars), about what it takes to reclaim and remake your life after decades in jail. It takes readers inside a world most know little about, a maximum-security prison, and inside the minds and hearts of men who live there. These men, serving out life sentences for aggravated murder, joined the fledgling lifers' writing group I started more than three years ago. Maybe they just needed to escape the brutal sameness of their lives. Maybe they had so much to say and no one who would listen. As the group has taken hold, meeting twice monthly, the men have revealed more and more about themselves, their pasts, and the alternating, crazy-making drama and tedium of their incarcerated lives. As they struggle with the weight of their guilt and wonder if they should hope for a future outside these walls, I struggle with the fiercely competing ideas of rehabilitation and punishment, forgiveness and blame that are at the heart of the American penal system.

I know the moment when I decided to become a writer. Exactly. I was nine years old, sitting under the crab apple tree on the front lawn of my parents' house, reading *My Friend Flicka*. This was a book written decades before I encountered it about a boy and his horse in Wyoming. There I was reading it, a girl with a cat living in a tract house in a Long Island suburb. But I forgot that. I forgot who I was, where I was. I was transported, suspended in time and place, part of a world not my own. I knew in that moment that this was what I wanted to do. I wanted to make others feel the way that writer made me feel. Later, as a teen, I dreamed of a glamorous life in journalism(!). I was then under the influence of a newspaper comic strip character, Brenda Starr, Reporter (flaming red hair, exotic boyfriend with patch over eye, intoxicating

international adventures), and the Susan Saint James character in the TV series *The Name of the Game* (perky, witty, winsome, works for handsome, powerful boss at great magazine). Journalism sounded great. I was then, and I am now, fascinated by true stories, by real people living their lives.

In another life, I might have been a private eye or maybe a medical examiner. That's right, the one who roots around in other people's insides. Searching for clues to how people live, what motivates them, what they do with their lives: this is the engine inside me, this is what powers both my mind and my heart. I love discovering, making sense of what doesn't immediately make sense, searching out and gathering details that can be woven into a story. I've never had a mentor, but at various points in my life, I've had people who believed in me, people who expressed in small—and unexpected—ways that they thought I was capable of great things.

Mr. Hawkey, ramrod straight, starched collar (equally starched personality), Mr. Discipline, Mr. Hard-ass—my eleventh-grade English teacher—said to me, as I exited his classroom on the last day, "Don't waste your talent." Wow. Mr. Hawkey thought I had talent.

Otis Pease, the best and most brilliant professor I've ever had or could hope to have, treated me with quiet respect. To be respected by a man like that was almost overwhelming. It made me want to be worthy. It inspired me.

I had a brief encounter with Robin Morgan, a pillar of the second-wave feminist movement, a cofounder of *Ms.*, an author, a poet, a national voice. A big deal. She was delivering a speech on a college campus, and I got to introduce her. The speech was amazing. She was amazing. I had never been that close to someone who burned so brightly, who radiated such energy, whose energy filled a space so completely. After the speech, when I ran over, beating the crowd, to grasp her hand, she looked at me, really looked at me, and

said, "Lauren, you're up next." The power of that ignited me.

I've been inspired by a handful of smart, thoughtful, clear-eyed, compassionate editors whom I've had the pleasure to work with on various book projects. These are people who challenged me to do my best, who expected me to do better than my best.

As a writer who learns from reading, my debts are many, but these stand out: Reading (and rereading and rerereading) Norman Maclean's *A River Runs Through It* has taught me more about storytelling, more about empathy and understatement than any class, any seminar, any teacher. Reading Joan Didion has taught me about the beauty of prose and the power of a single sentence—and that if you aren't as smart as your material, you aren't ready to start writing. Reading John McPhee has taught me that through the power of character and detail, a writer can make a reader fascinated by just about anything. Reading May Sarton has taught me that life is long, very long, and that I ought to use every moment of it.

And finally, a single poem by Marge Piercy has provided me with what I guess is the "anthem" of my professional life: "The real writer is one who really writes."

I do have advice for young women who would like to become writers. And it comes from years of butting heads, from spending too much time around naysayers, around people who tell you all the reasons why something can't be done.

Here it is: Lean into the yes the way a plant leans into sunlight. Seek out and surround yourself with people who see your potential, people who believe in you. People who say yes. It makes all the difference in the world.

Finding work you love, work that challenges you, work that contributes: that's it.

NANCY POLI

is a pig farmer

We began raising pigs about ten years ago. My son had recently left college and was looking for a career. Being a young man with much ambition and limited resources, utilizing the family land seemed beneficial. Farming appealed to him as a way of getting back to basics as well as offering a unique lifestyle. I was not enthusiastic about this idea at first, as we had no farming experience, but my son's vision was contagious and we dove into the endeavor wholeheartedly.

No one has ever personally spoken to me negatively about my living on a pig farm, but I must admit that at first I didn't like the sound of it, but then I asked myself if I cared what people thought more than I loved and wanted to support my son; there was only one answer and it certainly wasn't to live my life in order to please or gain approval of people uninvolved in our lives. If I am a likable, worthy person, it is so with or without my farm. I have suffered no ill effects from the people I know.

My son is involved in this business full-time. I have another, unrelated business that I have operated for many years and in which my daughter works as well. Seeing and working with both of my children every day is a mother's dream. I foresee working in both businesses as long as I am physically able.

The greatest influence on my path to farming has been supporting my son's vision. I have learned much since this venture began about farming, running a successful livestock business, and personal capabilities. Most importantly, I have relearned not to be afraid of the unknown; as a young woman, there was little that I found daunting. At this point in my life I wondered if my son and I were up to the challenge and I feared failure. Following my son's lead in transforming our property into a working farm has been one of the most rewarding experiences of my life.

Although we are a meat farm, I have a great appreciation for the animals we raise. I am involved with them every day and I am able to witness firsthand their lives and what motivates them. They share many human traits, but with animals you experience life at its most basic. There is an intrinsic simplicity being among animals and, much of the time, peace that is missing in today's fast-paced world.

The best advice that I might offer to young people who are looking to the future with their own dreams: Don't let fear of failure deter you from what you must always believe in—yourself. Positive results may be slow, but never stop thinking positively. Early missteps and shortfalls can't be seen as failures but as opportunities for future achievement. Listen to others and ask many questions, but in the end go with your instincts. You will experience both successes and non-successes, and they are yours; own them and you will be empowered because you accepted responsibility. By demonstrating perseverance and fortitude, by choosing challenge over comfort, by setting higher goals than those you just achieved, you will experience true success.

As I mentioned earlier, my drive in this venture did not originate and is still not a personal endeavor; it was and always will be about my family. Every day feels like a perfect day since I have the luxury of reflecting on my many years and experiences. To be vigorously engaged, to be active and healthy, and to be able to work is a blessing. Working with those I love and witnessing their well-being and happiness is truly a blessing. Everything else is secondary.

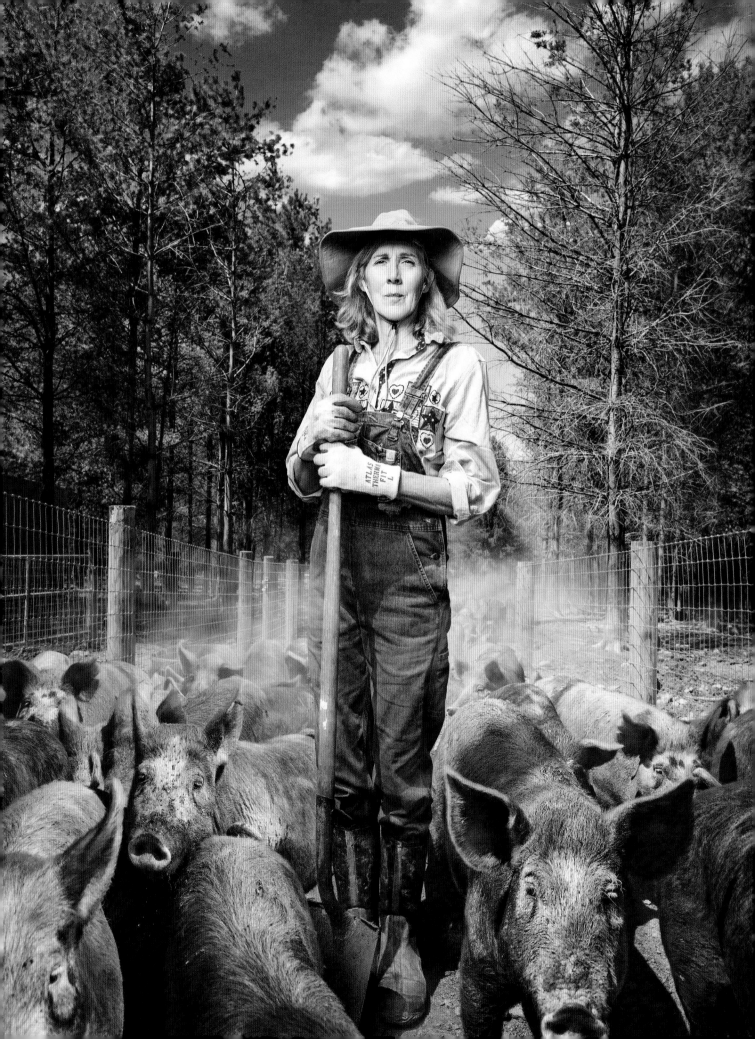

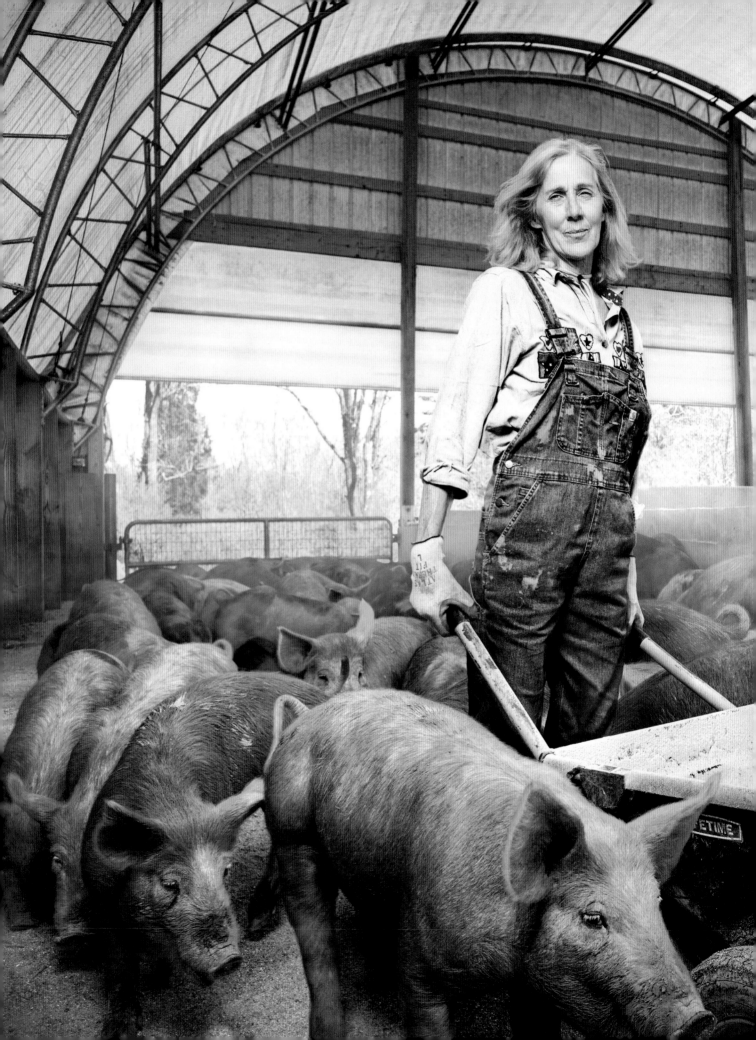

DAVINA SOONDRUM

is a pastry chef and the owner of Hey, Sugar

My mother is the second youngest of ten siblings, born and raised in Jamaica. My father was the eldest of two. He was born in Mauritius, studied mostly in England, and was an amazing engineer and cartographer who traveled through the Caribbean and Central and South America under government contracts making maps. This is the patchwork explanation of how my parents met, my older sister, Vanessa, was born in Suriname, and how I ended up being born in Trinidad. We moved to the United States shortly after my first birthday and settled more permanent roots in Philadelphia. I grew up in northeast Philadelphia, even though most people chide me for not having the accent. Though my father passed away when I was ten, we still stayed here. My mother and sister single-handedly raised me and have been my biggest support and source of encouragement in all

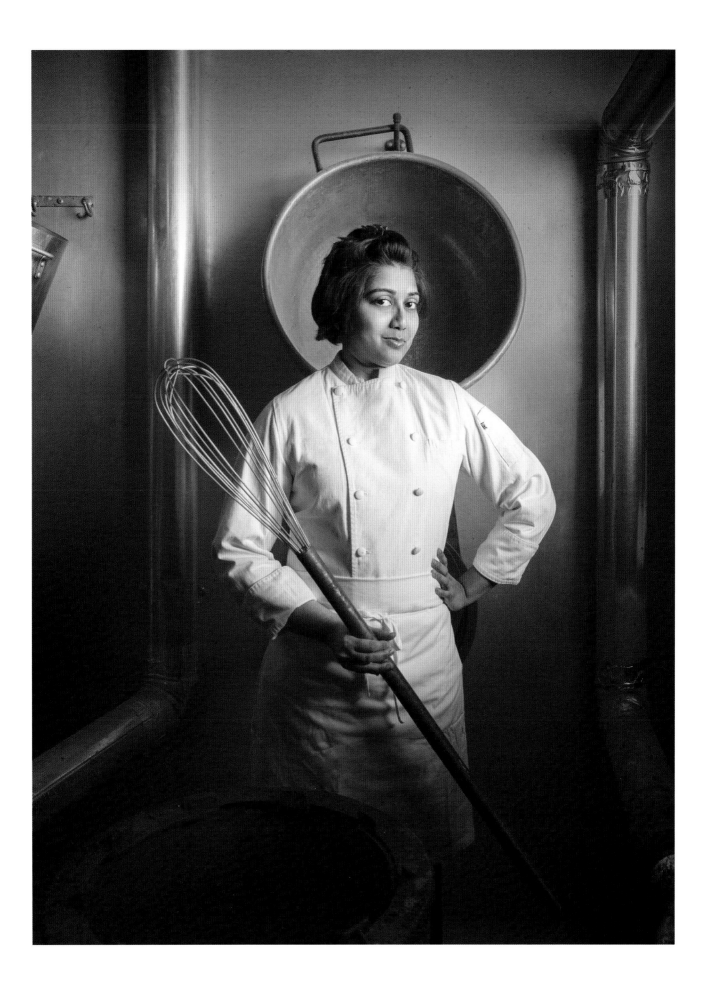

my endeavors. Philadelphia is home. It is where I met some of the best friends I have had the pleasure to know, learned how to cook, had my heart broken, and had some of my best and worst moments.

Cooking was a major part of growing up. My mother is hands down the best Caribbean chef you will ever meet, and anyone who says otherwise will have me to contend with [laughs]. She also was an insane baker and cake decorator. I used to play with her entire Wilton cake-decorating kit under our kitchen table! My dad had the more adventurous palate in our family, and we watched every single PBS cooking show on Sundays (his favorite was Graham Kerr). Usually he would end up cooking one of the featured recipes for our dinner that night. I had a voracious sweet tooth growing up, and pastry/confectionery was the coolest thing I ever encountered. It just made me happy. Incidentally, I told my parents from the age of five that I was going to grow up to be a nurse, tennis player, pastry chef, and model. Well, one dream came true. I'm funny looking and still working on my backhand.

My biggest influence in becoming a pastry chef, first and foremost, Roald Dahl and the movie adaptation of *Willy Wonka and the Chocolate Factory* will forever be the catalyst of my career path. I loved that book, and Gene Wilder was the most captivating embodiment of my childhood (and if we're really real about it—my adulthood) hero. In the real world, I was fascinated by Sylvia Weinstock—her wedding cakes were genuine works of art—and Jacques Torres and his PBS show *Dessert Circus* and Marcel Desaulniers's *Death by Chocolate*. There was a sense of magic surrounding the awe-inspiring confections and a warmth radiating from the creators themselves. I could not think of anything more addictive than making others happy by something I created, and I wanted nothing more than to be like my heroes.

My biggest inspiration outside of the food world is Jim Henson. His vision and creations shaped my childhood and sustain my adulthood. There are still wonder, dreaming, and magic in an often cruel world because of people like him. I firmly believe that these are qualities that we should nurture in children. So if I were to go back and do it all over again, I'd most likely be working with the Jim Henson workshop, either writing or puppeteering.

But I will always be a sugar pusher at heart. My pet project for the past four years has been researching and developing chocolate bars, infused cotton candy sugar, and hand-pulled sugar confections and gummies for my own business. It is the dream of everything I love and everything that I feel keeps me kind and absurd: my own personal confectionery circus, where I am the ringmaster. Stay tuned.

The restaurant industry is akin to a weird reality show where you constantly ask yourself "Is the world against me, or do I just need some sleep and some vitamins?" You spend long hours on your feet, you forget to eat even though you are cooking for others, and sometimes you don't have the luxury of seeing the sun. The espresso machine suddenly becomes your best friend and closest confidant. You love the holidays? Unfortunately you may have to tell your family to save you a plate because you are most likely making somebody else's. You work in close confines with people you may never have thought twice about if you passed them on the street. That's the interesting part; that motley crew of dysfunction you strive to find some semblance of work balance with. Gossip happens, tempers flare (oh the screaming matches I could tell you about), credit for your work may be given to others (super frustrating, let me tell ya), and yeah, it is not easy dismantling the boys-only club. As a woman in the kitchen (sometimes the only woman) it seems you constantly push yourself even further than you may be physically or mentally capable of, and support may seem few and far between. The insane part is we still are in the midst of the #timesup and #metoo movements—a concept that so many women in the industry have

had to deal with for years. A chef once told me "You can either tough it out, or leave." Freddie Mercury preserve me, I am still perplexed by the levels of ignorance and submissiveness many have (and may still be) subjected to. Yet here we are breaking down those barriers and becoming more of a force to be reckoned with. Sometimes it seems progress is too few and far between, but trust me, it is happening and I am here for it—big foam hand and all. We are still fighting and proving time and again that we belong and rightfully deserve our place at the table, gender be damned. We can be recognized as being a boss without the connotation of being bossy or a bitch. We can be kind without being deemed weak and a pushover. A woman who gets the props she deserves should be able to read that she is a powerhouse because she is a great chef, not a great female chef. I mean, spoiler alert, she and the rest of the world already know she is a woman. Being a female and a chef is not mutually exclusive. Keep yelling that point for the folks in the back! You may be asking yourself at this point "Why the hell would you put yourself through this?" The truth? We can call ourselves artists and craftspeople, but really there is a touch of crazy in all of us restaurant folk. It is this weird little demon that constantly prods us along. Throw in a masochistic streak. We go to battle every service with the hidden wisdom that at the end of the day the last plate has to go out and we may leave exhausted, but relatively unscathed until it is time to do it all over again. We get this rush knowing our customers are happy and this addiction makes us giddy for that next fix. I have had the honor of working with some amazing people I now proudly call friends, and the displeasure of working with some who are in dire need of a well-deserved kick and maybe some Ex-Lax brownies. Okay, before you clutch your pearls, I promise I have not done either.

It is easy to forget in any industry that being kind to yourself or kind to others is important. It seems such a simple concept, but it is one that we neglect more often than we realize. Taking time for your health (both physically and mentally), for your family and friends, and for helping others in need is essential to us as human beings. Be kind always.

To all the women who are reading these ramblings of a sugared-up Muppet, I truly am sorry, ha-ha. It feels as though I have a love-hate relationship with this career now spanning thirteen years, but I am here to stay for a while longer. I think if I could go back and talk to my younger self I would have to hit home the need to recognize self-care. You are human, like it or not. You are no good to others if your body and mind are screaming for help. It is okay to say no. See that doctor (and do what they tell you to do!), take that day off, drink that glass of wine, go see that concert, keep your friends and family close. Do what you love and own it— your career should not own you. That honestly is the fastest track to burn-out. Finding balance is so hard, but a million times more rewarding when you achieve it. If you do not love what you are doing, it is okay to change course and find what will drive you to be happy and be better. It took me years to realize I could do what I love and make others happy. It will never be easy, and can feel soul-crushingly daunting at times. You hear a thousand people say that no, you cannot do that. Well, honey, I'm more than certain some of the greatest innovations were shot down by a lot of naysayers. Keep your head up and your voice loud—you never know who is listening. Those that say yes you can are going to be such an empowering force. Hold your ground on what you believe. Be kind to others; it is an asset, not a weakness. You have a place in this world. You matter. You deserve that happiness. The world needs your talents. If you don't believe it, know that I am rooting for you. Shine bright, always.

AYAH BDEIR

is the founder and CEO of littleBits

I grew up in a loving home in Lebanon with three sisters; my parents were incredibly invested in developing our curiosity. When we were young, we were exposed to other languages and countries. We traveled extensively and learned often about the world around us. Lebanon doesn't have any natural resources, like oil, so its people are very entrepreneurial. They come from generations of traders; often they are comfortable speaking multiple languages, traveling, making connections with other people, etc.

I think that it's in the Lebanese nature to be inventors and entrepreneurs. We are resilient. We love life. Despite experiencing a lot of hardships and strife, we rise up and find joy in even the most difficult of circumstances. To that end, I've always had an inventive spirit. In fact, I would say that I've been creating my whole life. I used to break open VCR players to see how they worked, and I gravitate towards all things "construction."

Engineering is not traditionally thought of as creative, playful, or inclusive to anyone who hasn't studied it formally. People in the field can be condescending, exclusionary, and functional. I became very interested in finding ways to change that: to make engineering fun, playful, accessible, and creative.

After graduate school, I landed a job as a financial software consultant for a technology company. The work was unfulfilling and intangible, so I immediately began looking for other ways I could pursue my interests. I wanted to be creative, to make things!

I secured a fellowship from Eyebeam, one of the pioneering labs of art and technology in New York City's Chelsea neighborhood, with the goal of getting back into making. It occurred to me that there were probably a lot of people in my position, stuck in roles that didn't allow them to harness their creativity. While I had the technical background to push past that, many others did not. That's when I got the idea to make electronic components that could be used by anybody—regardless of age, gender, or technological background. Not only would I be able to invent things again, but I would be helping others to invent things, as well. This is how my company littleBits was born.

Aside from my innate curiosity, I must also credit others who have influenced my journey. I initially learned about the Maker movement in the first class I took at MIT's Media Lab in 2004. It was called "How to Make Almost Anything," and it was one of

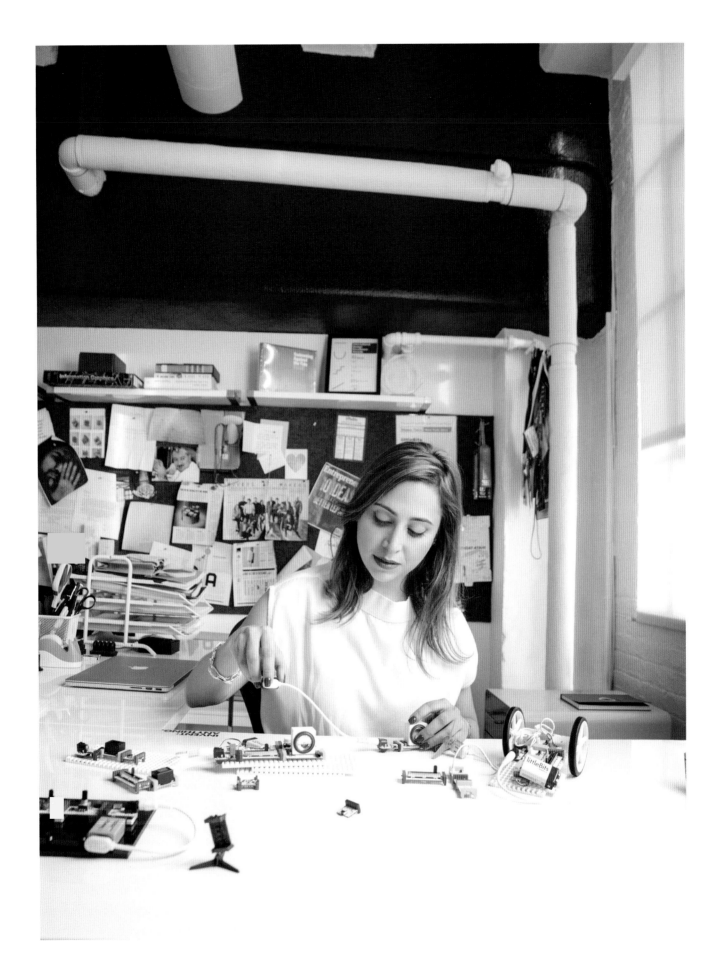

the most competitive classes to get into at the Media Lab. Taught by Neil Gershenfeld, the current director of the Center for Bits and Atoms at MIT and the father of the Fab Lab movement, the class gave me insight into a movement that would change my life.

I've since learned that making and inventing are meditative. When you have to create something, you must be fully present. Inventing instills a pride in creation. Feeling pride in what you've created becomes infectious and addictive; once they've started, inventors typically want to keep making. Makers are really open minded. They are always learning new things from other people. I think the qualities that make amazing makers are the qualities that lead to amazing entrepreneurs.

But there are few female inventors. This bothers me! The National Science Foundation has reported that 84 percent of professionals working in US science and engineering jobs are white or Asian males. We have to change that! If we really focus on this as a society, it shouldn't take more than a decade to really level the playing field.

We need to start with young girls. By the time they are in the fourth grade, there exists already a gap between boys' interest in STEM [science, technology, engineering, and mathematics] and girls' interest in STEM. By making sure we're keeping girls in the equation, we're ensuring that women will be part of the equation later in life.

The truth is that STEM doesn't have to be a profession. It can exist anywhere, whether robotics or arts and crafts or fashion or social activities. At littleBits, we try to reinforce this message every day.

We try to instill a love of STEM through the cycle of inventing. We get girls to fall in love with STEM by showing them how it fits in with the hobbies they already love. We try to show inventions and lessons in all sorts of contexts so that we can meet them where they are. And we introduce new concepts via hands-on, project-based challenges. As a result we see girls learning to code by inventing adaptive keyboards or designing interactive games—thinking about the applications of STEM by solving real-world problems with our littleBits technology.

As a result, our community is made up of 40 percent girls. That is unheard of in electronics. We work very hard at this number and track it to make sure we are staying true to our gender neutrality.

But creating a product that kids can use to learn modern skills they will need in the future is just the beginning. My ultimate goal is to give kids enough insight into the possibilities of STEM that they become inspired to practice invention every day—to come up with new ideas, to make them a reality. I wouldn't call a kid tech savvy for knowing how to use an iPad or play a certain video game; kids are tech savvy when they start to understand the inner workings of technology.

But I do have advice for those who are interested in my business rather than STEM itself. I think every entrepreneur feels "impostor syndrome" multiple times in their entrepreneurial journey. You are learning so many things for the first time: how to make a product, how to scale, how to hire, who to hire, how to sell to investors, how to sell to individuals. And you are constantly thinking: Everyone has all their stuff together except for me. Why is this so hard?

And the truth is, it just is. It's hard for everybody. Some people are just better at faking it than others. You must get your validation wherever you can. One of the biggest sources of validation for me has been our community. A few months after littleBits launched, I got a Google alert for a YouTube video showcasing a project a boy invented with his dad. I watched it, then decided to search YouTube for the word "littleBits." Suddenly I found all sorts of projects that people had made—from South Africa to Singapore, Mexico to Canada! It was such an exciting moment for me to

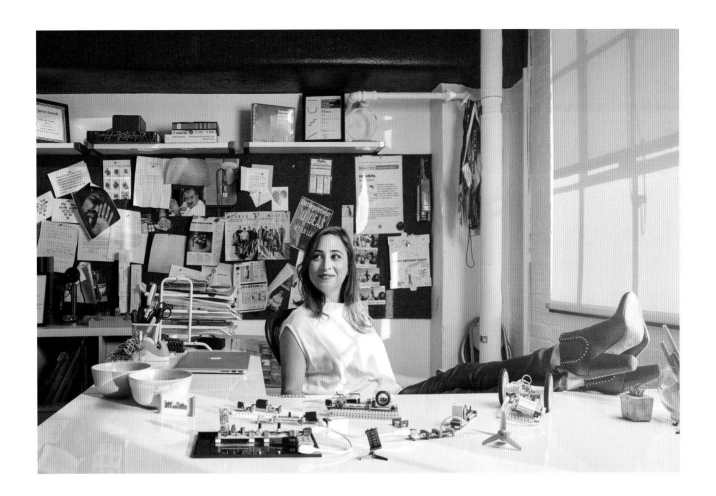

realize that littleBits had become a universal product making a global impact.

Even today, we still get a lot of fan letters from all over the world—from parents who have seen their kids suddenly take an interest in STEAM [STEM plus the arts] to kids who have discovered that they are more creative than they think to people who finally feel like technology is accessible to them. We also hear from teachers who report that kids who are struggling in class are often the ones who become the most engaged with littleBits.

It's this encouragement that makes me say I can't imagine doing anything else. I know I'll always be a maker at heart. I love what I do. I love what littleBits

has been able to make happen in the world. Any day that I get to see our mission in action—to see the spark in kids' eyes as they invent something new—is a good day.

The world is changing fast. The way that we work is changing—the way that we consume information, even the way that kids learn. At littleBits, we're strong believers that kids must learn to be flexible, creative problem solvers. Our goal is to empower kids everywhere, regardless of gender, race, nationality, and ability, to solve the epic challenges ahead.

I'm very, very lucky to be doing what I'm doing; I don't take it lightly. But I know there's a lot more to accomplish!

ALICE GRAHAM

is the executive director of the Back Bay Mission

I grew up in Chicago, Illinois, with two brothers and a single mother. I grew up in the Catholic Church, and when I was young, I thought I was going to become a contemplative nun. According to my understanding at nine, a contemplative nun spent her time praying for the needy of the world. Then I got to be about eleven or twelve years old, and I realized that if I became a nun I couldn't date boys. So I decided I couldn't become a nun. I spent my first twelve years of school attending Catholic schools. I graduated from Spelman College, an all-women college in Atlanta, Georgia. Spelman was a critical developmental experience in the sense that it was my first time in an all–African American environment. As a woman, being in a female-driven academic setting nurtured my sense of self, value, and purpose in the world. Up to that point I had been told that I was underperforming as

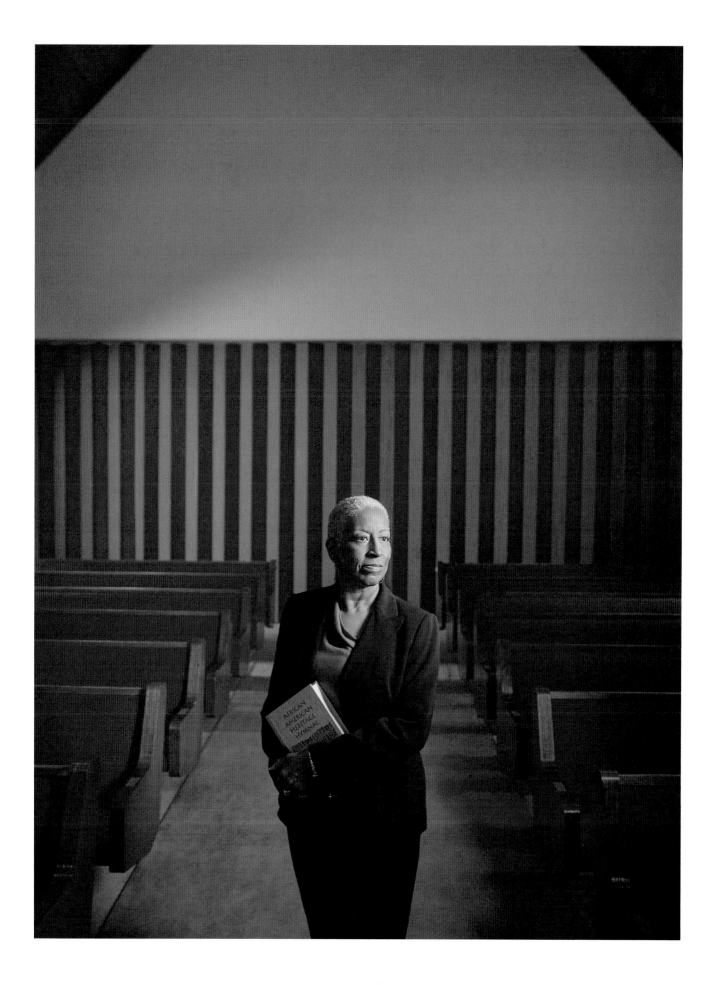

a student; nobody could understand why, because according to my test scores I should have been doing better than being a C student. At Spelman I had my first experience of doing well academically. For the first time I had the attention of teachers who saw me as someone who could achieve at a higher academic level. I was also exposed to a large number of brilliant African American women. I strove to keep up.

Once I graduated from Spelman, I spent a few years teaching at a Catholic grammar school and then became dean of students at a Catholic high school for two years. At this point, I was active in an African Methodist Episcopal church. I began to get a sense of being called into the ministry, which made no sense to me because I was very shy. I did not like speaking in public. I loved working in the classroom with students, but beyond that you couldn't get me to speak in front of anyone. Yet I felt a really strong calling. I decided I would go to Garrett-Evangelical Theological Seminary for my master of divinity. I took courses in pastoral psychology in order to really understand how to help folks struggling with the impact of poverty. And I really wanted to make a difference as a minister through counseling. So to continue my educational preparation, I applied for and was accepted into the joint PhD program between Northwestern University and Garrett-Evangelical Theological Seminary. I saw the program as a path toward making a difference in people's lives. I was particularly interested in focusing on African American communities because I saw so much poverty and the lack of hope that plagued communities of color. I was looking to be involved in communities in ways that could change the trajectory of people's lives.

I think the greatest influence over my need to give back is my mother. One summer, when I was thirteen or fourteen, I was lamenting about not having anything to do. She said, "Oh, you have something to do," and she made arrangements for me to become a candy striper in a small hospital. My mother was an active volunteer in our community. She always said, "You are not here just for yourself. You are here to be of service of other people." And she meant it. That was how I began to learn about the needs of a larger community.

Gwendolyn House and Roberta Harris were also influential in my career path. They were social workers, and I greatly admired them as I was growing up. Their willingness to coach me, and my mother really encouraged me to spend time and listen to them. My mother wanted me to see that there was more to life than crushing poverty. There were more possibilities for me beyond poverty. Those two women really inspired me to look at social work as a vehicle for improving the quality of my own life and a way to be of service. They gave me confidence that I could be a social worker and that I had the potential to be of service.

I did not realize when I initially went into the ministry—and this was my own naiveté—that it wasn't traditionally a place for women. I had grown up with nuns, so

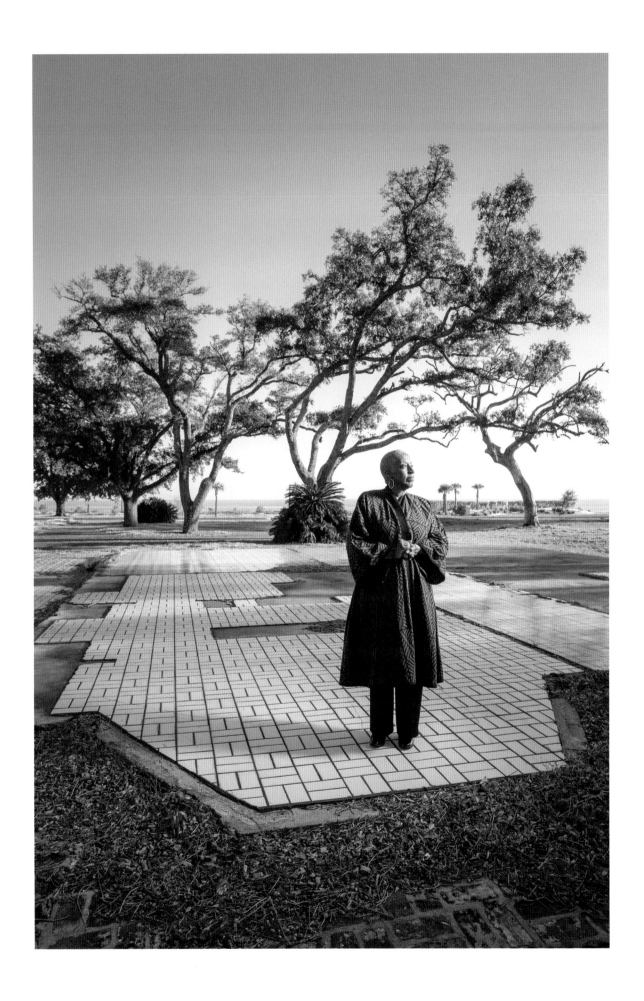

all of my spiritual leaders had always been women. I soon learned that the ordained ministry was not seen as an acceptable calling for women. However, I was very clear that I had a calling and that I was supposed to be in the ordained ministry. I don't know where that clarity came from, but it was from within, and that clarity guided my choices. When I went into pastoral psychology and counseling for my PhD, counseling was not generally accepted in the African American community. People often said, "Why are you doing that? Why don't you do ethics or systematic theology?" Well, I did not want to do those areas of study, so I stayed focused on what I was called to do. How did I know to do that? I didn't know how to do anything different. I had a mother that believed she could leap a tall building in a single bound. It never really occurred to me that I couldn't do what God called me to do.

Once I finished my PhD, I took a position at the Pastoral Counseling & Consultation Center of Greater Washington, in Washington, DC. I was there for about twelve years when my ex-husband and I opened a pastoral counseling center in northern Virginia. I loved the work and I loved what I was doing, but after twenty years I began to feel burnt out by the pace of the work. I began to look for a place where I could use my skills and experience more efficiently, as well as in a setting where I could make a difference. That's when I was offered a position at Hood Theological Seminary in North Carolina. I spent the next ten years there, and I was there during Hurricane Katrina. I had a friend who was a Lutheran pastor who had been assigned to disaster ministry in Mississippi to help in the recovery efforts after Hurricane Katrina. I asked her how I could help. She immediately told me to bring my students down to volunteer. So I designed a course titled "Ministry in the Midst of a Communal Disaster" for advanced-level pastoral care students. To be accepted into the course, the students had to agree to spend a week in Mississippi. Seven students accepted the opportunity and traveled to Mississippi.

We all grew in our understanding of ministry during that week in Mississippi. Even though I loved teaching, being directly involved in helping a community really, really reclaimed me. I took my sabbatical on the south Mississippi coast and felt compelled—called by a sense of being—to the coast. So I resigned my full-time faculty position and moved to the coast in 2009, when I accepted a position as executive director of Mississippi Coast Interfaith Disaster Task Force. In 2015, I joined the Back Bay Mission staff as the executive director. Back Bay Mission provides a wide range of services for the empowerment of vulnerable residents. This work allows me to use all of my experience, education, and training in supporting the efforts of marginalized residents to move forward to long-term sustainability. It is a place of hope. I am using my education and my training as a pastoral counselor, but this work is also an expression of my faith commitment—that we are in this world as servants one to another. We have eighteen people on staff, eighteen different personalities, eighteen differing gifts of humanity. If I can nurture and support the staff in such a way that they are able to be useful in the lives of the individuals and families we serve and are able to use their gifts to make a difference in the lives of the people we serve—that is a perfect day for me.

While teaching, my doctrine of ministry students would often ask me what else I would be doing if not this, and I would teasingly tell them that I would be a lounge singer. That would be my side job. I plan to retire in two years, and I have been thinking a lot about what I will do next. The short answer is I don't know. The fuller answer is I want to do something in my retirement that is life giving for me and for those I would serve. I know that I want to travel—I love traveling and engaging with different cultures. I want to do a lot more of that. The first place I would go is Ghana. I recently found out through Ancestry.com that I'm genetically predominantly Ghanaian. I have been to Ghana twice in the past, and I loved the country and

the people. I want to go back and do more research on my family history, maybe find a way to teach in Ghana. But for now, I just don't know what path is going to open for me.

My advice to young women is to pay attention to your own heart and what calls to you. Even if it doesn't make sense to anyone else, pay attention until it makes sense to you and the path opens up. Listen to your soul. I have learned that success and money are not the things you should chase, after all. If you are focused on just being successful or just making money, you can't listen to your soul calling. You can't listen to your heart and discover the deeper purpose for which you have brought to this life. You need to hold fast to the string that pulls you until it becomes a rope that leads you. Choose to open up to all of the possibilities presented to you. We are all so gifted. What is your gift that is unique to you? Give it to the world.

LISA CALVO

is an oyster farmer

When you work as an oyster farmer, the daily demands of the job come with a perk: they center you in nature. The Delaware Bay, where my farm is located, is rich with natural beauty. It's a quiet place, where the amazing light of sunrises and sunsets is uplifting and humbling. Day to day, and season to season, I'm privileged to witness the changes in the surrounding environment and its inhabitants. There are small details that many others never get to see. Yet my introduction to this fascinating environment wasn't through my career as an oyster farmer; it was though my other profession as a marine scientist.

As a child, I had a deep fascination with all things associated with the sea. It remained a constant in my life, and I knew I would make it my career. Shortly after graduating college with dual degrees in biology and geography, a Rutgers University field station specializing in shellfish research opened in New Jersey. Though I had grown up just thirty miles away, I had never explored this part of the Delaware Bayshore. Intrigued, I visited the facility tucked along the banks of the Maurice River. Looking out on the water, I couldn't help but be captivated by the incredible views, abundant wildlife, and rich maritime history. Enchanted, I was persistent in following up until they hired me, and my career as a marine scientist officially started. As it happens, this was also my formal introduction to oyster research. Nearby villages, aptly named Bivalve and Shellpile, were historically the heart of New Jersey's oyster fishery. Though the field station was new, Rutgers had a century-long history conducting critical scientific research to manage the oyster resource and serve the valuable fishery it supported. In retrospect, this emphasis on aquaculture at my new place of employment was a form of foreshadowing. At the time, however, my focus was purely on the science.

As I learned, this once-booming area along the Delaware Bay had seen hard times when oyster disease struck in the late 1950s. The industry all but collapsed, already challenged by overharvesting and development in the prior decades. Seeking to rescue a way of life that had once employed thousands of people in this tiny part of New Jersey alone, Rutgers researchers placed their focus on oyster restoration and redevelopment. Their first projects focused on understanding the diseases that had decimated the local oyster population. This led to a quest to develop a disease-resistant oyster that could make oyster farming a possibility once again. Fast forward, and the university has contributed a tremendous body of work

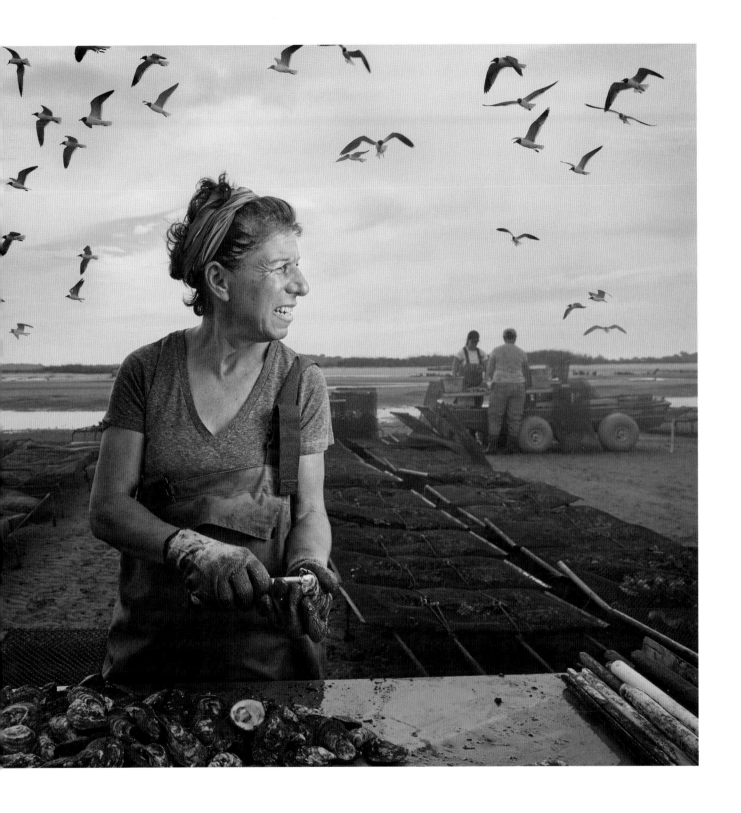

that has helped to manage and revitalize the oyster resource and also to develop modern aquaculture as we know it. Today, descendants of Rutgers' original resistant stocks are used by hatcheries to produce millions of "seed" oysters, which are "planted" in coastal bays and grown to market by oyster farmers up and down the Atlantic coast. Working at the field station, I was able to begin finding my place as a scientist dedicated to carrying forward this vital, fascinating work.

In time, this led me to pursue my graduate degree at the Virginia Institute of Marine Science. Just like in the Delaware Bay, oysters in the Chesapeake Bay had been impacted by disease. For the following fifteen years, I worked in Virginia as a marine scientist, contributing to studies that support oyster restoration and aquaculture. Those small shellfish had me hooked. I could delve into the science in a deep way: working in an applied marine science field let me explore the capacity of science to foster larger connections to people, history, culture, and food. In addition to contributing to a balanced ecosystem in numerous ways—filtering the water, bolstering the shoreline—oysters as a culinary crop offer a unique sense of place. While we were living in Virginia, my husband and I began dabbling in oyster farming. The first chapter of Sweet Amalia Oyster Farm, which was named after our daughter, was written in the shallow waters of Mobjack Bay, Virginia. Yet as our family grew, with the birth of our son, the security of a nine to five career path took priority. We eventually returned to New Jersey, where he worked in aquaculture policy and I rejoined the team at Rutgers, continuing my career in shellfish research and community-based oyster restoration. It wasn't until twelve years later that Sweet Amalia Oyster Farm returned to life, this time on the shores of the Delaware Bay that had captivated me so many years before. Though the farm was initially more of a focus for my husband, we worked side-by-side during those early years. So, when he decided to pursue an opportunity in his home country of Uru-guay, I found myself at a crossroads. I decided to keep the oyster farm going and have never looked back. The craft of oyster farming uniquely empowers me to apply my scientific perspective in a tangible way.

At the time, I didn't think too much about the fact that women were a rarity in oyster farming. My time was consumed by the demands of my dual roles as a scientist and farmer. In recent years, however, more and more women are launching careers on the water, echoing a trend I experienced in marine science. When I was a young scientist, there was a definite gender imbalance. Now, women are proven leaders, and the emphasis is no longer on "keeping up with the guys." It's on changing the course of the science. While there is a long way to go in many professions to achieve true equality, I believe that women bring diverse perspectives and approaches to their work, paired with a willingness to dig in with dedication, creativity, collaboration, and problem-solving skills. I see these strengths on my farm every day. Currently, women make up the majority of my crew—and while this wasn't intentional, the impact is clear. Whether they were drawn to the field through an interest in sustainability, love for the outdoors, or a taste for oysters, their ability to solve problems, pay attention to details, and move intuitively between tasks defines their work. I'm lucky to raise oysters with a select group of women who inspire me, as both my contemporaries and the rising generation. The young women I have worked with don't see gender barriers with respect to where they can direct their careers. They're just doing the work, with passion—and they do it extremely well. There is also a special form of community that emerges alongside the water. Oyster farming is physically demanding, but rote tasks like sorting them for market creates space for us to come together. We share our experiences and talk about the things that matter in our lives. There's a sense of camaraderie that bridges generations. This echoes something I have observed among women in the culinary field. The

chefs and restaurateurs that I have had the privilege to work with are very progressive. They think about sustainability and the ecological role of oysters. Just like the women who work on my farm, they draw inspiration from the oyster's clear ecological impact. And just like the women who are increasingly visible in oyster farming, they take time to support the rising stars.

Sometimes my daughter Amalia joins us on the farm, and that time is really special for me. This past August, she and her friends—a diverse group of very talented young women—came up one long weekend and worked every day on the farm. It was so fun to see their enthusiasm and their interest, despite coming from different fields. It was wonderful to share our world with them, and to see my daughter thrive in this landscape as she paves her way forward in the world in whatever she chooses to do. It means a lot to me to have served as a role model, both for Amalia and other young professionals in oyster farming and marine science. At the same time, I continue to draw inspiration from them. These young women have taught me to seek balance. When I was in college, the academics were challenging, and I worked all the time. My daughter manages her life in a way where she pursues her goals but makes time for things like hiking. She makes sure that she runs every day. She makes sure she's getting together with friends. It's going to be really fun to watch this next generation of women mature and thrive.

My advice to young professionals based on my own path is this: Be persistent when it comes to achieving your goals. The biggest rewards are often associated with accomplishments that require significant work, and you can't give up. There are so many challenges in oyster farming, yet when I look at what I've built, I know that I'm in the right place. Admittedly, oyster farming can be rather difficult when it is freezing cold and windy—or during that two-week period in the summer when the greenhead flies are biting. Yet through it all, it is glorious to work hand-in-hand with Mother Nature. Bringing my career full circle, my farm is a labor of love that allows my academic knowledge to come forward while creating new challenges that keep things interesting: running a business, connecting with chefs in restaurants, and growing a perfect food source that evokes this particular spot on the Delaware. On a practical level, I take pride in working to craft the perfect oyster. Yet ultimately I see Sweet Amalia oysters and our farm as a vehicle to bring people together. I always welcome people to visit, whether they are chefs, curious eaters, or young women interested in exploring oyster farming. When they experience it in person, they have a chance to learn about the environment, its ecology, and its capacity to contribute to a sustainable food system. They can see this place that changed and shaped my own life and work. Today, it's exciting to see women represented in all types of fields, from science to farming to the kitchen. By sharing my farm, it brings me joy to provide a potential entry point or source of inspiration for others.

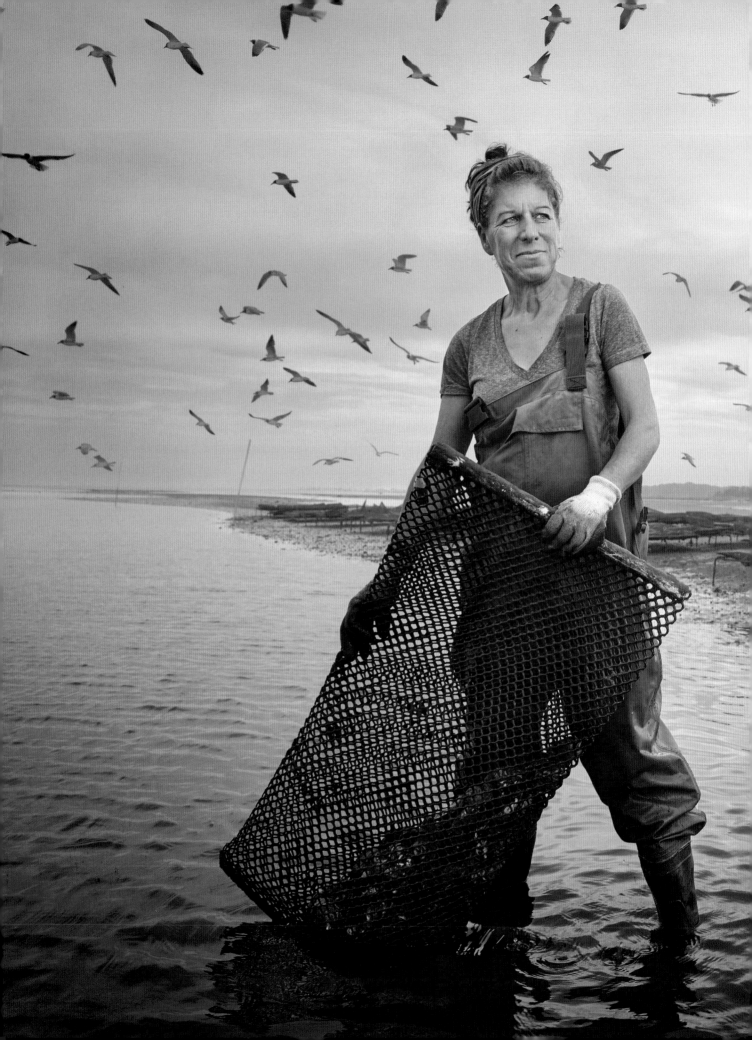

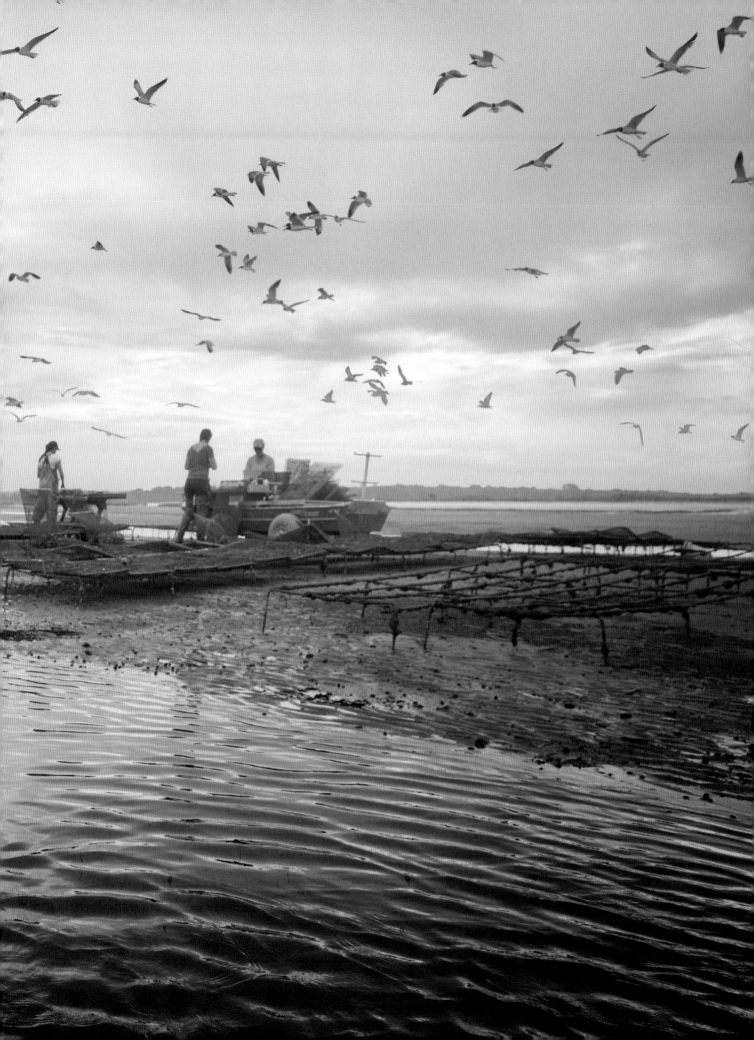

SOPHI DAVIS

is a cowgirl

I grew up with family that was always involved with ranching one way or the other, usually on the management side. My grandparents helped build and manage great ranches in the late sixties and early seventies, including Inverness Land & Cattle and the historic Silvertip Ranch near Yellowstone National Park. My grandmother has been managing ranches on the financial end for over forty years, but she is also a knowledgeable cattlewoman. Every weekday for thirty years, she had a morning meeting over coffee in her office with her ranch manager and his ranch hands, discussing the ranch and cattle. My grandmother taught me that the business side of ranching is every bit as important as the roping and riding.

My childhood revolved around our racehorse-breeding program and rodeo. My mother always had a passion for horses and made sure I was well mounted. She has obviously been an incredible influence on me. Some of my earliest memories of her are on horseback, as an outrider for the Great Montana Centennial Cattle Drive, and wrangling horses in Silvertip. She always made sure I had horses and encouraged me to stay engaged with my horses, even when sports and school started occupying most of my time. She was my first teacher and taught me what every cowgirl should learn: if you get bucked off, you get right back on.

I started training ponies and running barrels at age seven, spending my summers at the racetrack. I showed 4-H (a youth organization that promotes youth development and leadership through several programs, including horsemanship) and AQHA (American Quarter Horse Association) shows in both English and Western events. After college, I spent two summers as a wrangler for Mountain Sky Guest Ranch, wrangling around a hundred horses and leading rides through some beautiful country. After meeting my husband, Taylor, a fifth-generation cattleman, I became interested in roping and working with cattle. The first ranch job Taylor had outside of his parents' place didn't have a position for me. Instead, I worked for a reining-horse trainer and spent every spare second absorbing the cattle aspect of ranching. I've always had an interest in horses, both on the breeding side and the performance side, but when I was introduced to the working ranch lifestyle, I was hooked. There's incredible satisfaction that comes from a long day of cattle working, and nothing makes for a better horse. Eventually, Taylor and I moved to Lone Star Land and Cattle Company in Springdale, Montana, a commercial cow-calf operation at the base of the Crazy Mountains, where we still work and live today. For

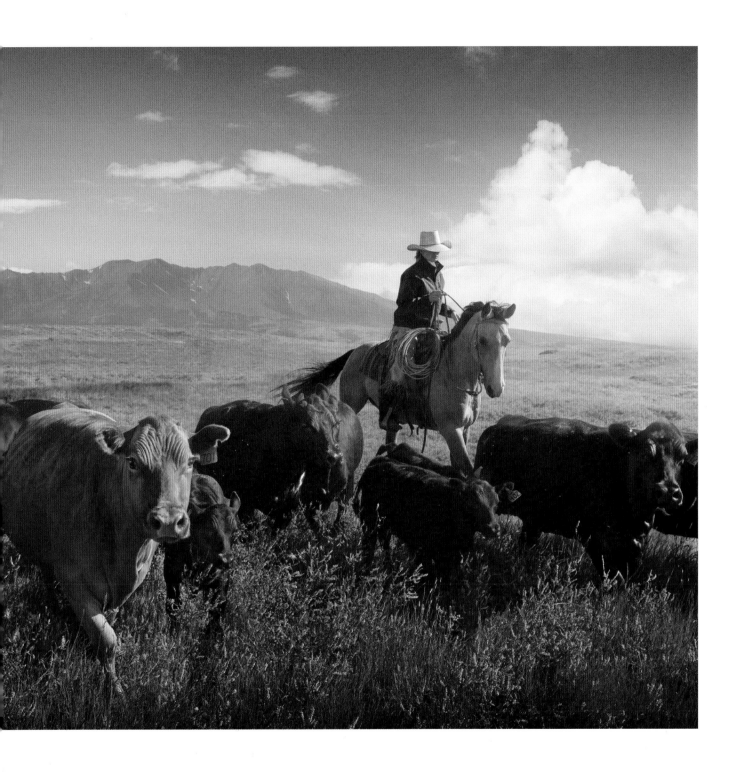

years I worked alongside my husband on the ranch until the arrival of our daughter. Nowadays, my full-time job on the ranch is to manage the ranch owners' homes and horses. Every chance I get, I help with ranch activities, such as branding, farming and haying, fall gather, and shipping.

My husband has been the most significant influence on me when it comes to ranching. He has taught me about the less exciting parts of my job, such as fencing and farming, and has been patient with my never-ending questions about the whys of ranching. The biggest lesson he has taught me is that the ranching lifestyle requires three things: passion, patience, and consistency. I have also learned so much from the ranch hands, ranch managers, and friends that we have worked with for the last ten years. In this life, there is an opportunity to learn something every day, sometimes all day. I have been blessed to be surrounded by men and women willing to share their knowledge.

And actually, despite what you may think, there are many women in ranching and agriculture, and the number will hopefully continue to increase. Most women are not in the saddle every day, but their contributions are vital to the health of the ranch, whether that's bookkeeping and managing records or simply cutting hay. Some, like my mother-in-law, work in town to support the ranch and then turn around and work on the ranch in the evenings and on the weekends. While I am so proud and impressed when I meet a cowgirl who can hold her own, working cows with a crew of guys, I am equally impressed by the women who buy my in-laws' calves, who have built a successful and credible cattle-marketing business, or those like my neighbor, who left her career as a professor to start a ranch-raised beef business. Those women remind me of my other interests, too; I studied communications and marketing, specializing in corporate events, but my interests outside of ranching are writing and photography. If I wasn't ranching, I would be growing a business to promote women in agriculture and ranching through my other skills.

Aside from ranching, raising my children, Ella and Hunter, has been my main calling in life. I love exposing them to this ranching lifestyle. In my free time, I have been working on a new project called Art of the Cowgirl with my good friend and cowgirl legend Tammy Pate. We are working to develop a fellowship program that will help facilitate mastering trades and skills, like saddle making, silver engraving, and rawhide braiding. They can then pass on their skills to other women. It has been an incredibly energizing opportunity to connect and celebrate cowgirls and our way of life.

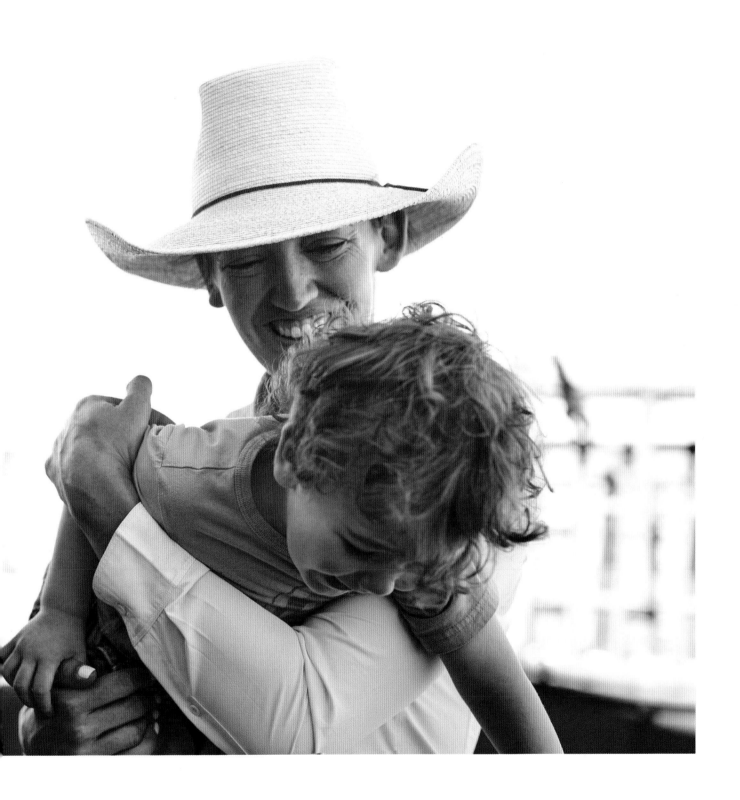

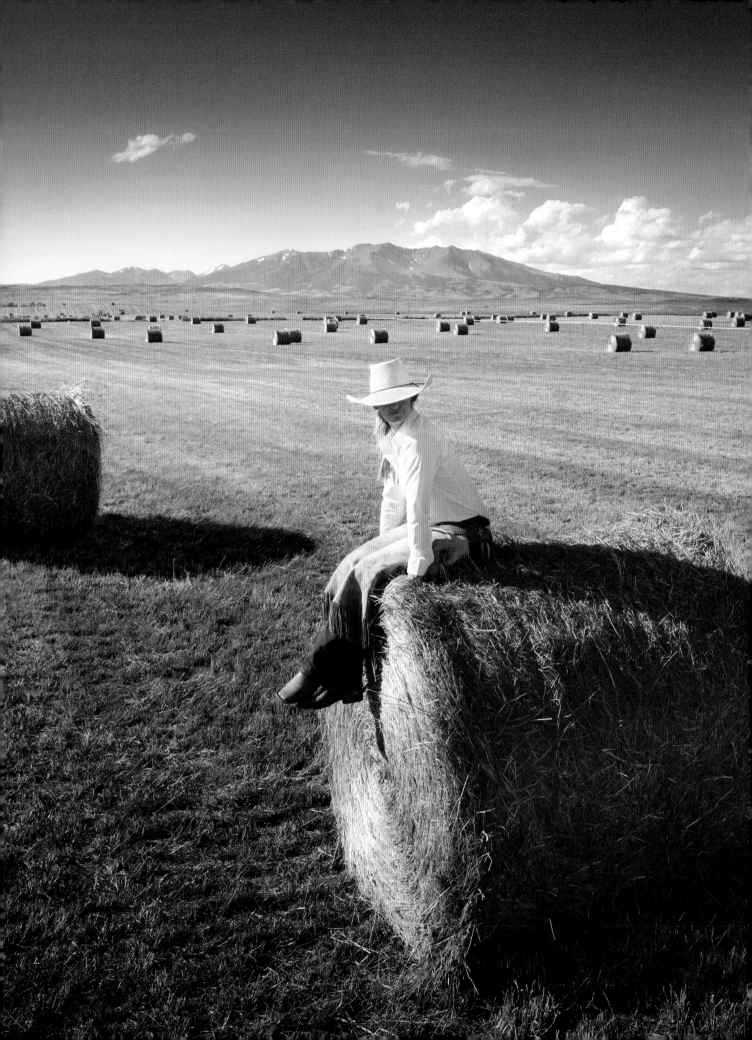

JUDY BOWMAN

is a gold miner

I grew up in southern Michigan on a dairy farm surrounded by family until going to college in 1990. I worked in the food service and hospitality industry for many years. I didn't fall into the mining world until 2013, when I moved to Round Mountain, Nevada. There was a great, wonderful lady who had been working there for more than thirty years—I now consider her a mentor and a dear friend—who was very encouraging and a great coach. She was one of the only two female supervisors at our mine site then. I believe there are still only two women supervisors. She gave me the opportunity to apply for my current position, but she also taught me the right mind-set and mannerism for this work: to stay tough and work hard. Because we were similar ages, a lot of my confidence came from her. She helped me hone my skills. So at forty years old, I had a huge career change. It was scary but a great experience. Today I am the environmental protection pad walking person for our whole pad crew department. It was initially a temporary position, but I've been doing it four years now. I'm so privileged and flattered that they asked me to do it.

What I've learned—what that first woman mentor has taught me—is to work hard. That was number one. Do what was asked of you. Safety's a big issue in mining, so I've also learned to think, to stop, to not go so fast. As women, we multitask a lot; here we have to stay focused because so much high-risk activity happens at mine sites—though business is highly regulated by the Mine Safety and Health Administration. So I've also learned to just be polite, mind your manners, don't get down, tomorrow's a new day, just do what's asked.

I think it's helpful to have the companionship of other women working in this industry. The women who are in superior positions are very understanding—though so are the men. I think our culture has evolved into one that is warm and inviting to men and women alike. I wouldn't say there was discontent from men when I started in this industry; there was a lot of congratulations when they realized I was going to pursue it. The few male mining friends I had understood what this work entailed. They understood it took a lot of tenacity. They embraced me; they were very supportive.

I believe that at the particular mine I work at, the male-female ratio has consistently been the same. But when spring comes along and we start to get our temporary help for the summer, there's a good chance that there may be more females than males this year. And shit, they're doing great; these women are on fire.

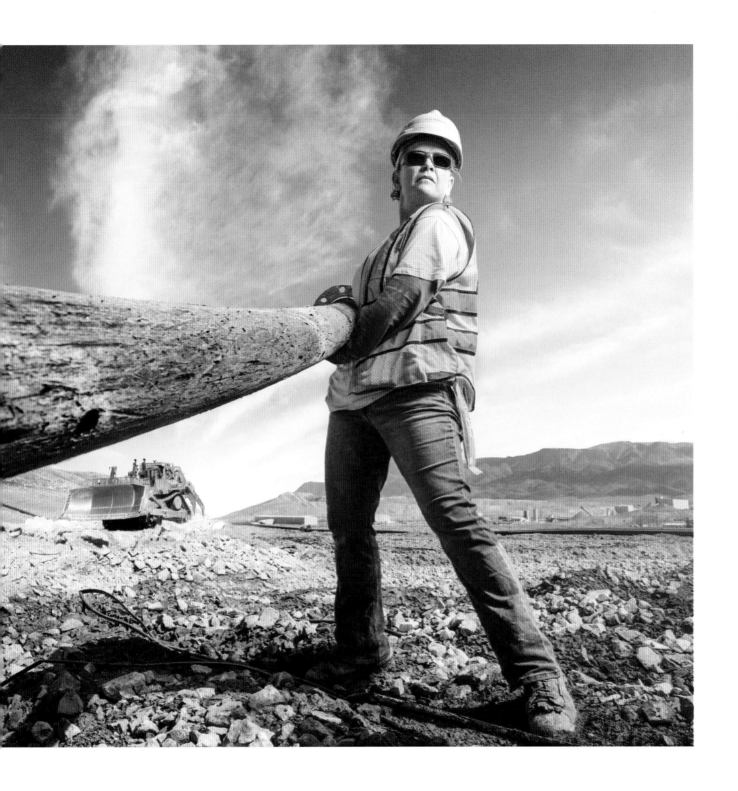

They're tough. They're not afraid. I don't know if a lot of women realize that gold mining is a real opportunity for them; I didn't until that mentor came along. It's so refreshing to see that change and see our industry expand. I have so much hope.

I will say that in the year 2019 we have the tools and opportunities to make our jobs easier, and this mine definitely provides that for us. Now, my department will always be very physical. We run leach lines across large leach pads, but we do have equipment to help as well. But as far as hand tools, power tools, loaders, dozers, for moving pipe and stuff, a lot of that will still have to be done by humans. We have been able to fine-tune how to run our business safely and methodically. There's a certain physical strength that you have to have, but we're given the time and opportunity to learn how to do it efficiently, and that's refreshing.

We line out in the morning as a group. Our crew is about thirty people. I focus primarily on the environmental management, making sure we're not causing problems for ourselves with wildlife. That might entail tightening leaks in pipes, tightening a four-inch to twelve-inch valve. That could mean shoveling to cover trenching. Trenching areas can cause environmental hazards to birds and deer, antelope, other exposed wildlife. So a lot of maintenance on our pipes, as well as site-specific maintenance, is what I handle: fusing pipes, hooking up pipes, bolting pipes, running leach lines, staking bird nets, putting up environmental decoys. Things like that.

To enter the mining world, there are, of course, college programs. Now, if you wish to come directly to the mines without the education background, there are still endless opportunities. One lady here had a good piece of advice: "Don't seek an entry-level position as chairman of the board." You have to work your way up, learn from people you admire, mind your manners, be polite. Stick it out, and you can go anywhere. I think as women, we partner well with men. We have just different approaches to tasks. Women tend to pay attention to details, which, in the realm of safety, can be very helpful to men. I think that might be our strength in the workplace. We're great motivators. What I've seen here on our launch pad is that when men and women come together and they work as a team, there's such camaraderie that eliminates outside or personal forces of influence. We've seen excellent working chemistry here. So do I think there's a place for women in this business? Yes. Of course.

JORDAN AINSWORTH

is a gold miner

I started at Round Mountain Gold Corporation (RMGC) maybe a week after I graduated from high school. I started at the Gravity Plant, was moved to a group dubbed "ADR Projects" (aka where they placed us leftovers from the Gravity Plant once it was torn down), then transferred to the utility crew, and eventually the mill, where I've been for almost two and a half years. I've been at the mine a little over three years. I didn't go to college, so if I wasn't working here, I'd probably just do that. That's the big plan: getting a degree or two in engineering.

But actually, it's funny—I grew up hating mining. Not for any moral reason but because both of my parents worked in mining and we moved around a lot. I didn't think about becoming a miner myself until the tail end of my senior year, and even then, the plan was only to stay for the summer and then leave. Funny how plans change.

I'd have to say my biggest influences in becoming a miner are the men of Crew 1: Aaron, Fred, Diego, and Jason. I worked with them for almost my entire time at the mill, and I owe a lot of who I am and what I am to them. When I started at the mill, I was a nervous, scared little jelly bean who didn't know the first thing about the milling or crushing. Over the years, they've taught me not only my way around the place but also to be strong and to be confident in what I'm saying and doing and to not let people run over me (literally and figuratively). They've pushed me to be better and do better every day, and they've made coming into work worth it every day. Those men became more of a family to me than coworkers, and I appreciate everything they've done for me and continue to do for me.

I don't know that the lack of female miners bothers me so much. I think what really bothers me is that so many women have it in their heads that they can't work in fields like mine. Working around almost solely men can be daunting, and I think women feel as though they might not have a place here. I haven't had many naysayers since I started at the mine. It's mostly been from men who were trying to convince me that I should just quit my job and let them take care of me. Or girls who hate dirt. And boys who hate dirt.

I think a lot of women feel as though they don't have a place in the mining industry or other fields similar to it. I want you to know that you do. There is room for you

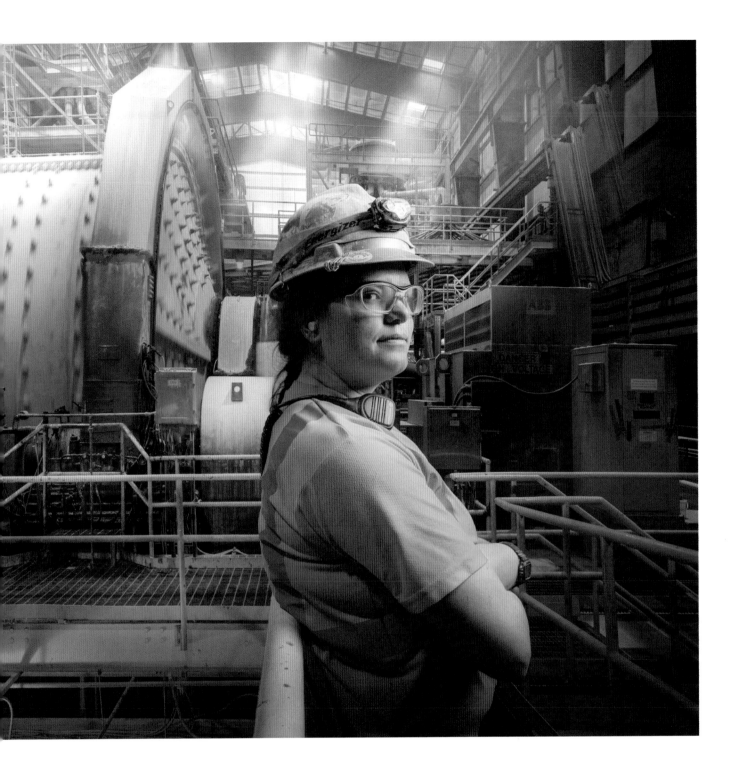

everywhere that you want to fit in. And if you end up where you want to be and start to feel discouraged or that maybe you're not good enough, I want you to recognize that somebody somewhere thought you were the right person for the job. Remind yourself of that, every day if you have to, and don't let anyone try to diminish your accomplishments. Stand up for yourself, and don't let others treat you like a doormat. And if in the end you decide that the job isn't for you and you decide to leave, I want you to recognize that quitting does not equate to failure. It's just the closing of a chapter so that you can begin the next one.

MARA REINSTEIN

is a film critic

I grew up in the Detroit metro area in the 1990s. This was back when people still read newspapers. There was a contest in the *Detroit News* to become a teen movie critic. Eager to see my name in print in the most fun context possible, I applied and got it. I was sixteen. My "audition review" was for the movie version of *Buffy the Vampire Slayer*. (I thought it was dumb, even though it starred my favorite teen idol, Luke Perry.) I was so excited and totally convinced my career had peaked before I even graduated from high school.

By 2011, I was a longtime senior writer for *Us Weekly* magazine in New York City. This was back when people still read magazines. I was burned out writing about Jennifer Aniston's love life and eager to spread my wings. A movie critic job had just opened at the magazine, and I brazenly told my boss that I

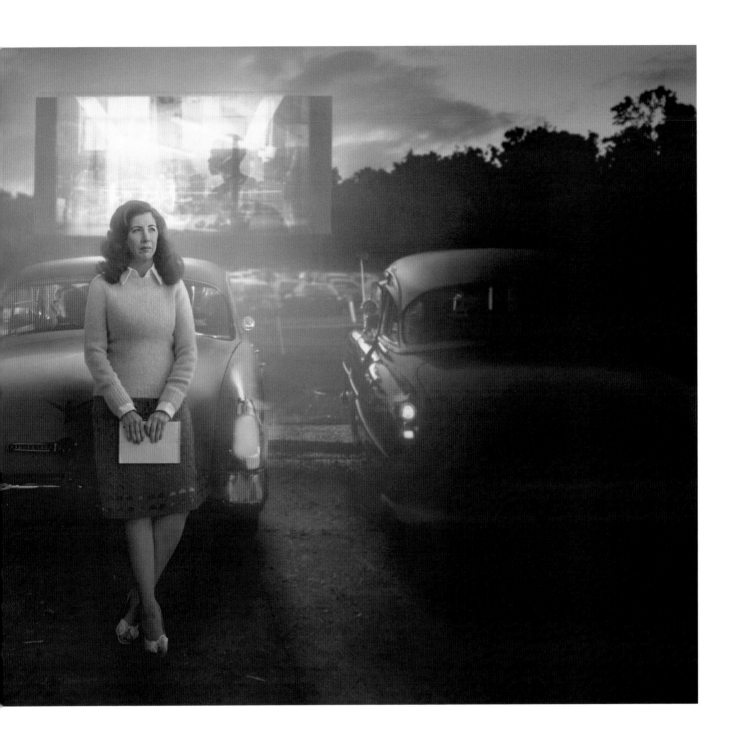

wanted it. Truth was, I needed it. I knew it was the only job out there that wouldn't seem like a job. Still, I had to apply for this plum gig along with other applicants all over the country. I labored over every word of my sample review for this dumb comedy called *Horrible Bosses*. The owner of the company, legendary editor and *Rolling Stone* founder Jann Wenner, was so invested in the reviews section that he personally selected "the winner." I never had a conversation with Jann in my fifteen years of working for him. I found out he selected me when my editor in chief gave me a handwritten memo from "JSW" to prove it. I'll forever be indebted that he chose me.

Before that, I can't say there's a moment in particular that led me to becoming a movie critic. But I can't remember a period in my life when I didn't love movies or writing. This is no hyperbole: my dad took my twin brother and me to rated-R movies back when we were in kindergarten. I saw early eighties classics like *The Right Stuff, Airplane!, Tootsie*, and *Chariots of Fire* in the theater! (For the record, we saw every Disney movie as well.) Even when I didn't understand exactly what I was watching, I still reveled in the vibrant images flickering in front of me.

I always make the self-deprecating joke that I had to be a writer because I've never been skilled at anything else. I wish I were kidding. I was never destined to be a chemist or a hedge fund manager or an elementary school teacher. I don't even know how to make a decent cup of coffee. But I've always been comfortable expressing myself by putting a pen to paper. When I applied for that teen movie critic job at the *Detroit News*, I saw it as an opportunity to get paid for combining two of my favorite hobbies. I still see it that way. Also, I like telling people what to do.

People often wonder what the day-to-day is like as a critic. Here's how a perfect day would play out for me: I wake up without an alarm ringing. I jog in Central Park. (This perfect day must be 62 degrees and overcast.) I do a little writing in my living room; hopefully a fun movie is airing on HBO or Showtime so I can keep it on in the background. I meet a friend, and we go to an early screening of an Oscar-caliber movie in my favorite theater on the Upper West Side. Free concessions are offered. (Never underestimate the power of popcorn.) I laugh and cry at said movie. I write my review of said movie. I brush my teeth and floss all the popcorn kernels out of my teeth. I dream that I'm married to Jake Gyllenhaal.

I was laid off from my full-time gig at *Us* and transitioned to working freelance in 2017, which forced me to do a lot of clichéd soul-searching. I toyed around with working for a movie studio because I'm interested in developing and marketing more movies to women. We're not just drawn to splashy rom-coms! But I ended up doing what felt right to me: starting a website called Mara Movies (www.maramovies.com). At long last, I could write reviews and views about anything I wanted, unedited! If I won the lottery, I'd do that all day, every day. Now I maintain that site, I'm the film critic for *Us Weekly*, and I write for other outlets as well. I also teach writing classes, which I find very fulfilling. Alas, teachers don't get paid as handsomely as movie execs.

There have been many influencers on my career path, of course. I'd be remiss if I didn't mention Gene Siskel and Roger Ebert as great inspirations. Every Sunday morning, my dad, my brother, and I watched Siskel and Ebert. If we missed it, we taped it on the VCR. They didn't just review movies; they stuck to their convictions and were unafraid to argue the dissenting opinion. (In fact, fights were a highlight.) I thought their show was more entertaining than the entire TGIF lineup on ABC. And this was before I even realized that they were equally talented writers. These plain-looking, middle-aged midwesterners were rock stars to me. And as a discerning moviegoer, "two thumbs up" was the ultimate seal of approval. In the wonderful Roger Ebert documentary *Life Itself,*

I learned that cinephile critics pooh-poohed the see it/skip it recommendation. But I'm a fan of this kind of accessible, bottom-line review. It's hard to believe that both men are gone now.

When asked who my biggest inspirations are, I know the correct answer is iconic *New York Times* film critic Pauline Kael. But I never even heard of her until I was deep into my journalism career. On Fridays, I read the movie reviews written by the *Detroit News* film critic Susan Stark. She also had a radio segment on WJR-AM in Detroit. I specifically recall that she said to never, ever insert personal stories or anecdotes in a review. Once in a while, I break the rule and silently feel her judging me. Sorry, Susan! What I loved about her reviews was that she was biting and smart and almost always right. In fact, Susan was a bit of a local celebrity because of her caustic, respected opinions. It never occurred to me that as a female movie critic, she was in the minority.

Nobody will ever outright admit it, but there is gender bias in this industry from the screening room invitation list to the movie review itself. One instance: In the summer of 2018, I went to a private screening for a violent summer action film. We're talking guns blazing every two minutes. I was the only woman in the room, and it couldn't have been a coincidence. I knew I had stepped right into a Dude Movie. And for what it's worth, I enjoyed the movie.

As a film critic, I often receive harsh blowback. I get it. People are passionate about their movies—especially if a film features characters that date back to their childhood—and take negative opinions personally. But it bothers me that female critics are on the receiving end of vicious bullying that doesn't extend to our male counterparts. When I write a negative review of a superhero movie, for example, I get to read comments like "You're a girl, what do you know about superheroes or comic-book movies?" (Needless to

say, that's the G-rated version.) These people think I'm unqualified just because I'm a woman. They have no idea that I love movies just as much as them, probably more so. Our society still tends to look to men as the end-all, be-all tastemakers in our industry. I don't know if or when that stereotype will ever disappear. I tend to ignore the haters, but I'd be lying if I said the nastiness didn't bother me.

One of my more challenging moments as a female film critic? In December 2018, I gave *Aquaman* a so-so review. I was bombarded with hate mail and even some death threats via social media, all from angry dudes who dismissed my opinion because of my gender. One guy called me a "feminazi." Another remarked of the photo attached to my review, "Look at that smile. That's someone who's been single for more than a year." Those were the ones that didn't threaten my life. But I was more disheartened than scared. Male bullies always tend to go straight to criticizing women for their genetic makeup. Worse, we're constantly doubted and, yes, targeted just because of our gender. Stereotypes like "Girls can't like comic-book movies" are as wrong as they are demeaning. A marvelous film in any genre will transcend any audience. So I've had to develop thick skin to go along with my thick hair.

But my advice for the young women out there—let me steal a quote from my all-time favorite movie, *Back to the Future*: "If you put your mind to it, you can accomplish anything." Seriously. Brainpower—and hard work—are your greatest attributes. To that end, I also want girls to remember a line courtesy of one of the greatest heroines in recent film history. Obviously, I'm referring to *Legally Blonde*'s Elle Woods, who once declared to a friend, "You've got all the equipment; you just need to read the manual." So true. You got this. (Oh, and whoever said that orange is the new pink was seriously disturbed.)

DAMYANTI GUPTA

was the first female engineer employed by Ford Motor Company

My name is Damyanti Gupta. I was born in 1942 in a very small village of Sindh, British India. When I was five years old, India gained independence. This didn't happen easily. The country was divided into India and Pakistan in the bloodiest partition in the world's history. The part where my family lived became Pakistan. There were riots and unrest everywhere. My family had to flee in the middle of the night to the coastal town of Karachi. Then we were loaded onto cargo ships bound for Bombay. When we reached Bombay, we were called refugees. We had lost everything and we couldn't communicate with anyone, because they spoke different languages. My family wandered around from city to city looking for work. We finally settled in Baroda, Gujarat.

There I was admitted in the refugee school. In first grade, I had to learn three languages; one was a right-to-left language, and the other two were left to right. At the age of five, I became a translator for my parents and grandparents. My mother, who had only a fourth-grade education, looked at me and said I was going to get something that no one can take away from me: a good education. She said she would help me, but I'd have to do my part. Be a good student, she reminded me every day. When I was thirteen years old, we heard that our prime minister, Pandit Nehru, had decided to visit our city. I was very excited. I wanted to see him and listen to his message. That morning I started from my home very early in the morning, reached there, and found a seat on the ground near the podium. In his speech, he said after two hundred years of British rule, India has no industry. We needed industry, we needed engineers. He looked at us and said, "I am not talking to only the boys, I am also urging the little girls to consider this profession." This was the first time I even heard the word *engineer*. I went home and told my mother that I wanted to become an engineer. She fully supported me. I graduated from high school with very good grades and was able to pursue mechanical engineering.

This didn't happen without challenges. It was difficult enough to be the only female student in a male-dominated college—there was not even a ladies' restroom. I had to ride my bike one and a half miles each way to use a restroom. When the dean realized that I was there to stay, they built a beautiful ladies' room just for me.

When I was nineteen, I remember coming across a biography of Henry Ford. In this book he showed how he was able to make a car affordable for the average family through assembly-line invention. I started dreaming about working for that company one day. I started working very hard and was able to get admission in universities over in America. I chose Oklahoma State University because it was the least expensive.

My parents decided to give me their lifetime savings to come to America. This amount was still not enough, so I applied for and got a job in Germany. On March 14, 1965, I left India by ship from Mumbai to Marseille and by train to Paris. Again by train from Paris to Düsseldorf, where I was held overnight in the train station for not having the correct transit visa. This was the first time I had left my home alone.

I arrived in Stillwater, Oklahoma, on January 25, 1966, and finished my master's degree in mechanical engineering in January 1967. I was the first female

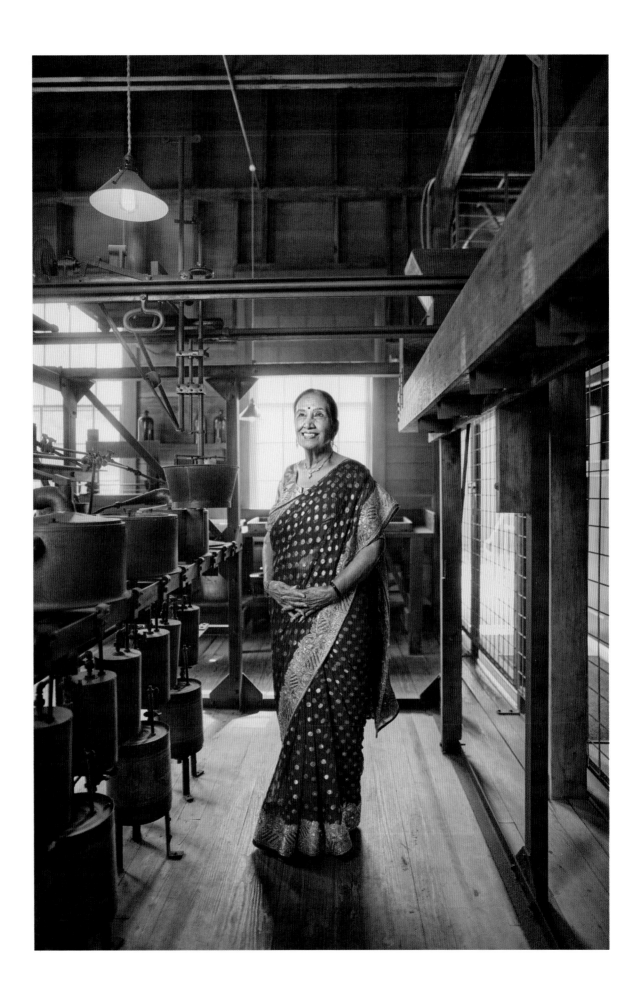

engineer to graduate from OSU. From there I took a train directly for Dearborn, Michigan. When I reached Michigan in the month of January, I had no car and no boots, but I had a big weapon: my lifelong dream.

The first time I applied to work with Ford, I was rejected by a supervisor, who didn't want a lady engineer working for him. When the weather got a little better, I applied again and was successful. Initially, when I went to apply for a job with Ford, the human resources person looked at my résumé and asked if I was applying for an engineering job. "Yes," I said, "is anything wrong with that?" He remarked that they didn't have any female engineers. I looked at him, smiled, and said, "Well, I am here. If you don't give a chance, you will never have any." He understood and set up an interview. My boss really liked my grades and what I had to bring to the position. He took me into his office to make me an offer. As we sat down he said he had a big problem: he couldn't pronounce my name. He told me if I could come up with a nickname, I'd have the job. I was very eager to get my dream job. I instantly came up with the name Rani. He liked that very much. *Rani* means "queen" in Hindi. I figured, if you want me to change my name, then you better call me "queen" for the rest of my life. Thus, on August 7, 1967, I went from Damyanti to Rani, landed my dream job, and became Ford's first female engineer.

But it was not without challenges that I held this title. A few days after I started working, one engineer came to me with a stack of papers in his hand and said, "Will you please type this for me? Our secretary has taken a day off." I looked at him and said, "But I am an engineer, just like you. Please bring me something more challenging." Shortly after I joined Ford, United Automobile Workers (UAW) had its longest strike in their history, and Ford then had a big layoff. I survived that layoff. But a lot of employees were very upset, because either they had lost a job or someone from their family had lost a job; they didn't like that anyone from other countries was still working. They thought we were stealing their jobs. I remember once going to visit one assembly plant to check on some parts to see if they had been installed properly. At the plant, one blue-collar worker came to me and asked where I was from. I replied that I was born in India. He told me to go back to my country. I said, "I am in my country." So he said, "Then go to your kitchen." I replied, "This is my kitchen."

I met my husband after I had landed my dream job. They say marriages are made in heaven, only celebrated on Earth. I was driving through Ann Arbor, and my car broke down and would not start. I had no AAA insurance. I spotted a pay phone. I opened the white pages and started looking for a familiar name. I grew up in the state of Gujarat in India, where Patel is a very common name. As soon as I found the first Patel, I dialed that number. The person on the other end said, "Mr. Patel is not here; may I take a message?" I said, "I am not looking for Mr. Patel. I just need some help with my car. It won't start." He asked me where I was. I told him the cross streets, and he asked if I saw a big building in front of me, University Towers. He was in that building and would come down. Shortly he and his friend came down, and we were able to start the car. I married that friend. His name is Subhash Gupta.

When we were expecting our first child and my boss found out, he called me into his office and said that women don't come to work when they start showing. He told me to make this my last month on the job and hoped I wouldn't return after having the baby. I was disappointed but didn't say even a single word to him. I was taught to respect elders. I went home and told my husband, who told me not to worry, that something would work out. After I had the baby, I reported back to a human resources person. In those days, Ford had something called Ford College Graduate Program, where new graduates were able to rotate every three months from department to department until they found the right match. The human resources person sent me to an interview for another

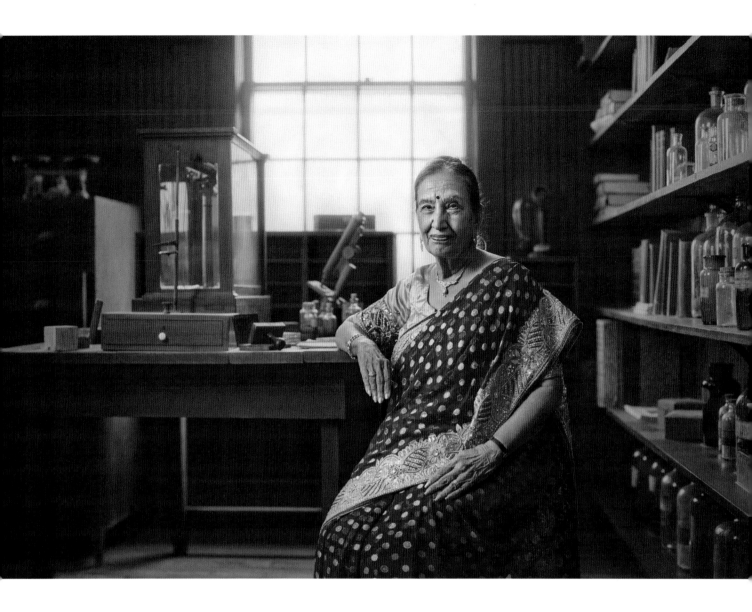

department; I got a job right away and was promoted within three months.

Without my husband's help, it would have been impossible for me to work at Ford for thirty-four years and raise two amazing, hardworking sons. Whenever I had to work on Saturdays, Subhash took very good care of the children. Subhash enjoys music and loves singing; both of our sons have inherited that from their father. After I retired, our hobby became singing karaoke together.

When Ford celebrated my thirtieth anniversary, they were playing my video on Ford Communication Network (FCN) every half an hour around the world,

wherever there was a Ford facility. The next day, when I opened my email, I had received so many notes, mostly from women. They asked things like: How did I survive doing this thirty years ago when we're still struggling now? Did I have children? Was I married? They thought balancing both lives must have been very challenging.

If a refugee woman with only a fourth-grade education and no money could keep her promise to her daughter, to help her daughter to realize her dream, we all are capable of doing whatever our heart desires. My mother used to say that we have to accept that sometimes we don't have control—but you must work very hard where you can to change that.

YOKY MATSUOKA

is a vice president at Google

Long before I became vice president of Google, all I wanted to do was play professional tennis. I moved to the US when I was sixteen with an idea to become a professional tennis player one day. That's all I knew until halfway through college, when injuries and everything piled on and I realized that that trajectory wasn't that realistic. I ended up knocking on a professor's door and said, "I'm a tennis player, I'm good with math and physics. You seem to work on robotics. Is there a way for me to build a robot for myself that can play tennis with me?" He didn't laugh at me, and he said, "Yeah, sure. Start working with my grad student, he's on the third floor."

That was really the beginning of my professional career. Isn't that amazing?

I immediately found robotics to be fun. That's what took me to MIT. I continued to build a robot, selfishly, in that I wanted to build it for myself. I've found that when you're passionate about something, you learn really fast. When I am interested in something, I dive really, really deep.

But this was in the nineties, and machine learning was not yet good enough to teach robots to play competitive tennis. So I got stuck. When I asked for help as a way to advance artificial intelligence, it was clear that I should study the real intelligence, the human brain, and how it learns to play tennis.

I pretty much, again, went and knocked on the professor's door, and this famous neuroscience professor took me on. I started conducting experiments with human subjects and built computational models. This work ultimately became the subject of my PhD at MIT.

At that point I was not thinking about how this would all connect to some great future plan. But I was ready to do something way bigger than me. When I learned so many people have disabilities at some level that makes daily tasks difficult or impossible, that that could be helped by technology, I realized that's my future.

One thing I've noticed about a lot of girls and women is that we look for purpose, right? I think somewhere in my brain I was also looking for purpose. I ended up retooling myself at Harvard to think about building assistive or rehabilitative robotic devices powered by machine learning to help people be able to lead a better lifestyle. That was a really cool transformative moment for me and led me to a professor position at Carnegie Mellon in Pittsburgh, Pennsylvania.

I met my husband there. It was a wonderful experience for me. At Carnegie Mellon, I started my research trajectory and really built my career around it. Because, again, I tend to go *whoosh* with my passions. I started building robotic devices for people who couldn't move their arms and hands. I thought, if people lose the function of their legs, they can get in a wheelchair and still go to places, but if they lose their arms, they can't do even the most basic things, like eat. I wanted to find a much better way to bring those functions back. As I started studying more on movement, how the mechanics work, I began building a replica of the human hand. I began to figure out which parts we could replicate, which parts we could abandon. That's the rabbit hole I went into; it was exciting, it was fun. This crazy infatuation with the

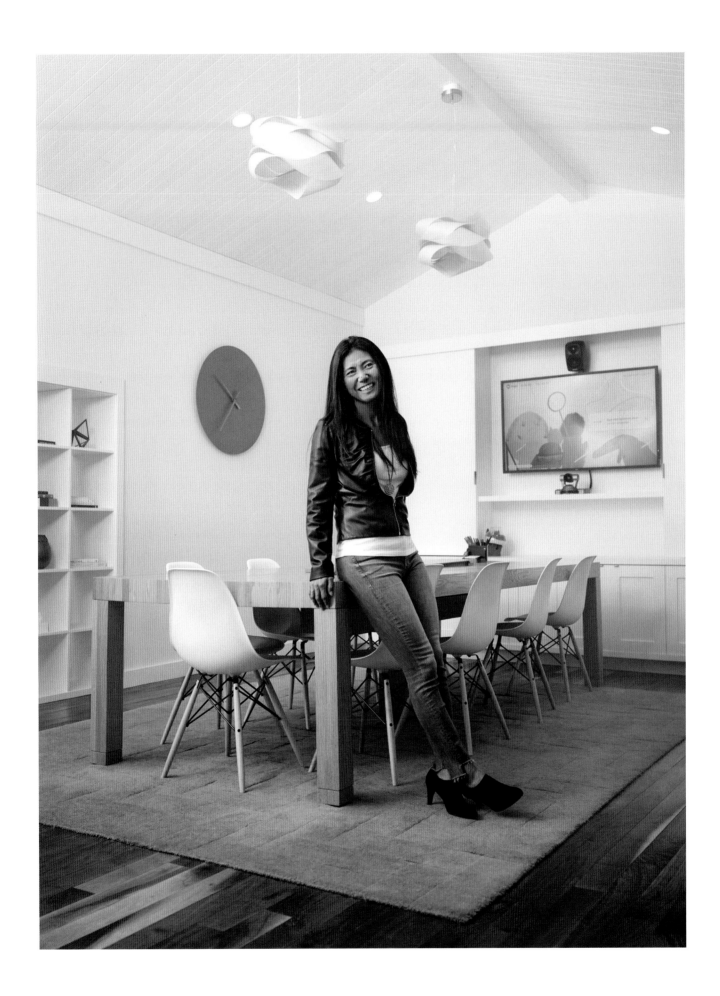

overlap of biology, medicine, robotics, and machine learning likely led me to becoming a MacArthur Fellow. I truly enjoyed discovering and inventing new things in the cross section of these different areas. But one thing that was missing was to actually help people who could benefit from technology in their daily lives.

One thing I did prior to coming to Silicon Valley was start a nonprofit called YokyWorks. YokyWorks builds engineering solutions for people to enhance their lives. It was incredibly rewarding, but we worked on solutions for each individual rather than building something that could be for many, many others.

Two of my children have learning disabilities (neurodiversity) that I also have, and I got to go through a journey of trying to help them. It's a struggle. I want to share my wisdom with all of those people who are wondering what's happening to their five-year-old so that they don't have to wait until they're nine to figure out what really is going on.

So YokyWorks is still my passion. Every day I want to do more of it.

As for my work in Silicon Valley: when Google X was starting, I was recruited to be a cofounder. I thought of it as an opportunity to touch people more closely. And I moved to Silicon Valley. The journey at Google X was great: we helped start what is now known as Waymo, Project Loon, and Google Glass, to name a few. But I was impatient and wanted to learn how to build consumer products that improve how people live now. So I decided to take, yet again, a pay cut to move to a start-up called Nest. At the time they were still in a garage with fewer than ten employees. That was 2010. That's been an incredible journey. That was probably one of the hardest but best times of my life: really building something people will use tomorrow. I had to think about putting the user at the center of the experience. The intuition I learned in the research world did not work in building consumer products.

If you create something so advanced that it works for one out of a thousand people, that isn't viable. It has to work for everybody, and everybody has different needs.

Google acquired Nest in 2014. I left to learn how others build consumer products, and I eventually came back again to Google and to Nest in 2017.

So why am I at Google now? I think there are so many reasons, but in order to really change the lives of a lot of people, you sometimes need scale. I'm much more of an entrepreneur, but it's hard to connect with a billion people in that environment. I'm here at Google so that whatever I build can have the chance to be used by and help as many people as possible. That's really exciting. But at the same time, the reason I don't give up on my nonprofit is so that I can still help those whose challenges may not be solved by large companies. I'm having an incredible time.

There have been many people who have influenced me in reaching the point I'm at today. I grew up being told by my parents that it was okay for me to be unique, okay to be different. As a matter of fact, that being different is often better. I credit my parents for this mentality. When I was a kid and trying to become a professional tennis player, I looked up to people who were more rebellious, like Andre Agassi. Those were the people changing how tennis was done. It was okay to wear colorful clothes, to have long hair, to question the umpire, to make noise. They reinforced that it's okay to be different. Coming from Japan and being a woman, this was not a common or even accepted view. My professor at MIT, Dr. Rodney Brooks, was somebody who also was trying to transform robotics in a way that was unafraid of being different. People didn't like his ideas. He was really bold about what he believed, and he was known as the "bad boy of robotics." I think, in that sense, I was inspired to stick out a little bit, even if it means being in the minority. If you are mission driven, if you have passion, and if you are willing to keep trying despite difficulties, you will change the world in the right way.

I went to an all-girls Catholic primary school. When I went to high school, it was to a predominantly male high school—a boarding school for boys with a coed day school. I played on the boys' tennis team.

So from those interactions, I started to become a little more comfortable around men. I went to college, and then I was often the only woman in my STEM classes. That's when I completely stopped noticing. Some days I would go home and look at myself in the mirror and I'm like, "Oh, I'm a girl." But it didn't bother me. Some people might say I was willfully ignorant, but I think that helped me get through a lot of my education. When I started at MIT, someone said, "You're not an MIT type." But I never related that to gender, because I didn't visualize myself as a woman. I just didn't think about it. What's funny is that now that this gender thing is getting more attention, I have flashbacks of repressed memories of discriminations, harassment, and abuse. If I was not ignorant and more aware, I would have never gotten to where I am today. Because of this, I want to help build a world where we're more aware of the disadvantages women face and help change things as appropriate.

I've always looked for a female mentor, someone to emulate, but I never had one growing up. I think girls more than boys tend to look for female role models—someone who proves, okay, I can do it, I can get it, and I wonder how I get there. I try to do that for girls now. I get pleasure out of meeting young people and saying, "Yeah, you're already so much better than when I was your age." Which is almost always the case. Their potential is amazing. I just get such a kick out of it.

I think girls tend to look for mission-driven projects, some way of contributing to society. I always try to connect those dots for the young women I mentor.

My advice to young women is threefold.

First: Follow your passion. You can't follow just today's passion, it has to be something that feels like you could follow for at least five more years because you're just so, so passionate about it; you have to, you're going to lose sleep over it.

Second: Have a mission. Over time, your career shouldn't be just about your specific passion; you need to find a way to contribute to society.

Third: Failure is important. I used to be so scared of failing. I tried to be a perfectionist. I avoided anything I might fail at. What I now know is that when I look back, those failed moments were the ones that built me, that made me be stronger. Now I can always look back and laugh about them. I'll give you one interesting example. When I moved to the US from Japan and couldn't speak English, I learned everything from people's body language. During that time, I learned that it helped to come off as an airhead as a girl to be accepted and be liked. So I wanted people to think that I was an airhead as a way to be accepted in this foreign country. I used that persona all the way through college and into grad school.

My second year in grad school, I stayed through Thanksgiving weekend to work but was doing so in hiding because I didn't want people to know I worked hard. A professor surprised me in the lab one day. He actually pulled me to the side and he said, "You know that airhead thing that you do? It's really annoying, it's not working. If you want to go far in your life, you gotta lose that thing."

I felt so offended, I cried. I felt like I was at the wrong place with the wrong people. But in that moment of criticism and complete failure, something melted away. This really transformed me. It made me feel okay to try and to fail. Up until then I just couldn't. Those moments of incredible sadness are so useful. This failure made me realize it was okay to be me.

CHERISE VAN HOOSER

is a funeral director

I have been a licensed funeral director and embalmer in Oregon for a little over two years now, but I have been in the funeral industry going on five years. I started school back in 2013, not really having a clue what I was getting into. The more I learned in school, the more excited I became to join this industry. My first hands-on experience in this world was when I began my internship at a small family-owned funeral home. Helping families came so naturally to me—I knew I had made the right decision. I was fortunate enough to find another internship at another family-owned funeral home, where I had the opportunity to grow as a funeral director.

I grew up with a death-denying family, which started a spark of curiosity about the taboo of death for me. I did not attend my first funeral until

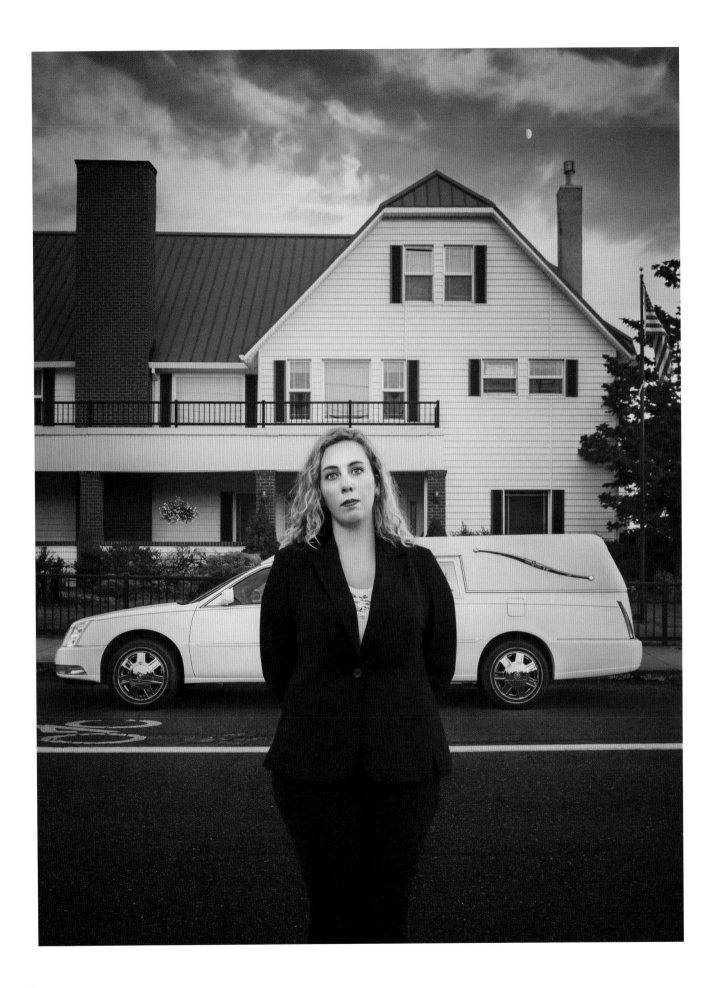

I was twenty years old, I had no idea what proper etiquette was for a funeral, and I just wanted to know about death—because everyone is going to experience it at some point in their life. Deciding to take a death and dying sociology course in college got the ball rolling for me. My professor at the time believed I would make a great funeral director. I thought she was crazy. When I had told my friends and sister about this crazy notion, a lot of them responded by saying, "That actually makes a lot of sense." Hearing that from my sister was important. My oldest sister is my biggest influence—and supporter—in becoming a funeral director. She believed that I could accomplish my goals and was incredibly supportive. I grew up admiring her—I watched her build her own business, grow in her career, and care for her family. It was amazing to witness how one person could do so much. My sister works harder than anyone I know, and I have learned a tremendous amount from her, but mainly I've learned from her that if you work hard enough and stay focused, all those sacrifices that you have made will pay off in the end.

So with her encouragement I did some research and thought: What is the worst that can happen? I enrolled in classes and began my journey.

I think funeral directing is a career that people don't often think about. That is why I think some people get into this industry after the death of a loved one, because most of us do not think of death until the moment you sit down and find yourself making arrangements for a loved one. There are funeral directors in every town, and while you may not personally know them or haven't had to use their services, they are there. Unfortunately, people do speak negatively about what I do. I have heard almost everything. While it has never bothered me, I always tell people that someone

has to do this job. I also remind them of the sacrifices that funeral directors make every day to serve their community. It is not an easy job, but someone needs to do it. There are so many moving pieces to coordinate a funeral, and therefore a lot of those moving pieces can easily change. A perfect day for me is simple: everything going according to plan. The funeral, the arrangements, the embalming all going smoothly.

There is a lot more to this job than meets the eye. Many people assume we just have meetings with families, answer phones, arrange flowers nicely around a casket. It is so much more than that. Being a funeral director is more than just a job to me, it is a calling. You can ask any funeral director, and they will probably tell you the same thing. In this profession you need to have passion for what you do because of the number of sacrifices we make.

I haven't had a moment yet in my career where I think, "I can't do this." It can be a difficult job that wears on you, there can be difficult cases, many sleepless nights, because you're always on the clock. But I always thought that if I was not doing this, I would be stuck in a cubicle working a corporate job. I know that isn't really for me. Honestly, I have always wanted to be a foster mom and start a dog rescue. I want to create a safe space for kids and animals to come together and heal. That has always been my dream, and it may still happen.

But I am not sure what is next. I have always aspired to educate people about the death industry. That and suicide prevention have always been my main passions. I have entertained the idea of going back to school for thanatology. At the moment, though, I am focused on my little community. I'm involved with the group Out of the Darkness, which is a charity walk that raises money for the American

Foundation for Suicide Prevention. I'm a member of a service club, too. But most of all, I hope that I can continue to learn and grow to be a better funeral director each day.

I would have a piece of advice for the next generation. It's something I wish I had learned much sooner in life. It is really simple, actually: be kind to yourself. It is easy to get sucked into a cloud of self-doubt and negativity, but do not ever doubt your abilities. You can truly accomplish whatever you want in life, but you can only do it if you are kind to and patient with yourself.

JULIE ENGILES

is a veterinary pathologist and professor

It has been fun participating in this project because as a veterinary pathologist and instructor I'm never on the other side of the camera. I'm always the one documenting and demonstrating. I'm never the one being documented.

As an academic veterinary pathologist, that's what we do: provide a clinical service that documents and bears witness to disease, as well as teach and advance the field through research. Oftentimes, we're doing everything simultaneously: performing a postmortem exam while instructing and managing the various people on the floor, making sure that the specimens go where they're supposed to, and paramount, ensuring that we answer the questions posed by our clients, whether they are hospital clinicians, referring veterinarians, law enforcement, animal producers, or individual owners. As a diagnostic pathologist, my job is to identify disease through the examination of animal tissues. These tissues can be submitted as smaller samples excised from a live animal (called a biopsy) or submitted as an entire dead animal (called an autopsy). Although our patients may no longer be alive, our business is still high stakes. Our mission is to ensure diseases are not missed and that we are able to safeguard against something that might not be visible with our naked eyes because it's microscopic, toxic, or metabolic.

Each animal receives a thorough and systematic exam performed in two stages. The first stage, known as the gross, or macroscopic, exam involves the initial dissection and evaluation using as many senses as we can: sight, touch, sound, and sometimes hearing. In my business, the sense of taste is not recommended (that's supposed to be a joke).

The movement, dissection, and processing of large deceased bodies such as cows and horses is inherently hazardous, requiring the use of dangerous equipment. Thus, each autopsy performed safely and expediently represents a large team effort including a highly trained technical staff working in conjunction with the pathologist. Add students or interested clinicians to the process and you've got a very carefully choreographed, albeit bizarre, ballet—some of which is exhibited in the photographs.

The second stage, the microscopic portion of the exam, is performed on ultrathin stained sections of tissues mounted on glass slides. These sections are processed from the various tissues harvested during the gross portion of the exam, and thus provide a literal "close-up" view of disease that can either confirm or refute our

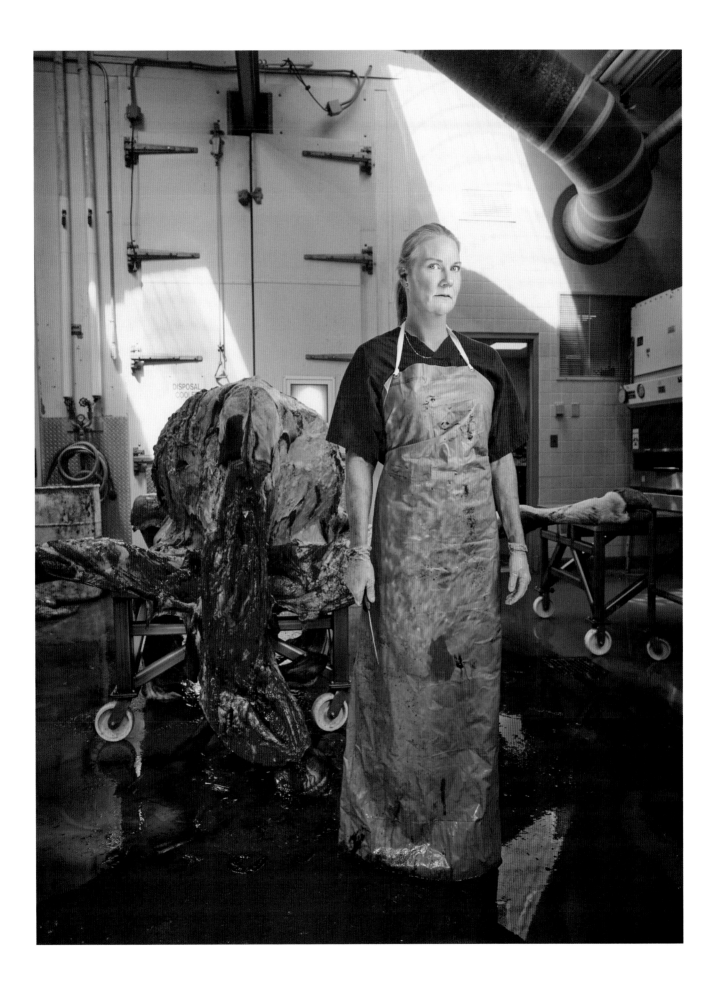

diagnostic suspicions from the initial dissection. The production of these slides is an art as well as a science, requiring very specialized skill sets and careful efforts by my technical staff. This stage of the exam may also include other "*CSI*-like" diagnostic tests that may be used to identify infectious or toxic agents. We use our training and experience, much of which is based on color and pattern recognition, to identify abnormal changes (called lesions) within the tissues. We ask ourselves critical questions, and proceed with diagnostics that provide answers that satisfy the questions posed by ourselves and our clients. For example, given an animal's medical history and its particular manifestation of symptoms, the gross or microscopic evidence that lies before us often represent a succinct list of plausible diagnoses, many of which are common natural diseases. However, we routinely collect a number of samples so if our initial hedge is wrong and the cause turns out to be some "weird flying zebra," then we have the samples to research and pursue it further.

Hollywood interpretations of CSI greatly oversimplify the forensics process, making a pathologist's job seem incredibly simple and straightforward. In reality, the process is complex, time consuming, and labor intensive, requiring the reconciliation of antemortem information reported from owners, producers, veterinarians, or government agencies with the evidence provided at autopsy, which may also include a number of microbiology or toxicology results. Depending on the tests selected, the final report that synthesizes all of these antemortem and postmortem data may take days to weeks to complete, requiring the input from numerous personnel representing multiple disciplines. Depending on the disease process itself (e.g., acute seizure or cardiac arrhythmias), the changes in tissues may be very subtle or inapparent, or sometimes the tissue changes are obscured by postmortem decomposition. Either scenario may leave the pathologist without a definitive cause of death, which is just as frustrating for the pathologist as it may be for the client. How-

ever, although we pathologists may not have all the answers, in most cases we are able to provide critical information that can help prevent disease, treat disease, or rule out a disease that might have devastating consequences to animal or human populations.

People frequently ask why I'd want such a disgusting job dealing with so much death. Pathology is definitely a "dirty job" that is not very glamorous and often very humbling. But to me, being the person whose job it is to definitively identify diseases suspected in the antemortem ("before-death") diagnosis, further investigate and understand disease, or even discover new diseases is more fulfilling than being the person who directly treats disease in the living animal. This job provides the opportunity to understand how organisms operate on the smallest level of the cell to the larger level of the global environment. You can see histories within the cells and tissues of these animals that maybe nobody knew prior to your identification. I find experiencing these different perspectives very Zen; you can step back from your microscope and see the forest for the trees, but also allow yourself to really focus on a single pine. There are a beauty, a mystery, and an intrigue in all aspects of it. You never stop learning. You're often in awe of what you discover and what that animal allows you to discover. It's a gift the animals give us, in that way, through their death. In addition to discovering, I also enjoy documenting the stories that underlie animal disease. As pathologists and scientists, these stories comprise compilations of carefully documented results from gross, microscopic, and ancillary tests. Using a combination of technical scientific language and digital photography, we logically organize, interpret, and categorize our findings in a way that (hopefully) accurately conveys the recent events and disease processes leading to the animal's demise. Sometimes the images taken in the postroom and at the microscope to photo document disease are quite beautiful and artistic in their own light. More important, the stories pathologists craft often provide answers to

important questions. These answers can provide emotional comfort to an owner on their animal's quality of life; with the answer that they did the right thing, or that no amount of money in the world could have healed this animal or made it feel any better.

The answers we provide can also have broader practical ramifications. If you're dealing with a disease outbreak in a herd, a farmer needs you to figure out what's going on, not only for the sake of ensuring a safe food or on-farm efficiency, but also for the health and well-being of the animals. In conjunction with other veterinarians, pathologists can advise on cleanliness and hygiene called biosecurity—as well as preventative measures such as vaccination, nutritional, or environmental management. We can often determine between a problem that may be a red herring or a problem that really seems to be recurrent or systemic and provide answers to properly treat and hopefully prevent that disease in the future.

In addition, as veterinarians we're linked to global human and animal health systems, and often networked together through municipal, state, and federal government agencies. For people who don't like "big government," I can empathize, but it does have some benefits, disease surveillance being one of critical importance. When funding is cut in the areas of health professions and science, it has a profound effect on local, regional, and global health.

You might think, "USDA, that's for cows. I don't have cows. Why should I care about the USDA?" Well, the USDA looks for diseases that not only affect the cow's health but also diseases that could also infect humans or diseases that impact the agricultural industry and trade, any of which could impact food safety or security, which has a direct impact on the economy and our overall well-being.

For example, in 2001 the UK experienced an outbreak of foot-and-mouth disease (FMD) that ultimately cost the nation more than a billion dollars and decimated their rural economy. While FMD is generally not outright fatal for animals, the pain associated with the lesions it causes reduces their willingness to eat and ambulate; in cattle, this can dramatically reduce milk production and growth rates. The highly contagious nature of the virus makes it very difficult to control and eradicate, requiring extensive quarantine measures with imposed restrictions on export markets, and slaughter of infected animals to prevent further spread of the disease.

Another example where the USDA plays a critical role involves zoonotic diseases, meaning diseases that can be passed from animals to humans, which are now estimated to be more than 60 percent of all infectious diseases and 75 percent of emerging infectious diseases infecting people. The USDA also helps veterinarians and pathologists diagnose food- or vector- (e.g., mosquito-) borne illnesses in animals to prevent disease in humans. Although veterinarians have always practiced medicine in the context of "one health," this concept is now embraced by agencies such as the CDC and international human health networks. I think one health really speaks to the interconnectedness of the planet, from human and animal populations to local and global environments to local and global economies. I love that my job enables me to give people a broader understanding about how we're all linked together. It goes beyond just self-fulfillment. As a veterinary pathologist, there's an aspect of service to it, where you can really make a difference in people's as well as animals' lives.

In addition, this job has really helped me appreciate and reimagine the food I eat. I totally understand why people are vegetarians or vegans, but gosh, it's become such a gray area for me. Although I used to be a vegetarian, now converted to an omnivore, I think of eating animals in the framework of the larger global ecosystem. I like the idea of supporting local sustainable agriculture, which ideally should include good antimicrobial stewardship balanced with the promotion of animal health and welfare. However, these balances can be tricky, especially considering that in Pennsylvania, agriculture remains the largest

industry in the state, representing livelihoods that go way beyond hobby farming. The principles and goals of sustainable agriculture are admirable and necessary for the future, but in practice they involve very complex processes. Therefore it's imperative that policies be created taking into account all stakeholders: producers, consumers, the animals, and the environment.

My story as to why and how I became a veterinary pathologist is a bit long and convoluted.

When I was a kid, I loved animals—I loved them to death (well, not literally). I wanted to be a farmer, an actual farmer, and people told me, "You know, you should be a veterinarian." I remember saying, "No, I don't like sick animals." I couldn't stand the sight of blood, and I abhorred suffering. I was petrified of injury, hurt, and disease. As a four- to eight-year-old kid, I said I would never become a veterinarian. Not to mention as a middle schooler I was really bad at math and science. I started thinking about law until I had a really good math teacher and a really good high school friend who were both extremely patient and believed in me. The friend sat me down and taught me the beauty of mathematics and science; they showed me that math is a language just like French or English. That was a paradigm shift and was the beginning of my winding path down the road of my scientific training and eventual career in medicine.

I began a major in astrophysics in college. I certainly liked and was more comfortable with math by then, but I thought I wasn't as proficient as I felt the field required. I was the only female in my honors physics class, and I felt inadequate, like physics wasn't my natural talent. However, when I took a biology class as part of the science major, I fell in love with it and began the discovery of my natural interests and talents. With the patient mentorship of another wonderful professor, I developed a personalized biophysics major at my university.

From there I wormed my way into a medical scholars' program that was for premed students soon to be

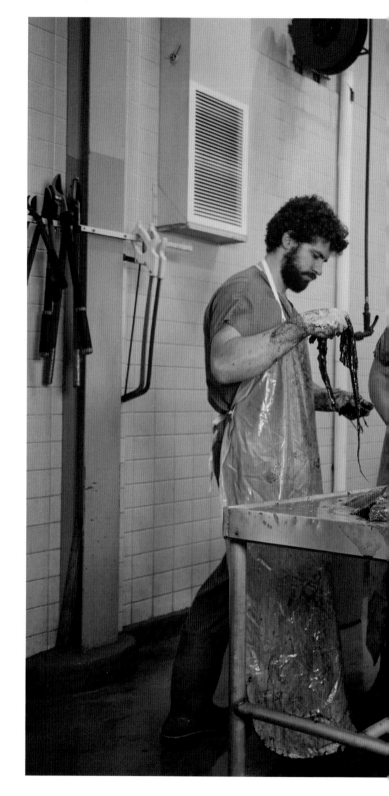

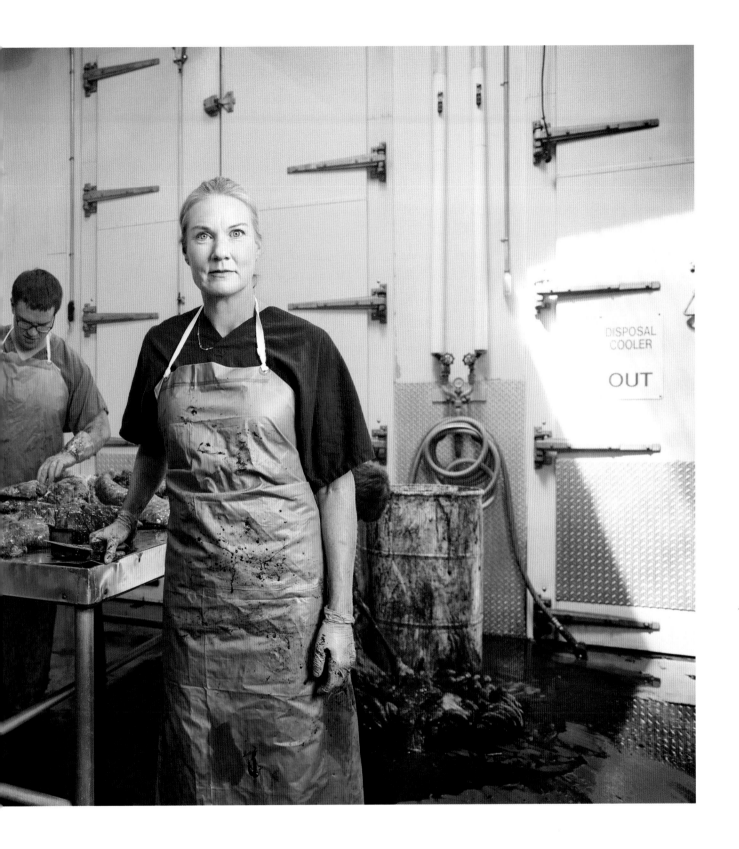

matriculated into a local medical school. It was in a problem-based learning course in physiology where I fell in love with medicine. Because an injury during my senior year prevented me from having the time to study for the med school entrance exams while completing my courses and volunteering in a laboratory, I ended up in an entry-level job at a cancer research center responsible for one laboratory's mouse colonies. One strain of mice started dying at an early age, which wasn't expected as part of our experimentation. I started performing my own postmortems on these mice and then actually doing my own histology to look at their organs under the microscope. This was my introduction to pathology. There was a comparative biology aspect that I fell in love with, and that's when the light bulb went off and I realized there were these people who practiced medicine on animals called veterinarians! That's how I ended up at Penn Vet for my VMD.

Another example of my winding path is that after veterinary school, I thought I wanted to be an equine orthopedic surgeon. However, in my surgery internship I realized I was more interested in the "why" disease happens than the "how" we treat disease. After considering residencies in anesthesia or equine ambulatory medicine, I happily ended up in my anatomic pathology residency (back at Penn) and ultimately in my current faculty position as a veterinary pathologist—happily ever after.

My winding path helped me realize that it's okay if you are not the type of person who fits into the mold or is a long-term goal setter. It's okay to take the time to figure out the path that best suits your soul. I think when it comes down to a career, you need to find something that reflects who you are deep inside, the core of you—something that makes you feel like when you were a kid, those times you were completely carefree and chasing sensations full of joy. It may never feel exactly like that, but listening to and respecting that inner voice, and finding the things that find you

joy, can nudge you toward a career that provides long-lasting satisfaction.

Don't be afraid to change your direction if you realize something isn't the right fit for you, no matter what you've invested beforehand or what others' expectations are for you. Don't be afraid to show vulnerability with others, and do use others for help and guidance. If they're good people, you'll want those good people helping you (and sometimes carrying or dragging you) along your path. There will always be obstacles, but if you follow your inner nudges, you should be all right.

It seems hard for kids these days. There are so many expectations. There are so many people saying, "If you want to do this, you better be studying Mozart at age four, and you better be in all these extracurricular activities because these colleges want to see well-rounded students." You're trying to be this ideal superstar, and you're spread so thin. It seems kids today don't have time to be kids. I see it in vet students who are so in their heads about what people think and what grades they think they need equating the letter grade of B with failure as a student and failure as a human being. It seems that they haven't been allowed to fail in small ways throughout their lives. As young adults, they won't allow themselves to fail even just a bit, because they're driven by a strong fear-driven need to achieve. As a teacher it is almost devastating to see. For failure is an integral part of learning, especially in science. Who is perfect? No one. Some students want to give up at the slightest bit of inadequacy. Perhaps I did the same thing, faced with my insecurities with college physics. But since then, through experiencing my own failures I've learned you have to shake it off, laugh it off, and know deep down that you're a decent human being, you're doing the best you can, and although sometimes you're going to screw up and feel inadequate, most of the time you're not and you're doing just fine.

The field of medicine can be very gray and nuanced. A lot of problems or questions have more than one answer, which may or may not be black or white. As a clinician and scientist, you have to learn to be comfortable with that gray, and if you're not, keep searching until you find an answer. It may not be the most absolutely correct answer, but if it's in the ballpark, it's at least a start and not necessarily wrong. It's why we perform research and why there is the "re" in "research," meaning we really do learn from mistakes. As a scientist, you have to be able to put yourself into a situation where you can make little mistakes and be okay with it. Generally, if you're being careful, you won't make an enormous mistake. As medical professionals we need to prevent or avoid mistakes that result in more harm to our patients. But the field will not advance without asking hard questions and making calculated risks to explore the unknown. I don't think students are often taught that, especially when internet answers are so readily available at their fingertips. When curriculums solely focus on standardized testing, education becomes confining. You're selecting for good hoop jumpers. Although the profession may need some good hoop jumpers, the profession also needs critical thinkers, students who can take the hoop, pop it over their head, and go through it in a way that shifts the paradigm or provides a novel perspective.

I don't know what's next for me. I've demonstrated through my personal winding path how I'm not a great long-term planner. I've always found my path through life by taking a step forward and sticking my toe out and going "That ground feels secure, I'll walk onto that" or "Oh, that feels like it's crumbling, let's go this direction instead." I've always seemed to feel my way across this planet, and thankfully, wonderful opportunities seem to present themselves in ways I wouldn't expect. However, I have absolutely no expectations for what's to come. For some reason, I find that comforting.

HILARY HANSEN

rescues and transports wild mustangs

I started working with mustangs after I saw the documentary *Wild Horse, Wild Ride*, and then I met one of my biggest mustang influencers, Willow Williams. I knew once I watched the film, I had to gentle a mustang—and that's where it all started. Willow and Wylene Wilson-Davis were my biggest influences in deciding to work with wild mustangs. I've learned from them that you need patience. There's no such thing as a timeline. You need to match their energy and bring in softness. I've had horses in my life since I was a toddler, because of my first babysitter, Wendy Hendrickson, and I couldn't imagine it any other way. We still continue to ride, rescue horses, and raise money to help those we've saved. Her passion and devotion have taught me how to love, learn, and do my best to teach my horses and, when training horses, to be safe. Being around horses since early childhood was probably the biggest positive influence I, or any young girl, could have had. Each equestrian strives to be a better rider, horsewoman, and partner. It has been a wonderful thing to focus on and helped me learn many lessons throughout childhood and into my adulthood.

When people speak negatively about the rescue and transport of wild mustangs, I explain that without the TIP [trainer incentive program] or without people who gentle and adopt mustangs, there would be a lot of mustangs sitting in the holding pens. They are incredible animals capable of anything a domestic horse is capable of. A perfect day for me is waking up, feeding the horses, loading up the trailer, grabbing some ponies in training, and adventuring into the mountains for the day. Then returning back to the ranch to finish up chores.

Even if I wasn't transporting and training, I think I would and will always be involved with horses. If I wasn't transporting them, I would probably be gentling mustangs full-time. Or doing something else in the horse world. That's what makes my heart sing.

I have met some amazing people throughout my years of transporting horses, and who knows where that can lead? My goal would be to ride and train more mustangs up in the mountains.

To young women interested in working with wild animals: Remain patient with all things, hug a pony often, live each day to the fullest. And eat whatever you want.

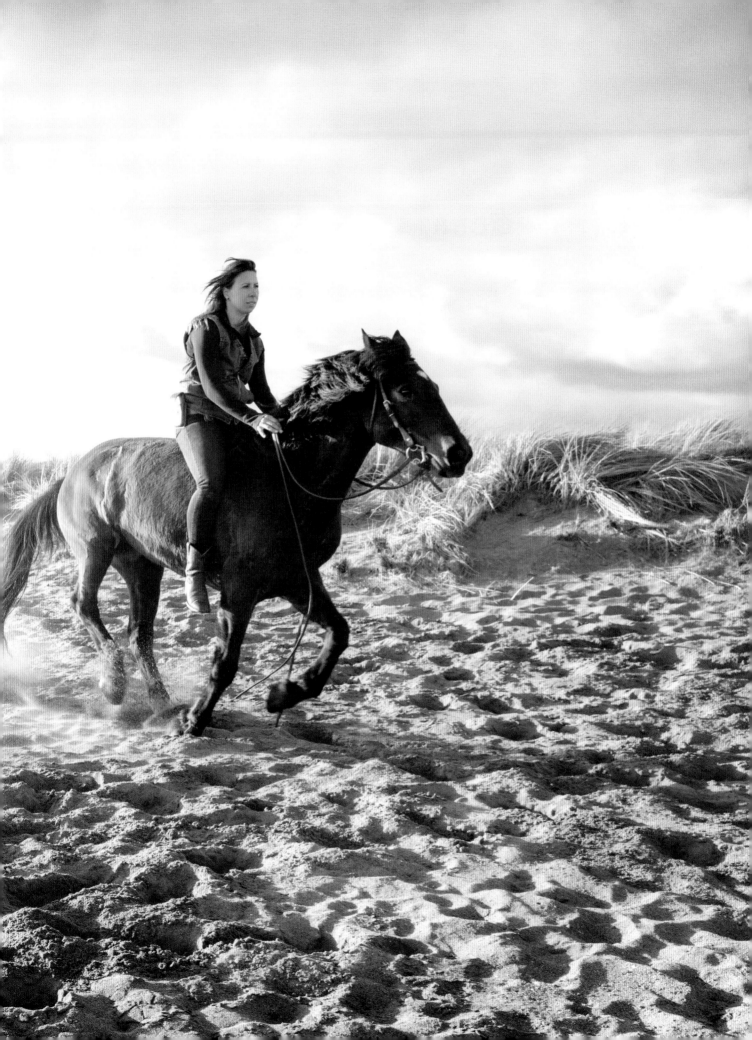

DOROTHY ROBERTS

is a scholar on the topics of race, gender, and law

My becoming a teacher really goes back to my child-hood. My father was an anthropology professor at Roosevelt University in Chicago; my mother was work-ing on her PhD in anthropology and had planned to also be an anthropology professor when I was born. She gave up her pursuit of a PhD and a career as a professor to become a mother. She always told me, "You're my PhD." In other words, "You are going to follow the path I gave up for you."

Because of my parents, I was interested in anthro-pology from a very, very young age. I went to Yale College and majored in anthropology and was en route to doing that. I spent my junior year abroad in Colombia, wrote all these great anthropology papers, and went on to do research in Mexico. I was very com-mitted to that path. But then in my senior year of col-

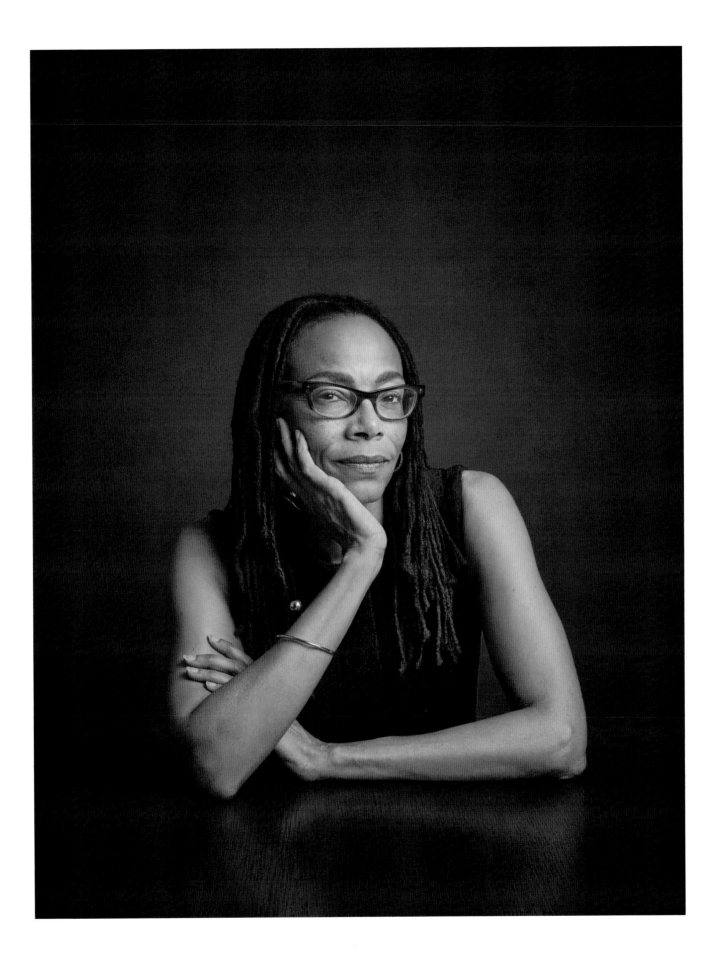

lege, I just felt that I wanted to do something more in terms of social justice advocacy; I was always interested in politics and social justice, even as a young girl. I grew up in Hyde Park in Chicago in the 1960s, where there was a lot of civil rights and antiwar activity in the neighborhood. Many of my teachers were vocal about their activism, and I used to go to civil rights meetings.

So despite the anthropology track, I ended up going to law school and practicing law for a while, but soon realized what I really wanted to do was advocacy through research and writing. While I was working at a law firm, I had three children, one after another. It made sense to transition into academia when they were all out of diapers. Having my children and reading about reproductive injustices in the newspaper made me interested in reproductive rights issues—not just the issues of abortion but the regulation of pregnant women's conduct during pregnancy. The first case that got me really incensed about policy regulating pregnant women involved a woman who was dying from lung cancer—her doctors wanted her to have a cesarean section so they could make sure that the fetus would have a chance of survival in case she died too soon. She refused to give consent, and they got a judge to order a forced cesarean section on her. The surgery killed her, and the fetus did not survive. Her only wish in life, which she knew was going to be cut short by cancer, was to give birth to this baby, and instead a judge's order that the fetus was more important than her autonomy or even her life allowed a surgery that killed her. I was just so moved and disturbed by that case.

I eventually took a position as associate professor at Rutgers Law School in Newark, New Jersey, and immediately began researching the history behind prosecuting women for drug use during pregnancy. This was at the height of the so-called crack epidemic, and most of the women being prosecuted were black women who had smoked crack cocaine while pregnant. And so my very first research project was documenting the racial discrimination in these prosecutions and arguing that these women were being punished for having babies, not for drug use. In other words, a public health problem of drug use during pregnancy was being criminalized because of a long history of devaluing black mothers. That article was published by *Harvard Law Review*, which was a prestigious journal that rarely published work on such topics. That article really put me into a spotlight as an expert on this issue and was the foundation for my first book, *Killing the Black Body: Race, Reproduction, and the Meaning of Liberty*. The research for the book, and the book itself, happened to coincide with the beginnings of what became called the reproductive justice movement, which was led by black women and other women of color to change the focus on individual choice to focus more on social justice and a wider range of social conditions and aspects of people's lives that are involved in reproductive freedom and well-being. I became very involved with this movement. And my book became a sort of foundational text for it. This topic continues to be a very important aspect of my research, teaching, and advocacy, my social and academic relationships, and my advocacy relationships with others who are working for reproductive justice.

When I started writing about this topic in the late 1980s, reproductive rights was synonymous with abortion rights. Today, with more prosecutions continuing and states beginning to pass fetal protection laws, it's very clear that this is part of a move to control pregnant women. For example, if *Roe v. Wade* were overturned, access to abortion could be banned from the beginning of pregnancy. But that would also mean that states could punish women for being pregnant and engaging in conduct that prosecutors and leg-

islators deem risky for a fetus. It's not a leap to think this when prosecutors have already brought charges and gotten convictions and prison terms for women who have stillbirths. These are women who wanted to have their babies and the babies don't survive. When I've warned that women could be prosecuted for miscarriages, the right-to-life people came out and said, "No, women would never be arrested for that, that's completely different." Well, why not? Some have already been prosecuted for stillbirths. What I and other advocates were saying in the late 1980s, early 1990s, was that we have to see these assaults on pregnant women as part of a unified way of controlling women and punishing them for alleged risks to a fetus, whether they want to have their babies or they don't want to.

Another reproductive justice issue is the influx of children removed from their families and placed in foster care. America is finally realizing that it traumatizes children to take them away from their parents. But this is something that the US child welfare system has been doing for centuries, actually, though the major boom began in the 1960s. I've been doing work in this field as well since about 2000, especially looking at race. I've come to understand that a big part of the reason why black children are more likely to be removed from their homes for alleged child maltreatment is the widespread belief that black children don't have close ties with their parents. Government authorities devalue the bonds between black parents and their children. This is a general assumption that I've seen pervade conferences, case files, statements by reporters and social workers and even administrators: black children are better off away from their parents, their families, and their communities. And so even if they acknowledge that foster care can inflict harm on children, they think that harm is less than they'd endure at home, based on an as-

sumption that the home has nothing to offer them in the first place.

So race has really affected the way in which child welfare decisions and policies are made. Because when most children in the US child welfare system were white—black children were actually excluded from the formal child welfare system before the civil rights movement—most of the resources went to supporting children in their homes. After more and more black children came into the system, the system switched to foster care as its primary service. So while white children were receiving funding and resources while living at home, the main service that black children were offered was being taken from their parents and put in foster care.

My latest book is about genetics and race. In my mind, all of my work has been about how false concepts of humanity, especially about innate human differences, have supported unjust policies. And I'm very concerned now about how the false belief that human beings are naturally divided into races—using genetic and other scientific justifications—has supported continued unjust policies in the United States and around the world. I see the prosecutions of black women for using drugs during pregnancy in the early 1990s connected to the false belief that biological differences between human beings produce social inequality, produce their privileged or disadvantaged status. This is absolutely related to the idea that black women transfer a disadvantaged status to their children and therefore should be controlled. That idea, in turn, is very much related to the belief that black people are biologically distinct from other people and innately predisposed to deviant behavior and therefore should be controlled.

There are many instances of the government spending billions and billions of dollars on punitive measures to penalize and control people; if that

money were spent to support families, we would have a healthier society, a more just society, and a more equal society. But we're living in a society where more and more money is spent on incarceration, surveillance, disruption, control, and less and less is spent supporting people and meeting human needs. We know that if we built a society that valued human beings equally and distributed resources equally, everyone would be better off. Everyone would be healthier.

My research has taught me that racism is a powerful way of making people support policies that are diametrically opposed not only to human rights but also to their own interests. I dedicate my work to shining a light on those false concepts and the injustices they support, with the goal of enacting social change.

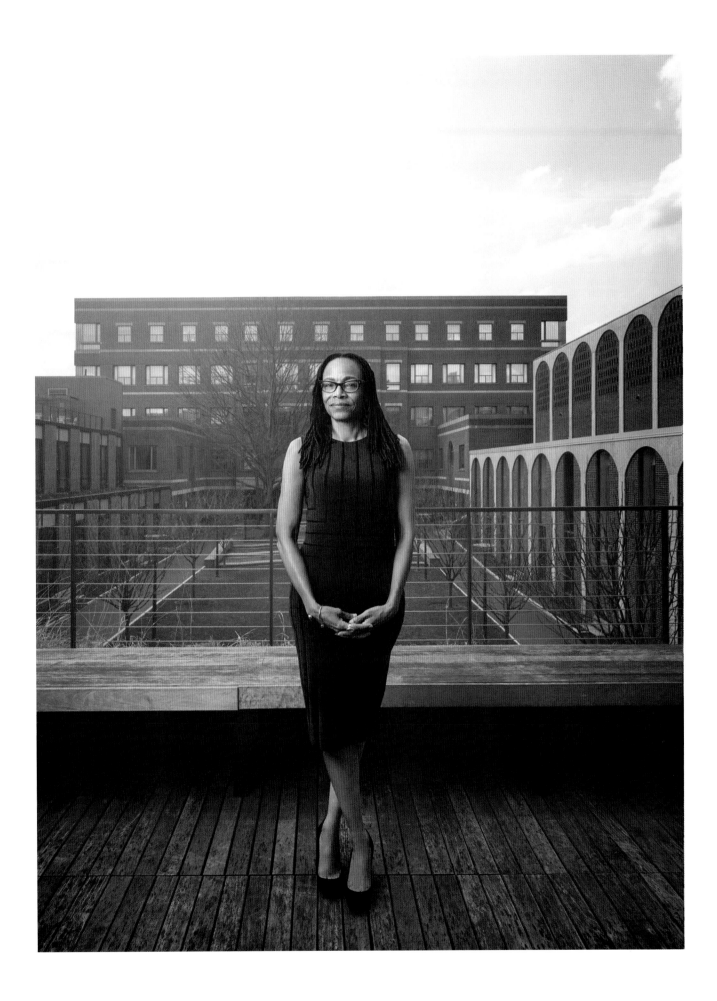

CHRISTY WILHELMI

is a beekeeper and urban gardener

I started gardening when I became a vegetarian in 1993. The more I learned about our food system, the more I wanted to take control of it and know what I was eating. I became interested in beekeeping from a gardener's perspective, because bees, of course, are very important to our food supply. When I started researching how to keep bees, I began to realize it's kind of like parenthood: you never really feel ready. But one day a colony of bees showed up in my community garden down the street, so I got a swarm box and, with the help of my mentors, rescued them and brought them home with me. Now I've been keeping bees for years. The benefits are more produce and, of course, the honey.

My bee mentors are a group of people from an organization called HoneyLove—Rob and Chelsea McFarland, the founders, now friends of mine—and I began working with a mentor named Ceebs Bailey. We're all very into gardening, chicken keeping, beekeeping—so we all dabble in homesteading together and we help each other out. Ceebs has taught me everything there is to know about bee anatomy, habitat, habits, and the way bees live as one organism. And if something ever goes wrong with my colony, HoneyLove is there to help. It's an organization geared toward urban beekeeping, encouraging people to address their fears by learning more about what bees like and need.

Often when I travel, I'll write down my occupation, on custom notices, as gardener. When I've gone to places like Mexico, the customs officers would look at me funny because where they're from, only men are gardeners. It has been unusual to experience that, because most people associate gardening with women or retired people. Well, I'm not retired. But it's true in beekeeping, too: the experts are very often men. But that's why I love HoneyLove and Ceebs—they offer a female influence. Someone like Chelsea McFarland, one of the cofounders, who is actually allergic to bee stings (oh, the irony), is admirably doing what she does despite her allergy because it's just that important to her to save the bees. I've been participating in more rescues lately, especially during swarm season. I'm always trying to find new homes for these rescues, trying to get more people interested in beekeeping.

I'll get a call or a note on Facebook from someone who has discovered a ball of bees hanging from a tree in their yard. I gather my equipment—bee suit, swarm box, gloves—and go transfer the bees into the box. You basically knock the tree branch while holding the box under the swarm, and they drop right in. Usually I go around sunset because if the queen is inside the box, all the bees will think that's home and will head inside as the sun goes down. Then I'll tape up the box and bring them to someone who is ready for bees. We'll dump the bees into an awaiting beehive during daylight hours, and they will orient themselves to their new location and decide whether or not to stay. If they like their new home, they'll start building honeycomb and the queen will lay her eggs.

I inspect my hive once per month to make sure everyone is happy and to ensure there are no diseases or pest infestations. Beekeepers use a smoker to calm the bees before opening up the hive. The smoke masks the pheromones that alert the bees to an inva-

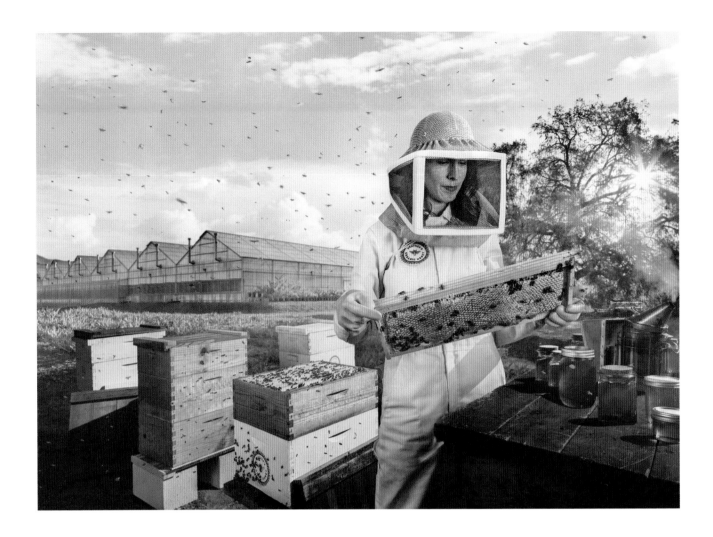

sion. My husband and I harvest honey once per year at the end of summer. We use it for sweetener and gifts and to barter for things I'm not growing in my garden.

Beekeeping is part of my goal of self-reliance. There's this unpredictable force called climate change that has made everything challenging. Where I live, our water comes from nearly 500 miles away and most produce sometimes comes from 1,500 miles away. Because of that, it's good to be as self-reliant as possible. So part of what I do is teach others to be self-reliant through gardening classes. Sustainable gardening helps facilitate beneficial habitats, food, and nectar for bees. Before I was beekeeping and gardening, I was a theater and dance person—a professional dancer for years before an injury took me out of that world—but now I want my own gardening

show that helps teach everyone about self-reliance and resilience. I also write gardening books. And I've written a novel that is, of course, centered in a community garden. It's based on gardening here in Los Angeles, where our growing calendar is completely different than everywhere else. So it's a gardening lesson told through story.

When it comes to gardening, I usually tell people: Fail big. Don't be afraid to fail—that's how you learn. And as a female business owner, my business card says "The Chick in Charge," and that's my title, The Chick in Charge. Someone suggested to change that because it's not very professional. No, that title will be on every business card I'll ever have. I wear a Wonder Woman pin on the side of my gardening hat because she is, like me, definitely in charge. It pays to assert yourself in what you're doing for a living.

SAM WHITE

is a theater director based in Detroit, Michigan

I have been an artistic director for six years now. I've been curating and producing my entire life, so theater directing wasn't completely foreign to me. I had seen a lot of great theater and knew what I liked; I used that as a catalyst to direct my own work within my own company. I am not a huge fan of preproduction and planning. I am good at those things. But I live for the days the audience shows up and they see the show we have been working on for months or a year and they laugh or cry or shout or complain or rejoice. It's all good. They are there with us, feeling something, thinking something, and doing something together as a community, as residents of Detroit and the world, from different backgrounds, races, ages, socioeconomic circumstances. It doesn't get better than show day.

I was a performer and journalist before I started Shakespeare in Detroit. I started directing out of necessity, as I wanted to start a theater company but I didn't really know anyone else who wanted to come direct for a theater company that didn't have a legacy. So I just did it myself.

I first decided I wanted to start a theater company and try on the artistic director hat after a visit to the Utah Shakespeare Festival in 2008. Seeing their beautiful work in the desert made me want to produce and direct theater in Detroit. I thought, if they can do this in Cedar City, Utah, I can do it in Detroit. And I did—but not officially until five years after making that decision. We've come a long way! We are getting a beautiful new building at Shakespeare in Detroit—the former Stone Soap Building on Detroit's riverfront. I'll be planning our grand opening for 2020 and programming the new venue. I am going to take the next year or so to figure out the right shows to live in that space with the right people. I'm excited. I am working toward making sure that it is an inspirational space for more women and people of color—for everybody to come play!

One of my biggest influences in becoming a theater director is Ava DuVernay. I love Ava DuVernay. She came from a communications background as I did and became a director—a film director, but a director nonetheless. I find her multipassionate life aspirational. I also look up to Antoni Cimolino, the artistic director at the Stratford Festival. His work is the epitome of everything that makes classical work classic. I love dramatic work that looks dramatic with costumes and big sets, but also with language that feels good to say and hear. Antoni's work allows each word, phrase, and rhythm of the iambic pentameter to fall off the tongue and delight your

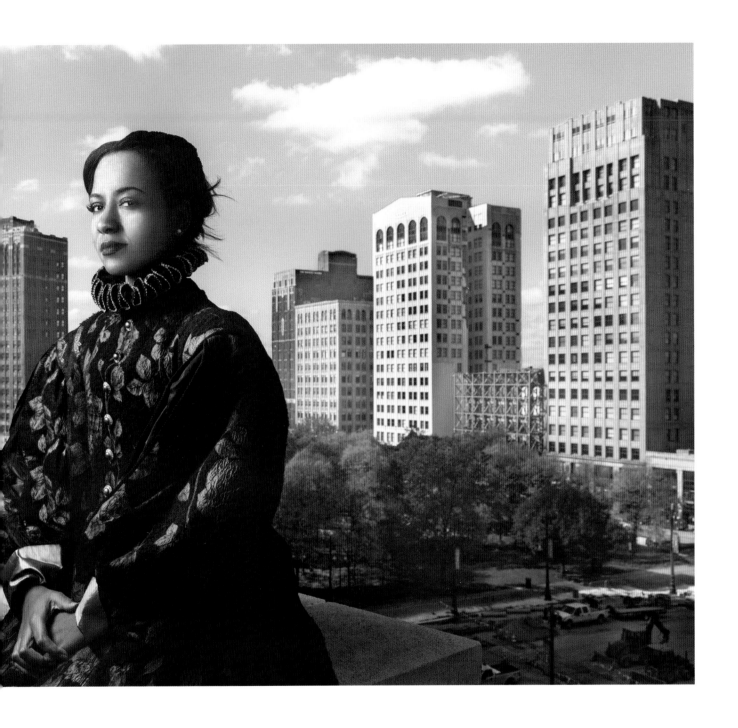

ears. He makes the words accessible and real for those who love it like me and for those hearing it for the first time. I admire that deeply. Hana Sharif at Baltimore Center Stage is also an amazing director. Elisa Bocanegra, the artistic director at Hero Theatre in Los Angeles, is one of my heroes. I am influenced by a lot of wonderful artists, some I know and others that I hope to meet one day.

There are a lot of women directing great theater. However, there are a lot of inequities in pay, visibility, and opportunity—especially for women of color. It really sucks, but I try not to let that be my focus and I am creating a theater organization that will uplift and enrich the artistic lives for women, hopefully, from all over the world. So when someone has something negative to say about me, I tend to not care too much. I'm a bit too busy to be concerned about things that aren't real, namely people's opinions who don't know me. I have to focus on what's real, like the people we impact positively in Detroit and our brand-new building coming to the city, which will empower us to take our work even further.

I can't imagine not doing what I do. I was a stand-up comedian before I started Shakespeare in Detroit. I guess I would've tried to see how far I could take that.

But my advice for young women who want to get into my line of work is to know that things do not happen quickly. Social media has created this false expectation of instant gratification or easy access. It's not real. If you have a dream, chances are it won't happen overnight—not in a few months or even a few years—and please don't expect it to.

Women are life givers, and I don't mean by way of childbirth; I am talking about the way we authentically bring our life force to all of the industries we touch through compassion and endless dedication to be great at what we do while leaving the door open for the women coming after us. It's important to shine light on the way we uplift each other and ourselves in whatever our fields might be.

Consistency and smart work with a few big fails in between will bring success. And if you are practicing self-care to make sure that your physical, mental, and spiritual health are up for the challenge, the time will fly and you'll enjoy the journey. Take it from me, as I had to learn this the hard way. You are your biggest resource, and if you aren't doing well, your career will not thrive. Oh, and don't compare yourself to anyone else. As Shakespeare said, "But O, how bitter a thing it is to look into happiness through another man's eyes."

Focus on you.

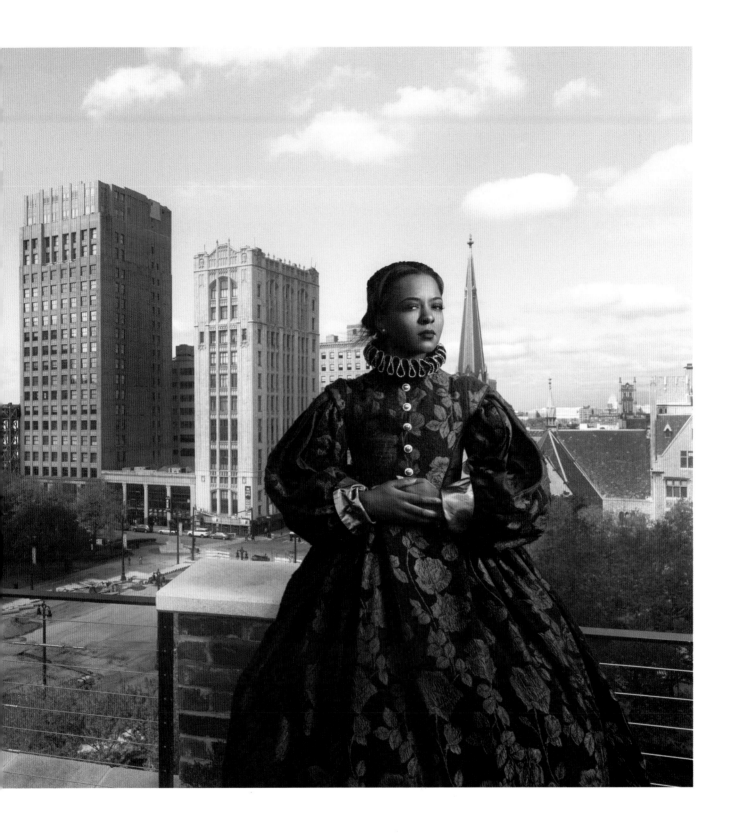

LESLIE MAH

is a paralegal turned coffee roaster

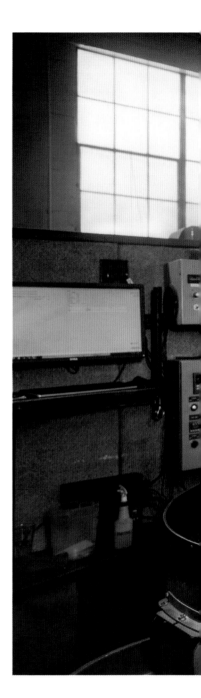

I am a first-generation Korean American woman and I am a coffee roaster—this is not a common combination. Growing up in a single-parent immigrant household meant that there was pressure to conform to a particular idea of success, which was to pursue higher education and a career as a doctor, lawyer, or engineer. So throughout university, I set myself on the path to becoming a lawyer, but my heart was not in it. I kept coming back to something I was truly passionate about, which was my love of tasting and being part of a process where I could provide and share a sense of joy and wonderment about what people were tasting. I dreamed of attending culinary school after graduation. I wanted to go further in expanding my palate and understanding the world of food and beverage. But I thought of my mother and how hard she had worked to provide me the opportunity to attend university—

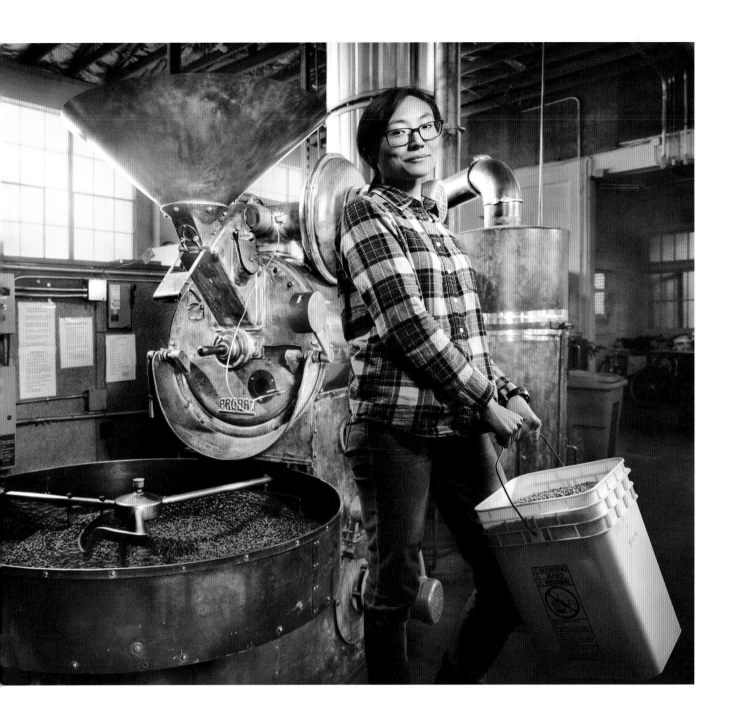

I did not want to disappoint her. After I graduated, I tabled my culinary school dream and continued my path to pursue a career in law. However, after working as a paralegal and spending time to reflect with better self-awareness, I returned to the conclusion that I really did not want to become a lawyer; I wanted to pursue a career which I was passionate about and I kept on coming back to coffee.

In 2014, I quit my job as a paralegal and took a leap of faith: I applied to be a barista at my favorite coffee shop. I started my journey learning the basics, from brewing coffee to learning how to best serve customers and, most important, how to connect with folks and share the story of the coffee beans in their morning brew. With each conversation about coffee and its journey from farm to cup, I realized I wanted to learn more and go deeper into the world of coffee, but I was not quite sure where to start.

Then an opportunity popped up to join the roasting team. It seemed to be the logical next step in trying to understand how to get that beautiful cup of coffee. Initially I wasn't sure if I was going to be qualified, but I figured I should apply anyway. I got the job. I remember jumping up and down in the street when I got the phone call. It was one of the best days of my life. My first day of roasting was a stomach-tickling combination of being excited about learning to roast but also feeling anxious about making a mistake. I have since learned that in roasting it is often through mistakes that you can learn the most.

Roasting feels like a ritual with its own rhythm. I start up and warm the machine, pick my music to jam out to for the day, and check my roast lineup of what lucky coffees get to be toasted up. Next, I head into the green coffee room and bucket out my green coffee batches. Once the machine is warmed up, I set myself up to begin the real work. The first batch of coffee is pitched into the *hopper*—a mass of green coffee beans waiting to be dropped into the roasting drum. I check the roasting program is ready to go

before I slide open the hopper to let the beans cascade loudly into the metal drum. Then it is a waiting game as I monitor the temperature of the roast on the roasting monitor and intermittently check the *trier* for the bean color, size, and aroma. Once the roast approaches the temperature for *first crack*, I lift up a metal exhaust flap and begin to listen more carefully to the beans in the machine. Once I hear the distinctive series of pops indicating the beans are going through first crack, I am in a flurry of motion readying to let the coffee beans out of the machine. The final stage is the trickiest time. It is when the roasting process feels like a tenuous balance between art and science. Pulling the trier out multiple times to again assess the color, size, and aroma of the beans while checking the roast temperature, I am attempting to determine the right time to end the roast. It is the most volatile point of the roast for both myself and the coffee beans because it is also during this stage that coffees can often show off their unique personalities and do unexpected things. At this point, I am a loaded spring ready to release the coffee from the roaster like a caramel waterfall into the *cooling tray*. A roast complete and a moment of triumph.

As a roaster I see myself as a steward of the coffee bean and the farmers who produce that coffee. My mission is to allow the roast of a coffee to express itself in the best way possible and do justice to what the farmer and nature has already provided. Roasting coffee in the day-to-day, this mission and job feels straightforward and certainly not related in any way to my gender. However, coffee is a male-dominated industry across the board and particularly so within the roasting profession. While the industry tries to welcome and encourage diversity, I have experienced being ignored and my contributions dismissed because I am a woman. Being a woman coffee roaster has also been an interesting experience because roasting requires physical and mechanical work and society tends to correlate gender with those two things. I am often ques-

tioned about how I manage being a female roaster in terms of my ability to lift or fix things. I usually respond by questioning the premise that my gender affects my abilities to do my work. Because in reality my gender is not a factor in my ability to lift heavy buckets, operate a forklift, fix a machine, or roast coffee. It can all feel aggravating and discouraging at times but I remain grounded by remembering my mission as a roaster and recalling the simple joy of roasting.

To any person who wants to become a coffee roaster, or rather become anything they desire, I would say give yourself a moment to reflect and determine your passion, curiosity, and willingness to dig deep in your pursuit. These will serve as your fuel to propel you forward through the inevitable ups and downs of your path.

Coffee is one of the things that I have enjoyed almost every single day of my adult life. In roasting, brewing, tasting, and enjoying coffee, I am able to find moments of reflection that give me pause and joy in the bustle of my day. I hope to share that with the world bean by bean.

MEENA VOHRA

works in pediatric critical care

I am a pediatric critical care physician and the medical director of UMC Children's Hospital in Las Vegas. I have always liked working with kids. If I wasn't a physician, I'd probably find another field in which I could interact with children. But when I finished medical school, I knew I wanted to work in pediatrics. I did my medical school training back in India before coming to the United States. Thirty years ago in India, there was no specialization in this field. When I came to America, I did my residency at Children's Hospital of Michigan. When I did my rotation in the ICU, I just absolutely loved it. It was a very aggressive field, and it was a perfect fit for my personality. You stayed up all night managing very sick children, and by the morning you realized that you'd saved someone's life. I absolutely loved that. I don't think I'm cut out to be an office doctor. During my rotations, even when I was

not supposed to be in the ICU—and I was doing my psychiatry rotation or my clinic work—I always found time to go back to the ICU. Even if I wasn't needed, I would just watch the others do their jobs. You could say I'm an adrenaline junkie.

My father was an army officer in the British Army and then the Indian Army. He had no sons, and he raised my sister and me to be independent. I always wanted to join the army because I liked the lifestyle. But in India in those days, women were not allowed to join the army. The only way you could get into the army was as a physician, so I went to medical school. I didn't stay in India; so much for joining the army. But I started my career in medicine by trying a roundabout way of doing something that was not possible for women in India at the time.

In the last five or ten years I have seen more and more women in this field. In my ICU at UMC Children's Hospital, we are a group of five doctors, and three of us are women. But twenty or twenty-five years ago, when I first came to Las Vegas, I was the only female in this field. It was a very male-dominated environment, and I actually had to fight my way up the ladder to be accepted. I had two strikes against me. One: I was a foreigner, and even though I've lived here for forty years, it doesn't really matter. And two: I was a female. For example, during meetings sometimes I would put forward my ideas and they were frequently shot down—*that's not a good idea*, *we don't like it*, *we don't agree*, things like that. But a male colleague of mine would say, "Well, you know we can do *X, Y,* and *Z.*" The response to him would be, "Oh, that's a great idea." And he'd say, "What do you mean, it's a great idea? Meena just said this. I'm just repeating what she just said."

It was tough; sometimes I would get really frustrated by having to fight to be taken seriously. It took time and persistence to get my male colleagues to listen to me, to trust that what I'm telling them is correct. Some of the surgeons had interesting names for me over the years. So while I had helpful allies, I also had a lot of opposition because it's very difficult to accept a female in an aggressive leadership role. Even today, I'm sure I'm still perceived as being a bitch, whereas if it comes from a man, we all say he's assertive. Sometimes I think, "Seriously? He's being assertive and I'm being a bitch?" Women still aren't supposed to be aggressive and assertive. That hasn't changed. But in my field you have to be, because you're trying to save somebody's life. You can't be touchy-feely. You can't just stand back and say, "Oh, honey, I'm so sorry. Or, "Excuse me, we just lost a life." That's not how it works.

To tell you the truth, our pediatric ICU is really one of the best in the state. Our outcomes, meaning the patients who do well, are the best in the state. And that's because I've been very strict about how things are done. We follow the best practices. I'm not lackadaisical about anything. I'm constantly looking for new and innovative ways to improve the care we provide to young patients. We still have a ways to go. We're not there yet.

My next big plan is to pursue a freestanding children's hospital for the state of Nevada. We have a children's hospital here at University Medical Center of Southern Nevada. But it's a hospital within a hospital. We have two floors dedicated to pediatrics, and we have the trauma center downstairs. The care is excellent, but we don't have one area where we can consolidate our services. There are also other hospitals taking care of children, but the care is fragmented. From the day I came here, that's all I've been harping about. I came to Nevada when there were only seven or eight hospitals. Now we have fourteen, but none of them are children's hospitals. We are one of the only two states in this country that does not have a freestanding children's hospital. We need to build that. The children in the state of Nevada deserve it. I want to keep working, but the ICU is tiring; it's harder as you get older. So I'm going to focus on my goal of a freestanding children's hospital for the state of Nevada.

Once I make that building a reality, then I'll sit back and relax. But until then, I will keep working.

My advice to all the young people is to get into a field that you really enjoy. I really liked critical care, so I stayed in the ICU. No job is perfect. You have to make it perfect for yourself. Always have a curious mind, especially if you're in a medical field. Always ask: *Why is this happening?* When you learn new things, share them with the younger generation. Have an inquisitive mind. If your patient has a fever, yes, tell them to take Tylenol and their fever is going to come down. But you should ask why that patient has a fever. What could you have done to prevent the fever from occurring? Or what can you do so it doesn't occur again?

Be happy with what you're doing. If you don't like it, don't stay in a field just because the take-home salary is good. If you don't like the work, you probably won't do a good job. Let me tell you this: When I first started working here, I went without a paycheck for a couple of months because we didn't make any money. But I just liked it. I just said, "What the hell, I'm not going to starve." I stayed because I was happy. If you're not happy, it will be evident in your work. It doesn't matter how good the job is. You will not enjoy it. I like what I do. I love what I do, but it's a profession with a high burnout rate. You work hard, and you're up late. There's a lot of burnout. People always ask, how come you're still doing it? It is because I like what I do. I've done it long enough to tailor the job toward what I like. I don't take many night calls anymore. I do a bit more administrative work. I adjust! But I'm still very involved in the ICU.

You have to figure out how to tailor your work so that you still enjoy it. But don't worry, I still duke it out with the surgeons from time to time.

PATRICE LANS

is a recreation specialist at the
Oregon State Penitentiary

My career working for the Oregon Department of Corrections began with a temporary job as a food service coordinator in the kitchen at Coffee Creek Correctional Facility, a women's prison. It was a tough job. I was lucky enough to get interviewed for a different position, this one in the Activities Department. That's the area I work in now, but at the Oregon State Penitentiary. I really like this niche. I love being in the trenches working directly with people, helping to make things happen, instead of managing and overseeing.

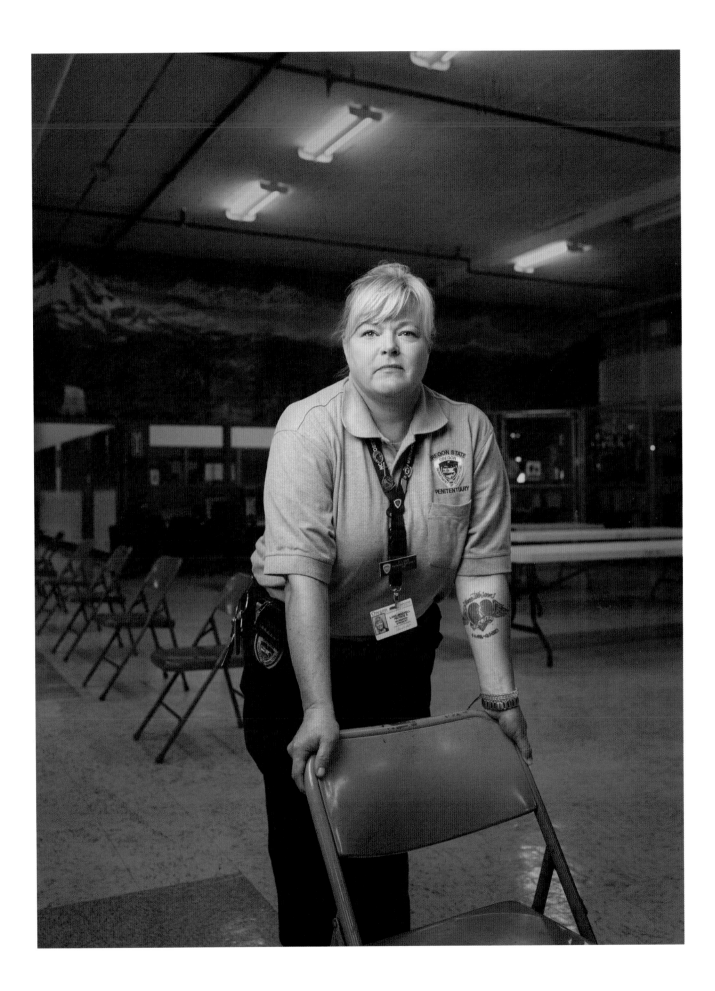

Sometimes when people ask me where I work, I just say, "Oh, I work for the state." Working in the prison system is not something a lot of people understand. But regardless of what people might think about this environment or this work, I feel strongly that the Activities Department has the ability to effect positive change by building and facilitating programs in the prison. I think these programs can help the adults in custody be better citizens when they get out.

Before this job, I spent twenty-four years in the grocery industry. I think my ability to work with people has absolutely helped me in my path. I find human behavior fascinating. Working in the grocery industry, learning every job I could all the way to the corporate office for twenty-plus years allowed me to just watch people. I can read people well, which helps me figure out how to best communicate with them. After all those years in that industry, I have that customer service mentality ingrained in me. Not everybody who works inside correctional facilities has those kind of skills, that kind of mentality. But we make it work.

Customer service has taught me that you get more respect when you give respect. If anything were to go down at the facility, I feel pretty confident I would be protected rather than attacked. I respect the inmates, and they respect me. They see how I do my job. My nickname here on the activities floor is "Pinball." You know when you're playing a pinball machine, the ball bounces from lever to lever, side to side, making contact everywhere? That's me. I go where I am needed. I interact with everyone. Of course, there are very strict boundaries we're required to keep. But you have to strike

up some sort of relationship with these men to help them accomplish the goals they've set.

I really appreciate this job and seeing the groups I help facilitate thrive. They're good, productive outlets. I really am proud of these guys who work toward achieving goals for their clubs. Doing that helps the community inside, because it changes the culture throughout the facility. I want them to leave this place and fulfill their potential.

Currently, in conjunction with an international Japanese garden designer, one of the groups I've worked with for the last five years has raised enough money to build the first Healing Memorial Gardens inside a prison in the United States.

I think a lot about fulfilling—or not fulfilling—your potential. It's personal to me. I have a tattoo on my forearm that reads, GONE TOO SOON with the initials MCW on a broken heart, with the dates 9/4/96–12/5/13. It's for my son Matthew. He loved gangster rap and quantum physics and everything in between. He wanted to become a constitutional lawyer. On December 5, 2013, I came home and found him on the floor of our garage. He had shot himself. He had so much potential left unfilled. So that's the significance of the work I strive to do with the men here at OSP. I want them to be better neighbors and people when they get out of here. It's about them fulfilling their potential—and not breaking their mom's heart.

There typically aren't a lot of women working in male correctional facilities. It's not for everyone. There's really a big difference working with men and working with women. Here's one interesting way to look at it: women speak over thirty thousand words a day, and men might average just six thousand.

Think about that and what that means for interactions.

We are seeing more women hired—about 10 to 15 percent now. But not everybody sticks around. We do have an intern right now, a twenty-one-year-old woman. She is a really smart young woman, and I like to make sure I'm teaching her about more than just this job in particular. What I have loved about many of my jobs was the training aspect. I loved getting those new hires and showing them how to do their job competently. I hope she stays around.

MAGEN LOWE

is a correctional officer

When I began my career at the Oregon State Correctional Institution (OSCI), I was first a part of a work group called Workforce Planning. In this group I researched recruiting and retention strategies for women in the corrections department. The Workforce Planning group eventually shifted, and the Department of Corrections developed Destination 2026 (an initiative set forth to reach departmental goals by 2026), and my role phased out. While this transition was taking place, I continued working with the department and recruiters and I've attended recruiting events in Oregon and Washington ever since. In early 2016, I was promoted to corporal at the Oregon State Penitentiary, where I am currently located.

I remember hearing that the correctional officer department was hiring, which was when I decided I absolutely wanted to try to become a correctional officer. I had taken numerous courses in college in various areas of law enforcement. The corrections work was the most intriguing. I had also previously volunteered with the counselors at OSCI on two occasions for six months each. I was familiar with the facility and the layout and had met many of the staff members in my previous time there. I applied and was hired initially as a temp and made permanent five months later.

While I was in school figuring out what I wanted to do with my life, it didn't take long to narrow it down. There were two people who were extremely influential in leading me toward becoming a correctional officer. The first person was my dad, who is also a correctional officer, having been promoted through the ranks up to lieutenant. Growing up, I saw him work hard at his career, but he never came home looking like he had

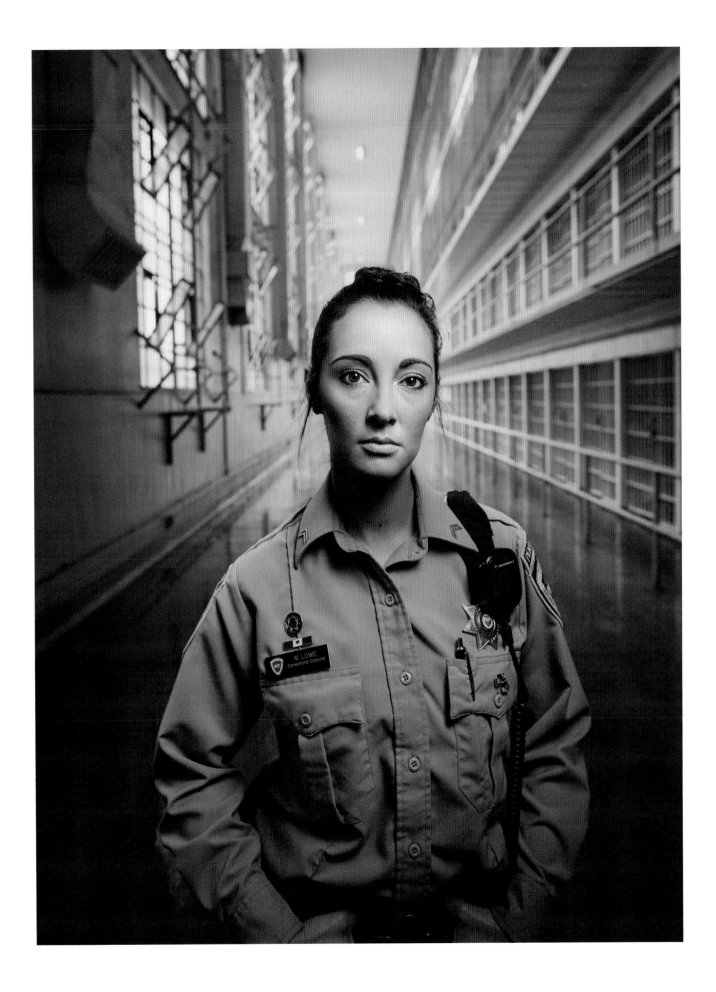

a bad day. The second influence was my high school law enforcement instructor, who was a former police officer in the Portland area. My first thoughts upon meeting her were how could this young woman, who had a really fun personality, be a cop? She did not fit the stereotype. I was intrigued by this and loved learning from her.

Looking at a male-to-female ratio, there are not many female correctional officers. And those who do become correctional officers usually don't stay one for their entire career. But this does not bother me. I cannot control what other people do with their lives. However, I love getting to talk to other women about what I do. Many people in this field keep their professional lives pretty private. This tends to be because those who have never been inside our walls find the work hard to understand. When a conversation does come up and I am asked what I do for a living, I get the "Well, aren't you scared to work there?" question. People tend to be shocked when I tell them, "Not at all." OSP, and ODOC in general, maintains a safe environment at a maximum-security institution, even though they house every kind of criminal imaginable. I know that my backup is right there if and when I need them. Some may say a perfect day in prison is when nothing interrupts the operations, and I absolutely agree with that. Then again, we are trained for so many types of situations as officers that when receiving the opportunity to apply our training in small or big situations, that is a good day, too. However, the number one priority and good day is when every staff member leaves in the same fashion they showed up to work.

I also assume that most people are shocked to learn I'm a correction officer because I don't necessar-

ily fit the stereotype. I am only five foot four and 125 pounds. And I'm especially small when compared to the average male officer. But I have no plan B. The Oregon Department of Corrections is a secure workforce and is growing as an agency. I want to grow with it.

My goal in the upcoming chapters of my career are to be promoted to sergeant and to begin instructing within the Professional Development Unit (PDU), the training unit where newly hired officers are trained. Both are tangible for the near future with consistency, dedication, and drive; from there I will see where my opportunities, interests, and promotions take me. I plan for short-term goals, knowing one day I will have accomplished everything I set out for in my career. If ever the time came and I could no longer be an officer, I'd probably go the complete opposite direction and learn to remodel houses. Learn to swing a hammer and use power tools.

But no matter where my career takes me, I will always be an advocate for women pursuing any career interest they have. You've got to remember that there are others, somewhere, doing what you want to do. Do some homework, and reach out and talk to someone. Ask questions, and seek guidance. Learn from others—male or female—who are experts in those fields and put knowledge in your back pocket. Apply it when necessary. The Oregon Department of Corrections has rules and policies and an inmate handbook; I read as many resources as I could when I was starting out. Knowledge is not power, but knowledge is key to longer term success.

Reach for the stars, educate yourself, and be aware of your limits—and push them just enough. But first and foremost, keep your mind and body healthy.

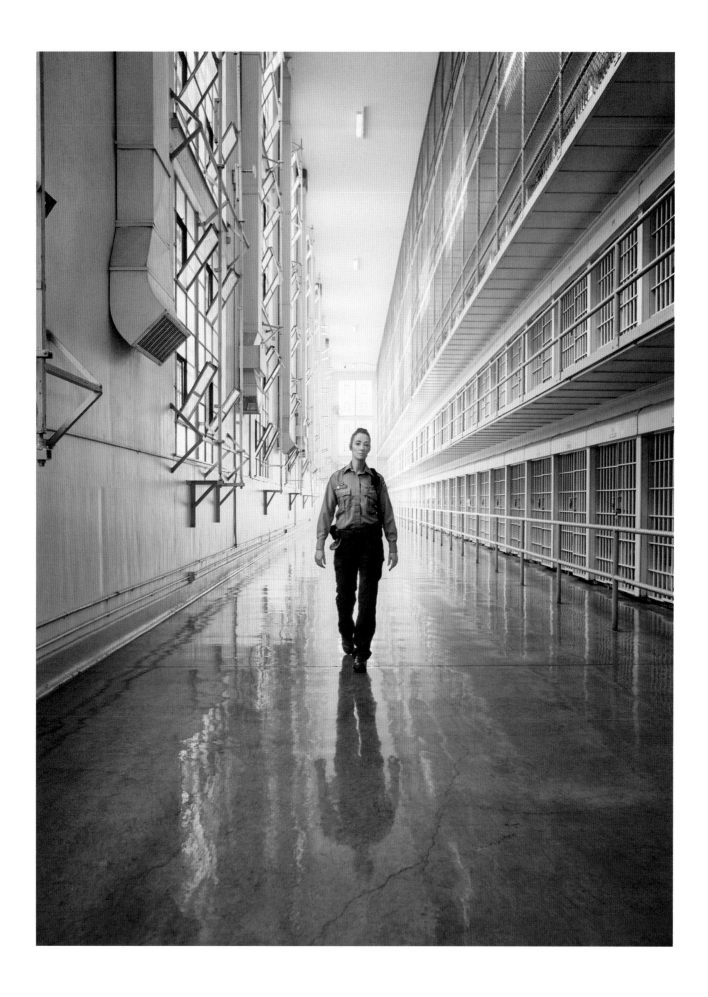

NATALIE EGENOLF

is an on-air personality and sports update anchor

I was born in the Kensington area of Philadelphia. My mother, my sister, and I moved around a lot before settling in northeast Philly. My parents had a custody arrangement where I was with my mom during the week until my dad picked me up on Fridays. Driving with him was when we would listen to sports talk radio, and for some reason, I never asked him to turn it off. So I started to listen to it myself, and I just really started to like it. But when he and I would spend time together, he would take me to the games. Our whole relationship was eventually built around sports talk radio and Philadelphia sports.

When I interned for the Eagles' radio network, Merrill Reese, the announcer, at the end of every game would thank the broadcast staff, and at the end he would thank "the inimitable Natalie Egenolf." I don't know why he ever said that, because I wasn't in

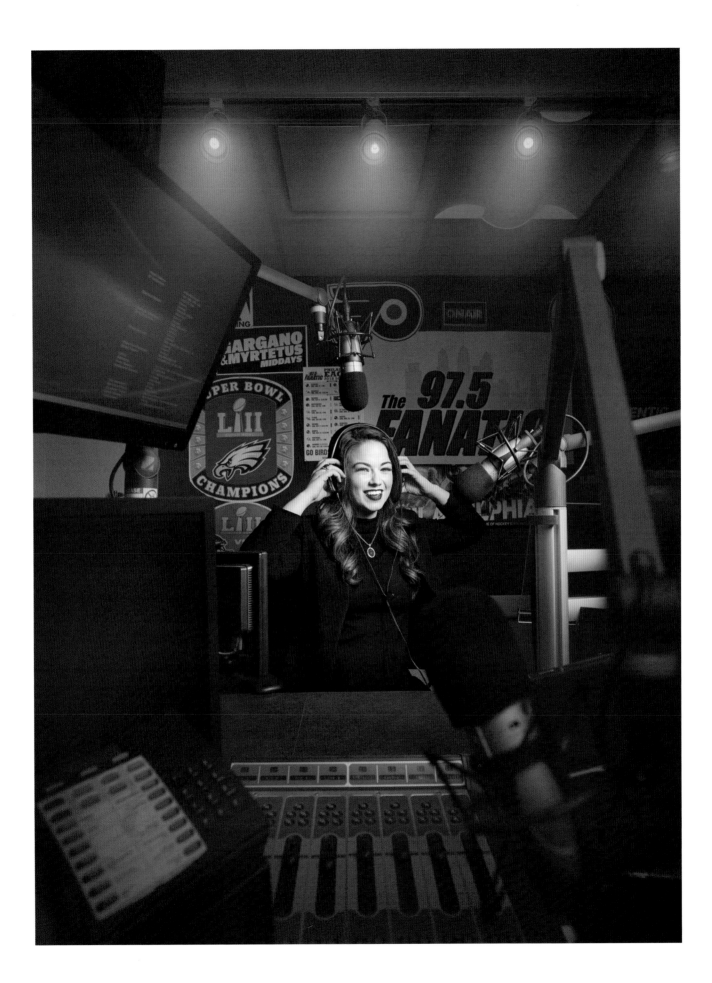

the studio with him. All I was doing was call screening and making sure that the phone lines were connected and running play-by-plays on Twitter (which was new at the time). But according to my siblings, my dad would always stand in the kitchen and wait for the end of the broadcast to hear him say "the inimitable Natalie Egenolf" at the end of the game.

The first thing I ever wanted to be was a singing cashier. Then an astronaut. But I had to start working at a young age, fourteen—anything extra I wanted, I had to go and work for myself. I think I've always had a passion for performance art, and when I was sixteen, I did the morning announcements for our high school on Cardinal Dougherty television. I loved it. Like I loved it so much and I was so good at it that I ended up doing it until I graduated. Being the morning news anchor is what made me go "Okay, I'm not going to be an astronaut anymore."

I never knew how it would happen or if it would ever happen. I've never been afforded the luxury to plan or think. I grew up in a very moment-to-moment world. So that was just how I worked, which I think has been helpful, because I've always had an attitude of having nothing to lose. A lot of why I am where I am today is because I would just email the heads of departments. I did not waste my time with the middleman. I always felt like the worst that they could say is no.

But things in sports radio have been set in their ways for so long. With the addition of digital media, we're trying to remain dynamic. Radio is sometimes seen as a dying medium. We're constantly trying to figure out how to reach the next generation—well, these days, the next generation isn't just men ages twenty-five to sixty-four. You have whole cities filled with sports fans of all colors and sexes. I feel like there's always going to be FM/AM radio in some capacity. It's a broad, free medium that reaches so many people. Everybody's

trying to monetize their podcasts, but a podcast can take a really long time to reach self-sufficiency. I had a podcast for a year, and it was challenging; I wanted it to be topical, and sports news happens every day. It was recorded, so that was a whole thing. So while we're trending toward podcasts, I don't think radio's going anywhere. I'm not sure about music radio, but talk radio, I think, is always going to have a place in society, especially for sports in Philadelphia. We're the fifth largest market in the country, but sportswise, I feel like we're number one.

As a woman in sports radio, I do feel like I had to work harder than others to get to the places I wanted to go. I was often the only woman in the room, so I sometimes questioned myself a little. People have also questioned me despite the fact that my résumé was usually longer than the guy's next to me. That's been a very harsh reality. Women also face harsher criticism, more unconscious doubt. No one ever questions the dues my male peers paid. Sometimes people will say, well, I only got the job because I'm a woman, because of how I look, when they don't realize that I have ten years of work experience behind me. Whereas some of my [male] peers who might have two years of experience in radio don't get that same line of questioning, that doubt, from the public or internally.

The public criticism is different, and I face it differently than my male peers. The public come at men for their opinions; I get it from all angles. Even if they want to attack my opinion, they start with my appearance. It's weird because internally, I'm very respected. My boss has told me I'm our best anchor. I do have the respect of my peers in the industry. But there's the issue of perception that a lot of my male peers don't deal with.

But then I think of someone like my mom. Her life was so hard. She was homeless as a child and was, like, on her own by the time she was fifteen. She's

somebody who did what she had to do. Her number one priority was always being a mom. But she was a single mom and faced a lot of stigmatization because of that. She worked so hard to send me and my sister to Catholic school. She saved up for two years, working as a bartender, to take my sister and me to Disney World. I know it's cheesy, but when we were at Disney we saw their signature slogan everywhere: "If you can dream it, you can do it." I remember my mom looking at me and seeing that in her. It was a dream for her to just take us there. She dreamt of the simple things. She always just wanted to own a house. Small things like that, that I feel like people take for granted. Those were always big dreams to her.

Being able to do this for her is really what it's been all about.

CHRISTINA BOTHWELL

is a mixed-media artist

When I was four years old and living in New York City, my mother explained perspective to me. She pointed out how the different sides of the street converged visually in the distance and told me that if I planned on drawing the street, I should make sure that the lines went toward each other to one point, so as to suggest perspective. I remember being captivated by this optical illusion and had to draw roads going in perspective, over and over again. That is my first memory of being excited about drawing and making art. I think I started considering being an artist then. I know I never wanted to be anything else.

My mother was an artist; she taught life drawing from our living room. I had a sketchbook and charcoal (as well as a bit of notoriety in grade school for having naked ladies posing in my house). She was also a big influence to me in becoming an artist. Seeing her make art all the time made being an artist seem normal, doable. She always bought me art supplies and encouraged me to be creative. Another major influence has been the jazz singer/songwriter Bob Dorough, who just died at the age of ninety-four in 2018. Even though he wasn't a visual artist, he had such a quirky and unique style; he was quintessentially himself. Hearing his music and watching him perform made me feel like I was on a bicycle with a loose chain—as soon as I heard his music, I would go right back into alignment. Listening to him, seeing his joy at performing, was (and is) a great example of how the only thing we can truly be as an artist is ourselves. Our gift as artists is to be true to our uniqueness, regardless of commercial success, money, fame, etc.

After high school I went to the Pennsylvania Academy of the Fine Arts to study painting, and then I moved back to NYC after graduating. I lived in the city for seven years before moving to rural Pennsylvania. When I was twenty, I saw an exhibit of figurative sculptures by the artist Daisy Youngblood. I knew nothing about sculpture at the time, but her raw unglazed figures and animals touched me and woke something up in me that I hadn't known was there. I wanted one of those sculptures so badly, but I had no money and buying art was out of the question for me. The longing I felt to touch her work (and own one) was almost painful. After I left the exhibit, I realized that I might have to try and make some three-dimensional pieces someday that would give me the same feeling I had when I looked at Daisy Youngblood's work. (If I had to clarify what that feeling was, I would say it was vulnerability and raw emotion.) Even though I didn't begin working sculpturally for fifteen years after that,

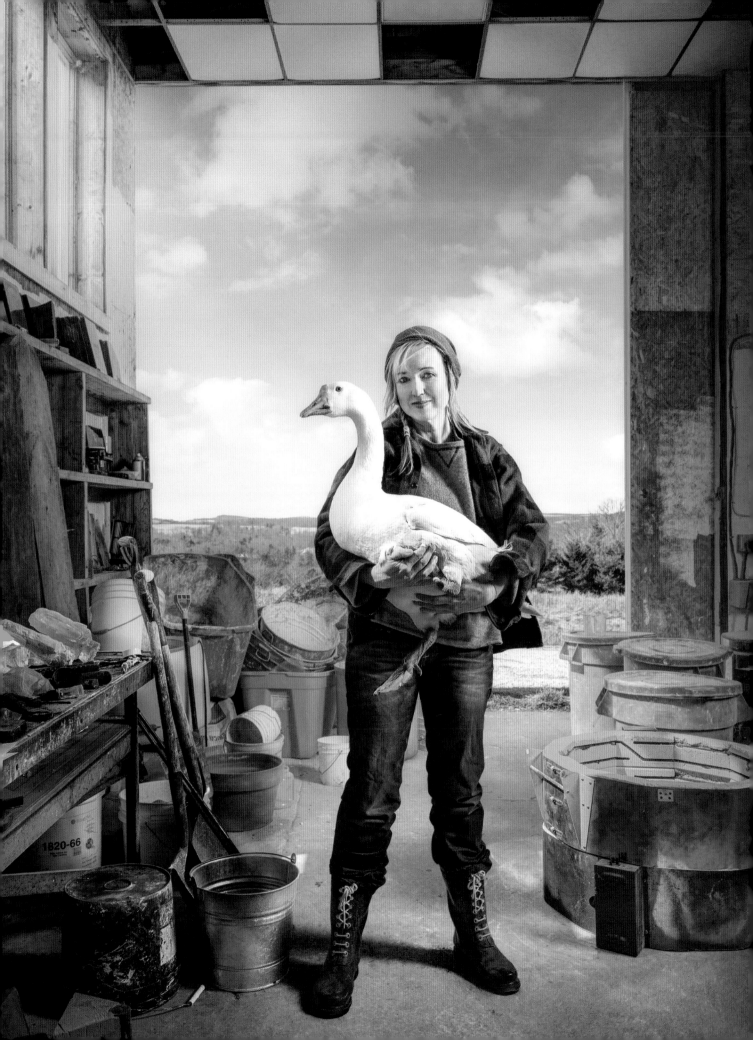

I never forgot Youngblood's work or the feelings her work inspired in me. Her work was deeply personal and seemed to exist outside of trends and fashion at the time. Looking back, I think she was a huge inspiration to me in becoming a sculptor.

I began making sculpture almost by accident. I was preparing for my first solo painting exhibit in New York City when I came across a ceramic kiln at an estate auction for ten dollars. I started messing around with clay, and I soon discovered I enjoyed making sculptural things more than I enjoyed painting. My identity was wrapped up in the role of being a painter, so it was a challenge for me to give that up and embrace something I knew nothing about. I didn't even know if I had any potential as a sculptor, but I couldn't ignore the direction I was called to follow. After a year, a gallery in NYC saw my ceramic pieces and gave me a show. I worked with ceramics and found objects for five years, and then to get myself out of a rut I took a glass-casting workshop at the Corning Glass Studio. I have been making cast-glass pieces that incorporate ceramic and found-object elements ever since.

It used to bother me that not many women work with glass and stone—or at least when I was in art school, there weren't too many historically well-known women artists. Especially women artists who also had children. But today there are many, many amazing and talented women artists working with all kinds of materials. There are actually quite a few women artists working with glass and clay, and now, with social media, it is possible to see a lot of their work through Instagram. But if I weren't an artist, and if I could be anything at all, I would like to be a clairvoyant, someone who can speak to the dead and bring messages back to the bereaved.

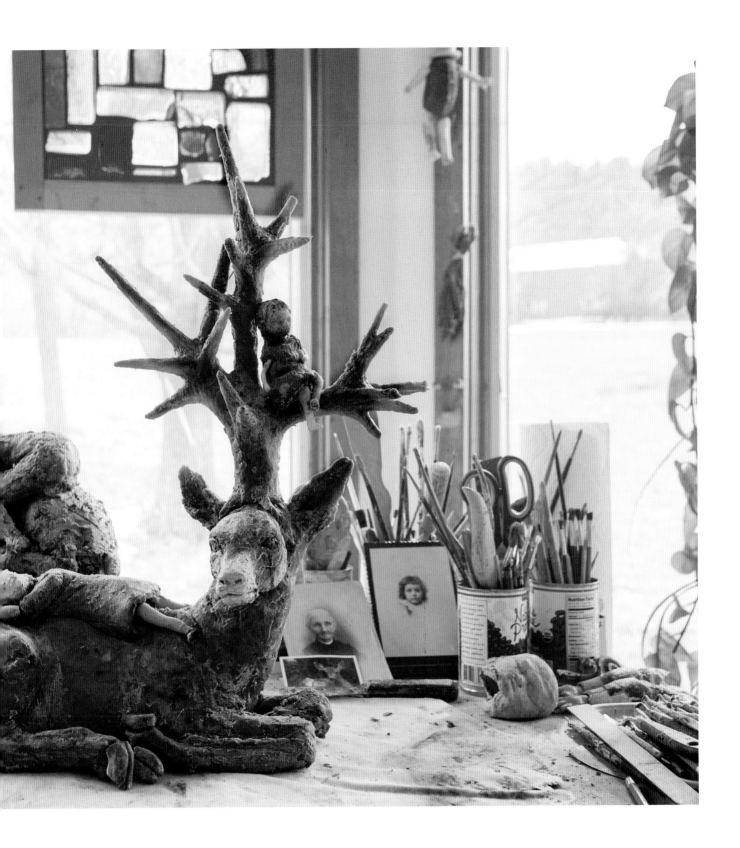

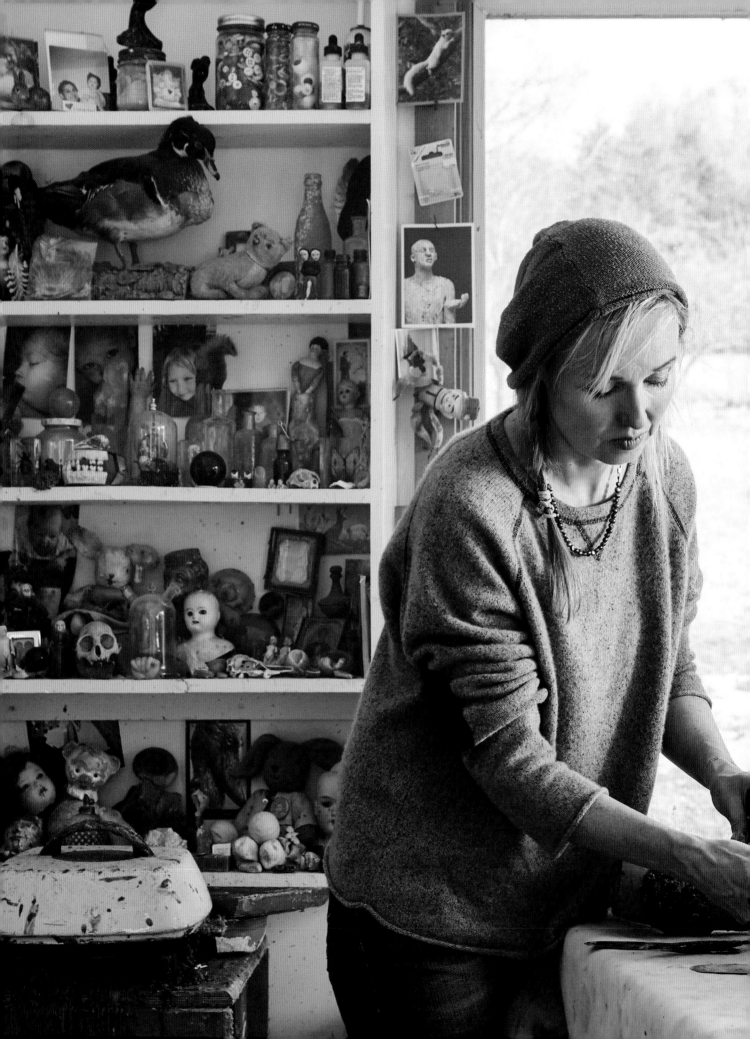

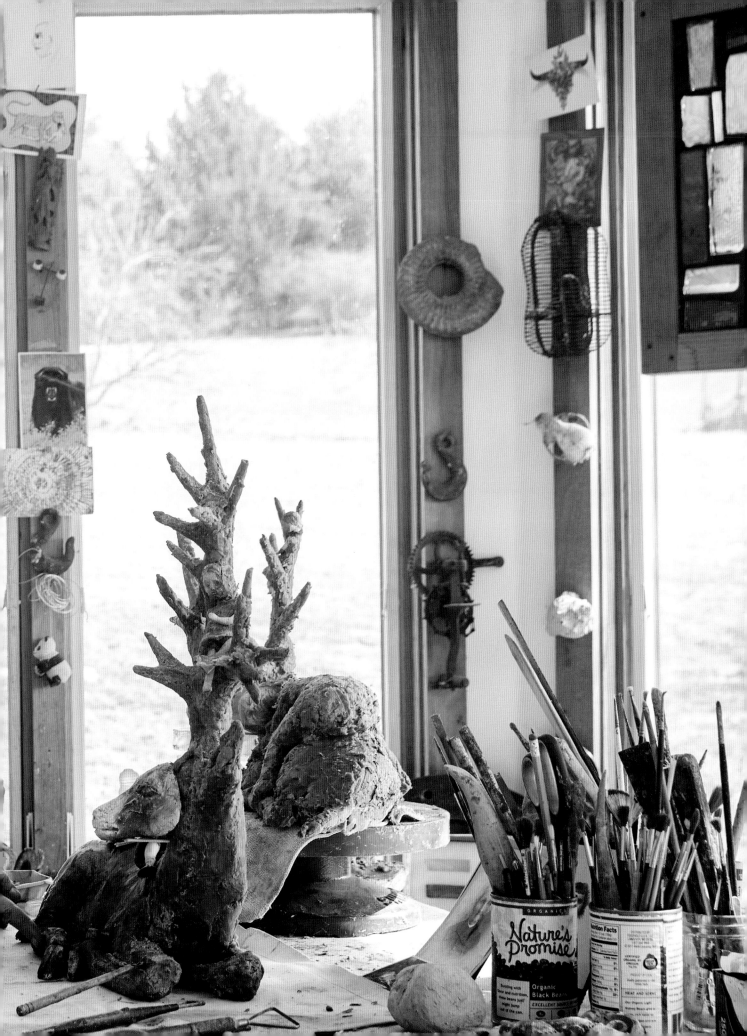

BETH BEVERLY

is a taxidermist

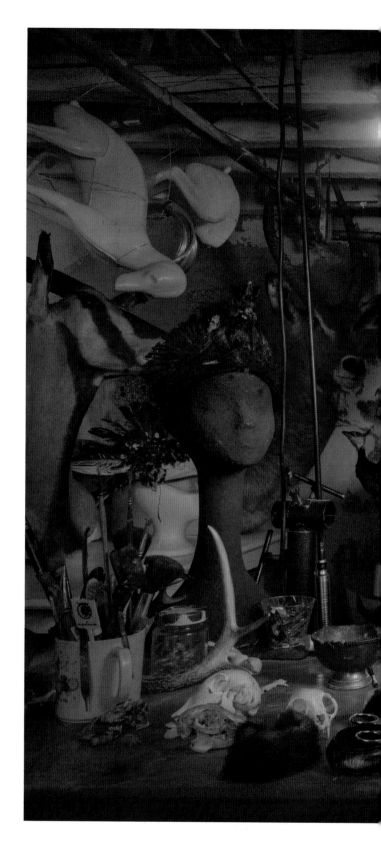

I have been practicing taxidermy since 2000 and was state and federally licensed in 2010. I'm called Philadelphia's premiere couture taxidermist, specializing in wearable mounts and unusual home decor. My hats have won awards at the Devon Horse Show and the Brandywine Polo and Radnor Hunt Clubs. My work has been featured in the *New York Times*, the *Wall Street Journal*, AMC's series about competitive taxidermy, *Immortalized*, and most recently the Netflix series *Stranger Things*. Since 2013

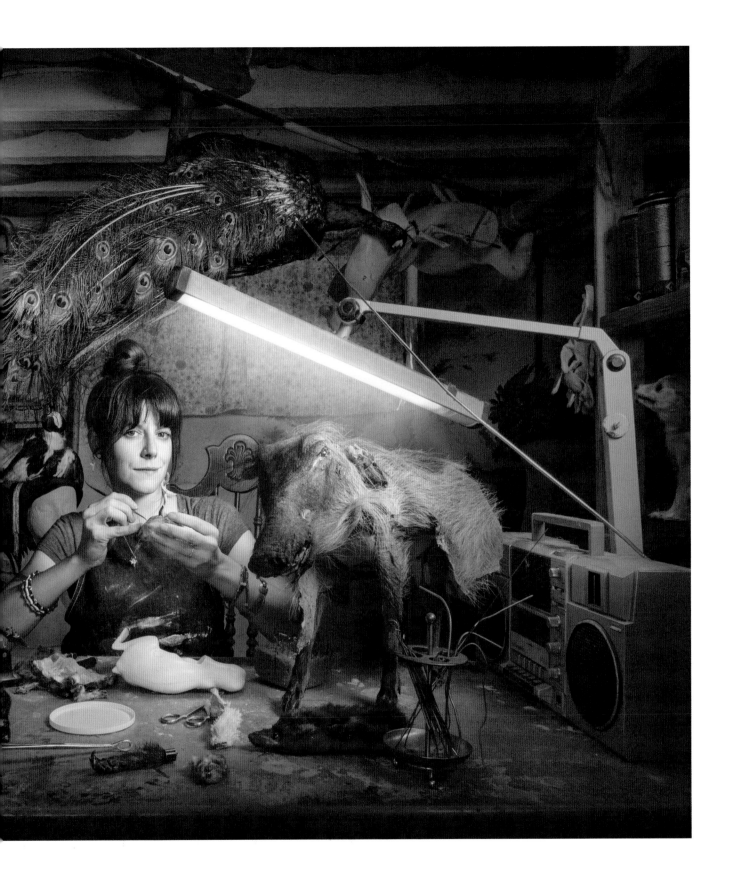

I have been giving demonstrations and lectures and leading workshops on taxidermy at the Wagner Institute, the Philadelphia Sculpture Gym, the Morbid Anatomy Museum in New York, and the University of the Arts in Philadelphia. I've also worked with museums such as the Academy of Natural Sciences of Drexel University, the Franklin Institute in Philadelphia, and the Vadon Hunting Museum in Transylvania, Romania.

Each day takes on its own course in my studio; it all depends on which deadline looms largest. Usually if I've thawed out a specimen the night before, I will begin skinning it first thing to get the grimy work out of the way. At any given time I have about eight to fifteen mounts or projects in the works, so after processing a specimen and either salting or freezing the hide, I'll usually work on anchoring some pieces that are already dried to their respective hardware, such as sheep hooves to brass candleholder parts or a curled-up fancy chicken bust to a buckram hat form for a millinery piece. If I have time later in the day, I'll spend a chunk of it on the third phase of a mount's life: the finishing work. This entails painting in detail, like a fox's nose, and gluing any embellishments onto fancier pieces: crystals onto pheasant talon necklaces, etc. Some time each day is always gobbled up by regular administrative work, like email correspondence, searching for and ordering supplies, photographing my finished work and editing those photos, listing pieces for sale, and promoting myself online. Some days a client will drop off a specimen with very little notice and I'll have to rearrange my day, which can get tricky since I now have a one-year-old and work out of my home. Just last week a woman dropped off an eighty-pound dog (her pet), which was much too heavy for me to carry down to my basement studio, so I had to process him in the living room. Because of the winter weather, my son's day care had been canceled, but thankfully I am able to work in spurts while he naps!

As for my path toward this career, I've been inspired by natural fibers and found objects for as long as I can remember, so it only seemed natural to want to do something with the dead birds I would see on the sidewalk while working as a window dresser downtown in 2000. I bought a book on how to do taxidermy and made terrible taxidermy for a decade before finally deciding to pursue formal training and make this my career.

Traditionally, in the sense of hunting lodge trophy mounts, taxidermy has been thought of as somewhat of a boys' club. But a quick search on social media for alternative or "rogue" taxidermy will reveal a field dominated by women. Almost all my students are women, and I don't see that slowing down anytime soon. I think a human who can handle bleeding out of her vagina for days at a time, plus growing a whole other person inside her body only to expel it at some point, is well suited for the less-than-glamorous parts of processing dead animals.

When people make nasty comments on my social media or send me hate mail, I tend to dismiss it. I'm not in the business of changing minds, and I understand my work isn't for everyone.

It's hard to say what I would be doing if I wasn't doing this. Early in my taxidermy career, I was juggling anywhere between four and eight gig-type jobs: simulated patient for medical students, aerial dancer for bar mitzvahs, flapper girl for corporate events, warranty technician on cruise ships, wardrobe stylist for editorial shoots, window dresser—as long as it doesn't require dealing with too much au-

thority, I'm usually up to the task. I love getting paid to do what I love doing.

I'm a new mother, so I'm still trying (and failing) to navigate time management with parenthood, so hopefully in the near future I'll strike a hint of balance when it comes to being the frontline parent and running a business at the same time.

Many people have written that seeing my work on a larger scale has influenced their daughter or niece or granddaughters to try taxidermy. My advice to them is: Don't pay too much attention to rules. They were most likely made by someone who bears no resemblance to you and never had your best interest in mind.

MIA ANSTINE

*is an outfitter, guide, hunter, and
firearms and archery instructor*

My family moved to southwest Colorado, to a small town, when I was a toddler. Before I was ever a glimmer in anyone's eye, my great-grandfather used to travel to the area in which I grew up to deer hunt. He'd load my grandma and uncles up in the truck, and they'd make the trek. They hunted as a means of putting meat on the table. The big-bodied deer put lots of steaks in the freezer and made tasty jerky or summer sausage. After I was born my parents moved to the area. And as my great-grandfather had, my dad hunted to put food on the table. I grew up around a hunting family. My uncles would travel from San Diego, and I'd spend days in the mountains hunting with them.

While my father hunted to put food on the table, my mom grew a garden and taught me how to fish on the San Juan River. In my youth, my parents divorced, and my mother and I moved to San Diego, where I attended high school and college. Ever since I was a young girl, having grown up near the river in southern Colorado, I've loved exploring. When I lived in San Diego, I realized how fortunate I was as a child. Many people in urban areas never notice birds, plants, or trees. But I quickly learned that looking hard enough led to finding wild places and outdoor areas to explore. In San Diego, I just had to look a little harder and wander a little farther sometimes. After college, and after missing the country life for such a long time, I moved to Texas and then to Oregon, and finally I returned to my hometown in Colorado. I once again embraced the mountains and made a life in the small town.

No matter where you live, there are always places to go, see, learn about, and explore. What we can do

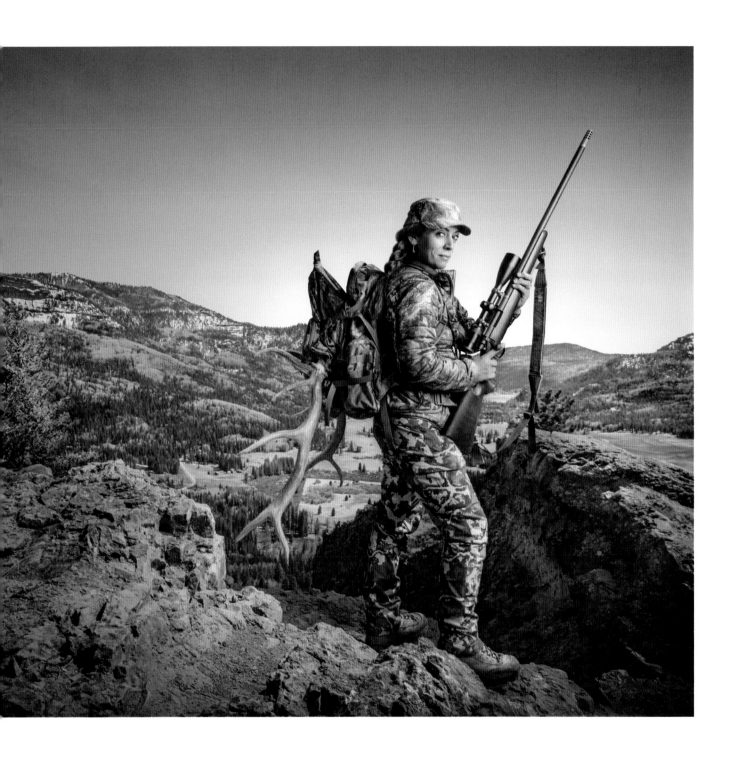

in the outdoors is limitless, though we should always keep care and conservation in our thoughts. I love exploring the outdoors, teaching others, sharing gear; I love the tools for hunting, fishing, and shooting. This all led me down the path to becoming a professional hunter, guide, and outfitter.

Eventually I had my daughter. Then I became a single mom. I became highly successful as the top salesperson in the building industry company for which I worked (also male dominated). I worked night and day to stay in the high ranks. My dad helped me with putting healthy meat in the freezer. But honestly, I grew tired of him providing for us. Although I'd been hunting since I was a toddler (I learned how to shoot guns when I was five years old), I wasn't the one behind the trigger. I told him I wanted to hunt on my own, and that year for my birthday he bought me a hunting rifle.

I headed out on solo hunts on the weekends. Sometimes Dad would watch my little girl, and other times I'd take her along and carry my shotgun to go bird hunting. The mother-daughter time was priceless, and the outdoors was a welcomed break from my nonstop commissioned sales job. The outdoors is good for your soul.

The two of us had so much fun exploring the mountains together, as I had done by myself as a child. I'll never forget her smile when I knocked a grouse out of the sky.

Later we met my now husband. He owned an outfitting business. On the weekends my daughter and I would take the horses and pack out his hunters' elk or help him check on camps. One season he was short a guide. He knew I was a good hunter and asked if I'd be willing to help. I agreed to pitch in, taking novice and experienced hunters out to pursue elk.

I used to write about my days guiding hunters and email them to my grandpa. Some of the hunters noticed me typing away every evening. They wanted to know what I was doing. They asked me to send the stories to them, too. After some time the email list grew so large that I decided it would be simpler to put my writing on my website. This eventually grew into my current business: I'm a hunting guide, a writer, a podcast host, and have a host of other jobs mentoring others into the outdoors.

Though many of my early influences in becoming an outdoorswoman were men like my father and grandfather and uncles, in our area there are many ladies who pursue wild game. There are even other women who own outfitting businesses and guide hunters themselves. For the most part I've been met with a positive attitude when I meet male hunters, but there have been times when I had to "prove" myself. You may be surprised that it's not always to men.

I once guided a lady on an elk hunt in New Mexico. She was very standoffish. She'd hunted all over the world but had never harvested an elk. She didn't have much to say to me and instead chatted a lot with one of the other male guides. He and I decided that he'd take the lead. I'd manage the horses and pack out her elk, if and when she tagged one.

Yes, a woman had an issue with a woman. That's nothing new. There are egos everywhere, and I don't think anyone should take issue with them. You simply have to figure out how to work around them and go about making a positive impact.

After the first morning, the lady commented that I had Swarovski Optiks, a very-high-quality brand of binocular. She had a similar set of smaller size. I decided to take the opportunity to strike up a conversation. I asked about her quests around the world. I inquired about her other experiences, asked why she hadn't hunted elk. Eventually she was tagging along with me as I tracked down a bull elk for her to shoot.

It's not always a gender thing; sometimes it's a relationship thing. You have to be confident in yourself and what you know; as a hunting guide, you have to build relationships that foster positive experiences.

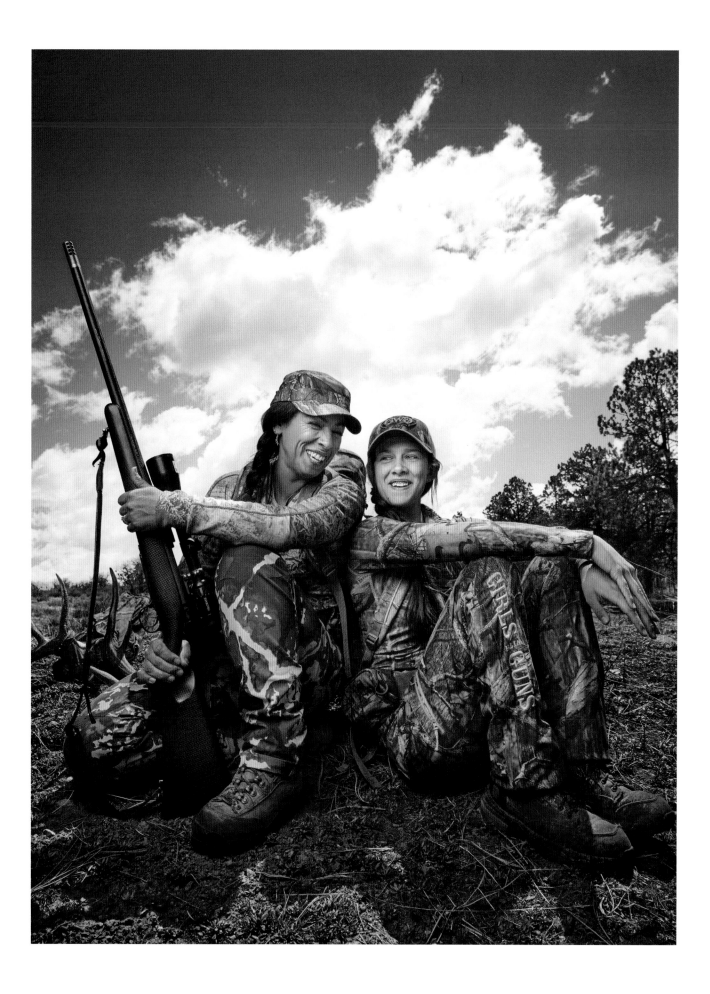

But this is applicable to more areas outside of hunting and guiding, I think.

For me, it's easy to be positive: I'm doing what I love. I spend most of my days outdoors. I get to be so many things: a hunting guide, writer, podcast host, guest host on outdoor television shows, archery and firearms instructor, hunter education instructor, and all-around mentor. I travel to teach hunter education seminars, speak at events, teach women to shoot guns and bows. I'm a regional director and chapter board member of Safari Club International. It's been an honor to serve the local community. I'm a board member of the Professional Outdoor Media Association, where I've worked with young writers, photographers, and influencers.

After sending my daughter off to college, I continue to write and to mentor others. In between assignments and adventures I've written an ebook about mule deer hunting and am working to publish a book about elk hunting out west. I was granted a limited archery elk-hunting license for the Colorado Wilderness, and some of the experiences from the trip will be featured in the writing.

During that epic elk-hunting adventure we packed our camp in and out of the area three times, hunting a total of eighteen days. Camping in a remote area, away from civilization, at 12,000 feet, is an awesome experience in which you'll learn a lot about yourself. Viewing God's wild animals and coming face-to-face with them is always exhilarating. You know, they don't care whether you're a man or woman. To spend time in their territory is a profound experience of which I hope others will witness.

These days I still work in a male-dominated industry; I make a little less money than I did when I was the top salesperson for a large corporation, but the rewards are far greater. Everything I do to encourage others to get outside, hunt, fish, shoot, cook, eat, survive, create, and live life positively with others is empowering. Man or woman, we can always learn, always share, and always be successful.

To young women I'd say: Always know that you are valuable, and you'll find strength in your self-confidence. Respect yourself, and others will, too. Work hard; the rewards are so much sweeter if you put in the effort. Find what makes your heart sing, and you'll be able to do anything. Once you find your happiness, find a way to share it with others and you'll be richer than you can imagine.

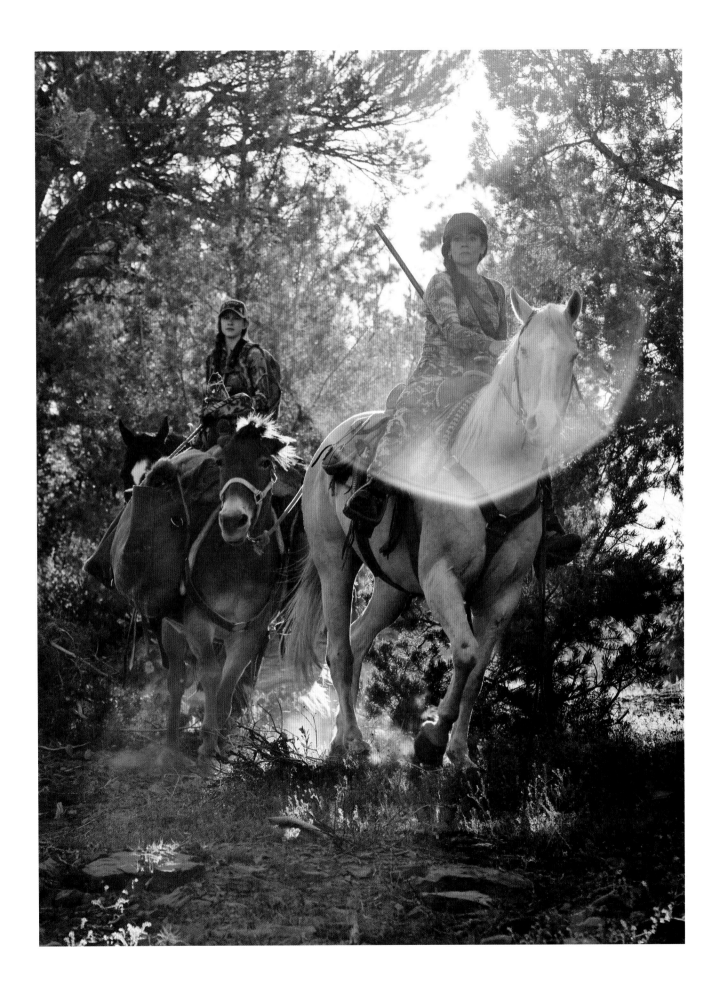

DANIELLE PEREZ

is a comedian in Los Angeles

I started comedy in August of 2014. I was thirty years old, living in Los Angeles, and had no idea what I wanted to do with my life. My best friend, Madison Shepard, had a roommate at the time who was a stand-up comic. We started going to his shows, and by the third one I was like, "I can do this! This doesn't look that hard. He's not funny!" I hit up Madison like, "How do we do stand-up comedy?" and my life has never been the same.

My first open mic was at Rock Paper, a coffee shop in Hollywood that doesn't even exist anymore. I hadn't prepared anything because I thought I was just going to watch, but Madison made me sign up and when the host called my name, I took the mic. I immediately loved the power of commanding a room—I loved that people were looking at me and listening to me, and that I was making them laugh! I've been chasing that high ever since.

Growing up, I was a big fan of Margaret Cho. Her show *All-American Girl* was really important to me as a first-generation American, daughter of immigrants. In my twenties I gravitated to the comedy of Kathy Griffin, Natasha Leggero, and Chelsea Handler. Now, in my thirties coming up in Los Angeles, I get to learn from and work with modern-day greats: Maria Bamford, Cristela Alonzo, Laurie Kilmartin, Ali Wong, Beth Stelling, Marcella Arguello, Aparna Nancherla, Sabrina Jalees, Maggie Maye, Debra DiGiovanni. I love watching these women perform and am constantly inspired by their work.

My style is bubbly, dark, and confessional. On stage, I perform a heightened version of myself. No one has ever told me I'm not funny—at least not to my face, but, after shows I still hear "I don't like female comedians, but I liked you," and that always bums me out. You don't need to put down women in order to compliment a woman. For all the great things about the Internet, it is also a place where flagrant sexism and racism run wild. I generally try not to read the comments on videos and articles about myself and actually have the comments turned off on my own YouTube videos. I'll take my feedback live, on stage, and in person.

I'm grateful to be performing comedy in 2020, where the question "Are women funny?" tells you more about the person asking it than it does as a valid topic for discussion. And even though there are more working female comedians than ever, major comedy clubs across the country still don't book many women. I hear from older female comedians that bookers are using the same tired excuses they've

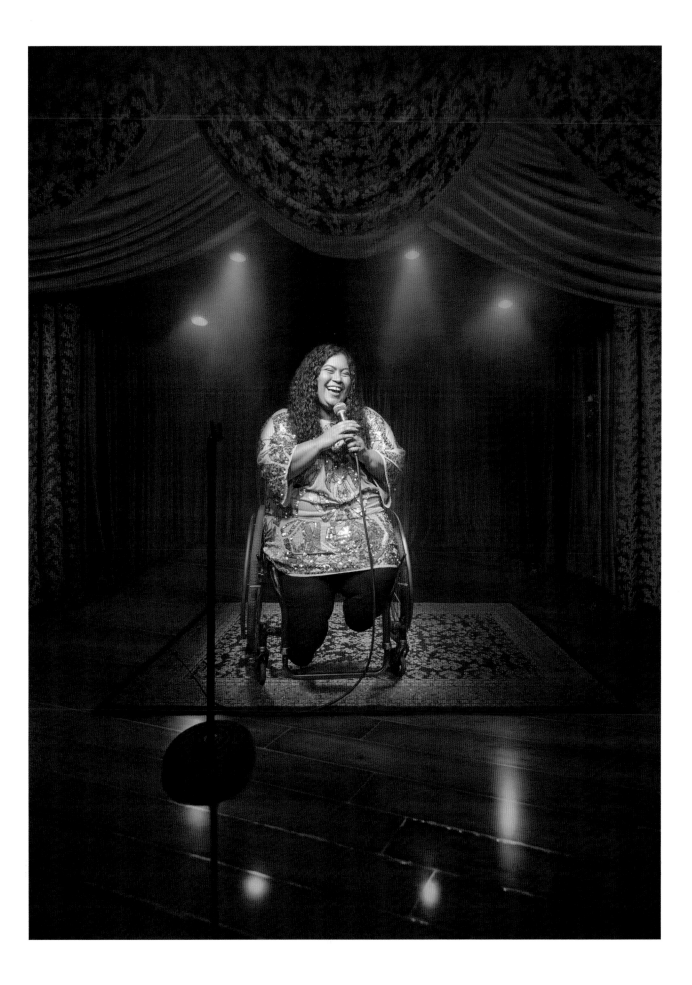

used for decades: Women don't sell tickets! My question is, do these guys who have a Comedy Central credit from fifteen years ago that no one's ever heard of really sell tickets? The biggest thing you can do to support female stand-up comedians, besides buying our albums and merchandise, is to call, email, and Tweet your local comedy club and tell them who you want to see perform there.

I am so thankful I started comedy with my best friend, Madison Shepard, because even though I was born and raised in Los Angeles, starting comedy here was a huge culture shock. I had never been in such straight white–male spaces. Both Madison and I are mixed—I'm Afro-Latina, she's black and white, and we saw very few women who looked like us and sounded like us when we first began going to open mics. Madison has a theater background, so immediately she said we needed our own show and production company. We started Thigh Gap Comedy in 2015 with Danielle Radford, and through it produced the show *GENTRIFICATION*, a diversity showcase celebrating minority and underrepresented voices in comedy. Our lineups predominantly featured women of color, people of color, queer comics, and disabled comics; comics who are often overlooked and tokenized on nondiversity-focused shows. With *GENTRIFICATION* we not only put on a great show, but created a space for marginalized comics to come together and connect in a way that you can't when you're the only you on a show.

When we started Thigh Gap Comedy I was inspired by Jenny Yang, Atsuko Okatsuka, and D'Lo of Disoriented Comedy. Disoriented Comedy originated as the first ever (mostly) Asian American female stand-up comedy tour. In Los Angeles, they produced shows, hosted open mics for comics of color, and created The Comedy Comedy Festival: A Comedy Festival showcasing the best in Asian American comedy. Jenny, Atsuko, and D'Lo helped me understand how necessary community is to one's success in comedy. Seeing how fiercely they supported one another and their community I was able to witness a rising tide lifting all boats.

Helping other women in comedy is so important to me because it's the only way I have been able to succeed. In addition to hard work and talent I succeed on the good graces of women in the Los Angeles comedy scene who have booked me on shows, recommended me for writing jobs, taken me under their wing, provided guidance and advice, put me in their sketches, created and collaborated with me. We aren't one another's competition. Scarcity is a myth. The more we show up for one another and share resources, the stronger we all are.

Comedy saved my life. It has given me direction and purpose. I am so thankful that I get to do what I love. I struggle with depression but am really fortunate to have a strong support system of family and friends. I hate the saying *If you love what you do, you never work a day in your life.* That's bullshit. It's work. It's very hard work, actually. And because it's creative work, it takes so much from you mentally, emotionally, and physically. For the last five years I have been pursuing comedy nonstop to the detriment of my health. On tour in New York, I was hospitalized with pneumonia. The physical and emotional toll of being a disabled woman of color in comedy constantly fighting against inaccessibility, sexism, and racism in order to perform wears on you. You can't perform to your best ability unless you're healthy, so that's what I've been trying to focus on, striking a healthy balance between life and comedy.

Telling myself to slow down and take care of myself has been hard. I have to constantly remind myself that I'm doing this forever and it is a marathon. There are only so many things I can control, and as long as I keep writing, getting on stage, and telling jokes—I'm a comic. The amazing thing is that I'm doing this forever, so I will achieve things I haven't even dreamed up yet.

My advice to young women who want to do stand-up is: show up. Go to open mics, write, and get up on stage as much as possible. Find your tribe. Seek out other women in comedy who are as funny and motivated as you are. Encourage each other, support the fuck out of each other. Collaborate, work together, create your own shows and spaces. Support the women coming up behind you, and as opportunities and doors open up for you, reach back to pull up other women along with you.

A day in the life of a stand-up comedian isn't as glamorous as *The Marvelous Mrs. Maisel* would have you believe. Though photoshoots like this one are fun surprises! Generally I spend my mornings on administrative tasks: phone calls, emails, updating my calendar and website, following up on booking requests and projects. I write in the afternoon, which means, I work on a mixture of my stand-up, topical or monologue jokes, sketches, packets, and pilots. Evenings I go to open mics and perform on shows. Depending on what I have scheduled I work in auditions, shoots, meetings, panels, podcasts, radio, travel, and host-ing. I had my first writing job last year, on a Netflix show, which was exciting and challenging. I was a 2020 CBS Diversity Showcase cast member, so I spent the last three months of 2019 pitching and rehearsing at CBS. No one week is ever the same, which keeps everything exciting!

For all the cool opportunities I've received and projects I've been a part of, rejection is still a reality of this industry. I believe if you're not being rejected you're not putting yourself out there. Reaching out and submitting for shows, parts, and writing jobs is how I exercise control in an industry where so much is out of my control. Every comedian can tell you about that one show that never booked them. No one is going to get all the things. That's okay because I don't want everything; I want what's right for me.

So, what does success look like for me? It changes every year, but right now I want to perform stand-up on late night and write and star in my own TV show. I just want the opportunity to keep performing, growing as an artist, and creating with my talented and wonderful friends.

KATHERINE KALLINIS BERMAN
& SOPHIE KALLINIS LAMONTAGNE

are sisters and the founders of Georgetown Cupcake

We had dreamed about opening a bakery together ever since we were young girls. Because our parents both worked, our grandparents raised us and we spent much of our early childhood with our grandmother Katherine Ouzas, baking with her in her kitchen. She was a profound influence on us growing up, and she was our inspiration for starting Georgetown Cupcake. We developed our passion for baking from her. Our grandmother also taught us the importance of hard work. From her we also learned and experienced the joy that we could bring to others through baking—the notion that something that we made with our own hands could bring happiness to others. And that's ultimately what our business is about: bringing happiness.

In 2008, we traded our careers in fashion and venture capital to follow our dream of opening a

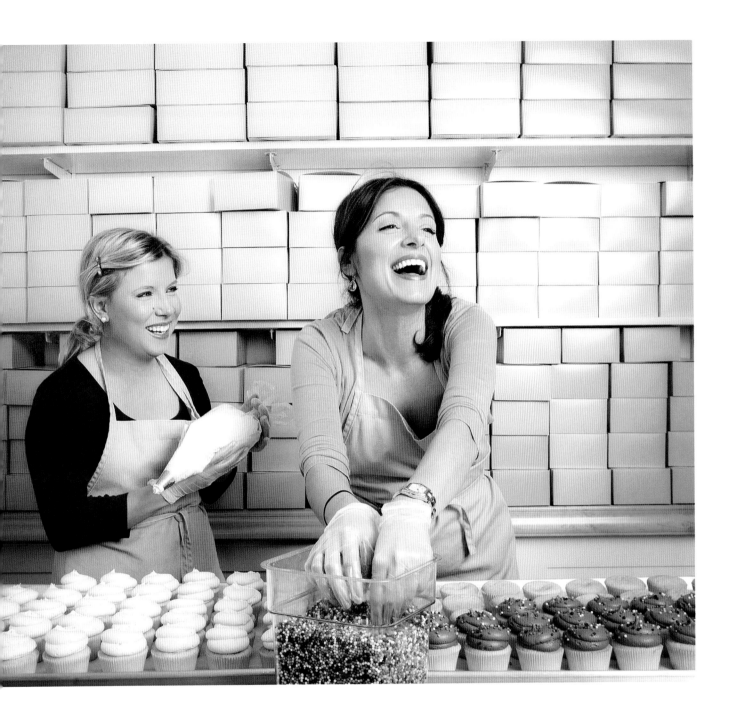

bakery together, inspired by our grandmother. We opened Georgetown Cupcake in Washington, DC, on Valentine's Day 2008. Since then we have expanded Georgetown Cupcake to five additional cities (Bethesda, Maryland; New York City/SoHo; Boston; Los Angeles; and Atlanta), begun shipping our cupcakes nationwide, and developed a cupcake and frosting mix baking line in partnership with Williams-Sonoma. With a menu of over a hundred different flavors, we now bake over twenty-five thousand cupcakes a day and have over three hundred employees across the country. Our cupcakes have been featured in publications and programs such as the *New York Times*, the *Wall Street Journal*, *USA Today*, the *Washington Post*, CNN, *Better Homes and Gardens*, *Food & Wine*, *People*, *InStyle*, *Town & Country*, NBC's *Today* show, *Good Morning America*, *The Oprah Winfrey Show*, and *The Martha Stewart Show*.

When we first started to seriously discuss opening Georgetown Cupcake, our family initially discouraged the idea. They had come from Greece and had the mentality that they were working hard to send us to college so that we could work for large companies. So we went to college and ended up working in the finance and fashion industries. However, we never let go of our dream. We always talked about it, and finally, in the summer of 2007, we asked ourselves if we were going to spend the rest of our lives wondering "What if?" We had a very frank and honest conversation, and we decided to take the plunge and start Georgetown Cupcake. That moment—the one when you decide to become an entrepreneur and make your dream a reality and give up predictability and stability for uncertainty and the unknown—is a very frightening one. When others around you doubt you, you start to doubt yourself. The most important thing is to have confidence, believe in yourself, and stay focused on your goals. We haven't looked back since.

As a businesswoman, it's important to have confidence in your abilities and believe in yourself. We've always viewed ourselves as equals to any male CEO. Persistence is also important. When people have told us no, we've always found a way to get to yes. We also try to stay focused on our goals and block out any negativity. We try not to pay attention to what others are doing or saying—especially if it is negative. To succeed, it's important to be able to tune out any negativity to stay focused.

All entrepreneurs have an entrepreneurial spark in them—and it's only a matter of time before you know you need to take that leap of faith and follow your dream. We honestly could not imagine being happy doing anything else.

The best part of being an entrepreneur is that every day is different. At Georgetown Cupcake, we're constantly developing new flavors and working on new projects. Right now, we're focused on developing more flavors for our cupcake and frosting mix line with Williams-Sonoma so that Georgetown Cupcake fans around the world can bake their favorite flavors at home.

One of the best parts of starting Georgetown Cupcake is that we can see the tangible impact that we have on people's lives every day—whether it's witnessing the smile from a customer whose spirit was lifted by entering one of our shops or the photos of our cupcakes that our customers share from their weddings, anniversaries, children's first birthdays, and other milestones. When we first started our company, it was hard for us to imagine that something as small as a cupcake could make such a large impact. But as we've grown our business over the past ten years, we've learned that that has been the most rewarding part of starting Georgetown Cupcake—it's not just about sugar, flour, and eggs, it's about spreading love, comfort, happiness, and joy to others. Witnessing that firsthand helps us know we've made a difference.

As entrepreneurs, it's important to give back to your community. At Georgetown Cupcake, we support numerous local and national charitable organizations that are focused on women's and children's issues. Giving back to your community is one of the most rewarding parts of owning your own business and a way to build strong relationships within the communities you serve.

For all the young girls out there: if you are thinking about being an entrepreneur and starting your own company, go for it. Entrepreneurship is not for the faint of heart; it can be scary and uncomfortable at times. However, you should embrace the uncertainty. Feeling uncomfortable is a good thing. It means that you are challenging yourself and breaking barriers. Most importantly, believe in yourself and dream big.

REBECCA BLUE

is a space health expert

Aerospace medicine is a field of study that requires primary medical training, then an additional period of time dedicated to studying medicine in aviation and space environments. After medical school, I first trained as an emergency physician, then in aerospace medicine at the University of Texas Medical Branch. Since that time, I have had the great fortune to work in a number of positions within the aerospace medical field, in both the commercial spaceflight industry and in support of NASA medical operations, including current spaceflight activities and in planning for future missions to the moon and Mars.

I was fascinated by aviation and spaceflight as a child. When I was seven years old, I remember telling my mother that I was going to work at NASA. When her response was "Oh, you want to be an astronaut?" I responded that, no, astronauts would need doctors, so I would be an astronaut's doctor instead. I'm not even sure I really understood what that entailed, but I remember thinking that it would be an honor to be able to take care of such incredible people. Regardless, I suspect I would have found a way to be a part of the space community, one way or another. I have always loved math and physics—if medicine hadn't called to me, I would probably have ended up in another science field that involves human spaceflight.

The aerospace field changes every day, and each day is full of new challenges, unexpected turns, and endless opportunities to make a difference. For me, a perfect workday is exactly this—the opportunity to be a part of the space community as we strive to leave our own world behind and venture out into the universe. The field of aerospace medicine is expanding—we are getting very, very close to commercial spaceflight, and we expect that the number of people with the opportunity to fly to space will increase exponentially. All of these new astronauts will need doctors, too. We are setting new goals to return to the moon, followed by missions farther and farther from the Earth—I'm excited to see how the role of those of us in the aerospace field will change to support this rapid expansion of human spaceflight!

I have been fortunate to have extraordinary role models and mentors throughout my life. One person who has always been a source of inspiration for me is my sister, who is an amazing person: she is poised, graceful, and independent. I have looked up to her ever since we were little girls. When I entered the field of aerospace medicine, my program directors, two extremely experienced and talented aerospace medicine physicians, were a source of unending encouragement and examples of the type of doctor that I wanted to be. They taught me the role of aerospace medical physicians, which is to support our pilots—our job is not to ground pilots or astronauts but, instead, to keep them flying, and to provide them the medical care and preventive health interventions that keep them in the skies.

There aren't many women practicing aerospace medicine, but there aren't many aerospace physicians practicing in general. I believe that excellent work speaks for itself—my goal has never been to be an outstanding *woman* in this field, but simply to be the best physician and scientist possible. If I can

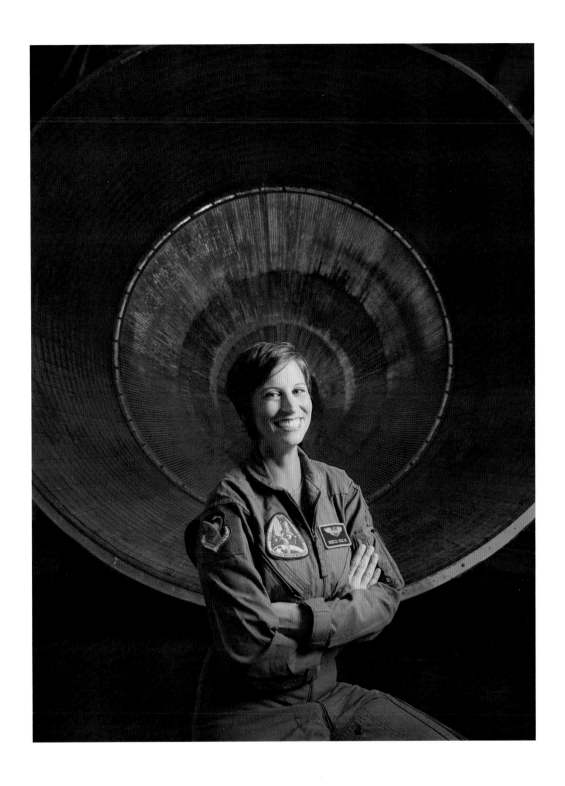

achieve that, then the quality of my work will stand for itself.

I would encourage all young people to find their passion in life, and to never let anyone convince them that their interests are not worth pursuing. My daughter is just a few months old, and I am already looking forward to discovering the ways in which this world will delight and excite her. I believe that the most important thing we can teach our children is to be fascinated by the universe around them, and to find opportunities in whatever ignites their soul.

TIQUICIA SPENCE

is an Army NCO/CBRN NCO

I grew up in Philadelphia and went to Penn State for college, which is where I first began the Army ROTC program. I was interested in becoming an officer in the military and planned to achieve the rank by obtaining my degree. After a year I decided that instead of becoming an officer, I'd enlist as a Non-Commissioned Officer (NCO) and ended up joining the Pennsylvania Army National Guard in 2004. I completed basic training and individual training, and returned home to be stationed in Lock Haven, Pennsylvania, in the Penn State area. I wanted to continue school but was deployed to Iraq shortly after training; I returned home from overseas to obtain a full-time position with the army and bounced from Lock Haven to Easton to Lehighton, Pennsylvania, and eventually ended up back in my hometown, Philadelphia. Over the years I've held five different MOS's (Military Occupational Specialties)—five different job titles—in the military.

The CBRN (chemical, biological, radiological, nuclear) position has been the most challenging thus far. My training was conducted at Fort Leonard Wood, Missouri, which houses the only site in the United States that trains with live agents. My battle buddies and I completed various levels of HAZMAT training, along with scenario-based training that required us to wear full SCBA (self-contained breathing apparatus) gear; it was incredibly stressful but we made it through and graduated with flying colors. My next position was going to be a supply NCO, far different from the chemical position I now hold. With lots of administrative functions it's very different from anything I've done before. In my previous full-time job I functioned as the training NCO, working alongside and closely with the commander, setting the training schedule for future events, and preparing the soldiers for the next step in their careers. Supply deals with maintaining property, handling incoming and outgoing equipment, and maintaining sensitive items: it's more so property management as opposed to training soldiers but I'll take it.

My first introduction to the military was my family. My brothers and dad were all military, as well as some uncles and cousins. I loved the diversity of the service and the opportunities to travel and meet new people. I also liked the monotony. You take in the schedule. You stick to that schedule, and your job, for the most part, is pretty predictable. You know what to expect, and you know what's expected of you.

Being a woman in the military is substantial. You've got to take in experience and make the very best of it—it's not for everyone. Until recently, the combat arms

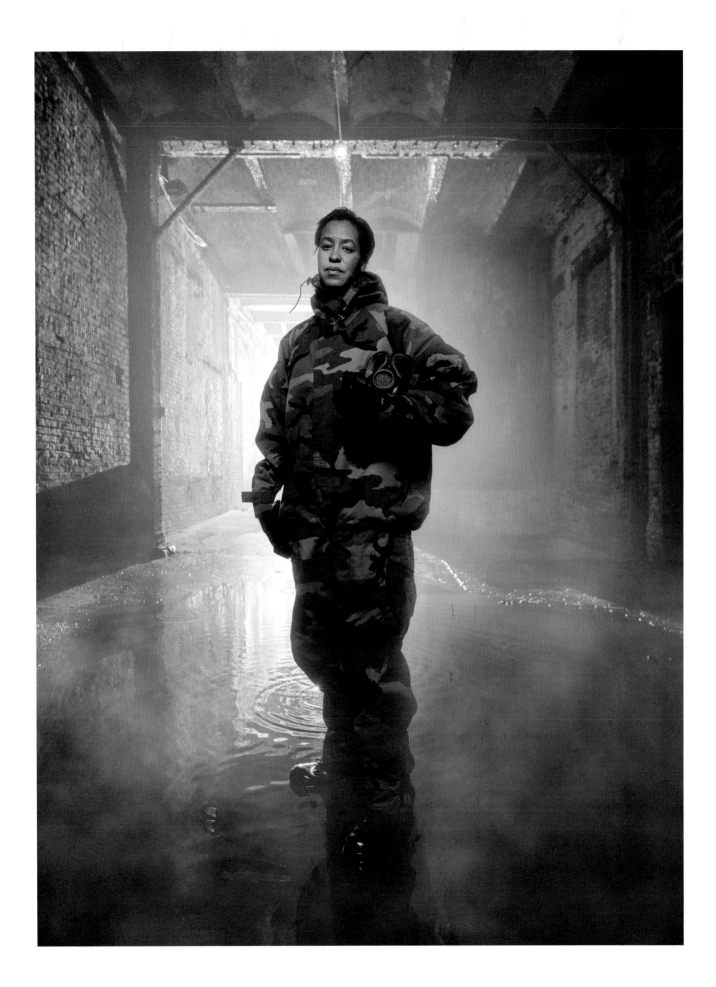

positions, infantry, CAV scouts, and engineers have been male-oriented, but the military is transitioning and female soldiers are being given the opportunity to fill these jobs. This is the first time ever in history where we'll have women serving alongside of men as engineers and infantry soldiers. People can say that they don't like it; they can say that women don't make the cut, but it's happening.

It's all about how you train. I've seen both women and men who are great in a particular position but not so great in others. Male or female, you just have to be able to do the work, without expecting leniency—you do the job just as efficiently as any other person in the world. This is something that I strive for and will continue to exercise.

I'll be comfortable in a full-time administrative position, but no matter what you pursue, you have to commit, and it's a very, very big commitment. Imagine: There you are, a woman training with what used to be an all-male unit, or training for a job that used to be all-male. You're going to come across scrutiny from your counterparts. You just have to be physically and mentally prepared to deal with that kind of reaction. It's inevitable.

It's worth the risk. The benefits in the military are wonderful. I know my son's taken care of. I've got medical benefits for myself. If I go to retirement, I have benefits that I can transfer over to my son to make sure that he'll have them for the rest of his life. I know that he is going be well-cared for; that I won't have to worry about that.

If you're interested in the military, I say just keeping reaching for the top. Opportunities are going to come as long as you work. Some younger soldiers don't see the rewards in the near future, but as long as you continue to work hard and do everything you're supposed to do, do your best at your job, something will come along—always does. I've been very, very, very lucky, and it's taken some time for me to get where I am. But that's because I didn't quit. People looking from the outside in, they see that work ethic in you. And you'll get those job offers. You'll get the promotions. You'll get those opportunities, because your leadership sees your potential and that you're serious about the job. Above all, you must be patient and never, never stop working.

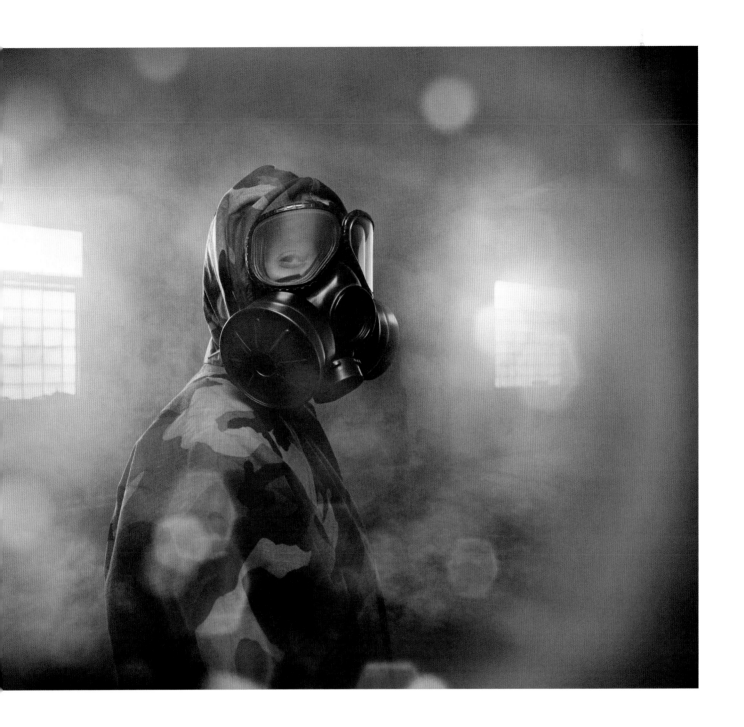

ALISON GOLDBLUM

is a luxury home builder

I did not begin my career in real estate; I started out my career in public relations in New York City. PR was fun for a time, but eventually I was burned out by the hours and the lifestyle—it just wasn't for me. My father had remarried and I had a new baby brother, so I wanted to be closer to my family in Philadelphia. I liked the idea of working for myself, I knew how to sell, and I wasn't too fond of the idea of a desk job. I had always been a so-called people person, so I naturally found myself looking at becoming a realtor.

Real estate allowed me to explore Philadelphia, glimpse inside people's lives, and help clients navigate a particularly challenging and exciting moment.

After eight years as a realtor, I had become a pretty good student of interior spaces and had developed a good understanding of what made certain homes work and others fail. I began learning the vocabulary of interior architecture and design, and I had a feeling that if given the opportunity, I could design some really interesting spaces myself. I never thought of myself as a builder until my boyfriend, now husband, started his own creative agency and suggested that I could make it as a realtor. He was right, and I started to take the steps needed to make that happen.

With an investment from friends and family I bought my first property, a tiny home off a small side street in south Philadelphia. I recruited my crew and found my general contractor.

There are not many women in building and construction. I am usually the only female on the construction site. Like many industries, this one would benefit from some more diversity. I love being able to mentor women in this field. I have already guided two

women through their first renovations. I find that female builders bring a different perspective to the job site. I personally like the idea of being a new kind of "homemaker." When I design a layout, I like to imagine how someone would live in the space and what would make that home a happy one.

Compared to some of my recent projects, the first home I worked on was pretty modest and conservative. Still, once it was finished, standing inside filled me with pride and excitement; I could see how this could be a career. It didn't hurt that I also made a decent profit and was able to pay back my investors with interest.

Over a dozen builds and two little kids later, I am much more confident in my craft. My new work has more personality, I take more risks, and thankfully these properties sell quickly to people who appreciate what I am trying to do and want to make my spaces their homes.

My favorite part of the process occurs right after demolition, when everything has been stripped away and all that is left is the building's bones. In that moment I imagine how to shape the space into a beautiful and functional home. It's very energizing to begin seeing the trajectory for the home. As the project moves along, I like to bring my kids on-site to witness the process of how these houses become homes. My oldest is six, and he has gotten into the habit of saying "Wow! This is amazing. It's going to sell fast!" Which makes me smile.

My projects almost always entail rehabbing a home that has fallen into disrepair. I even renovated my own home; I stand behind and live in my prod-

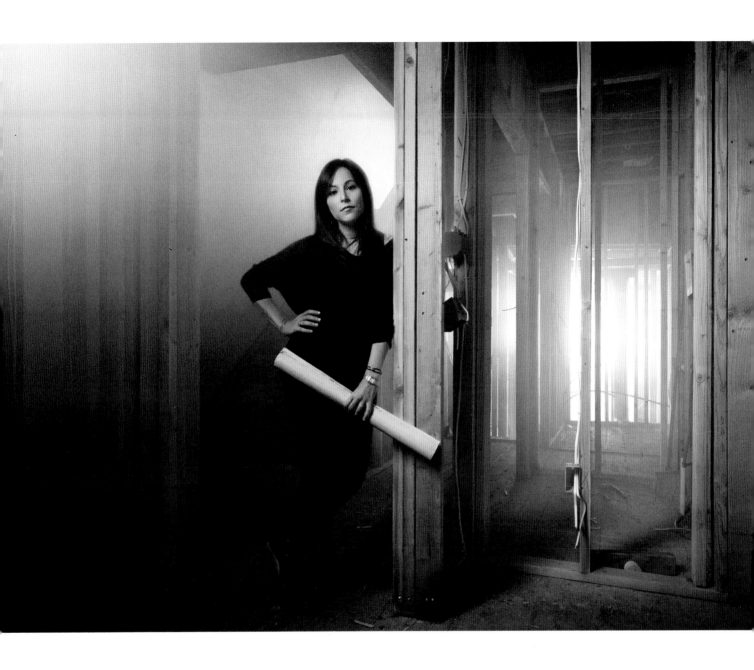

uct. These are not move-in-ready homes when I find them; often they are dilapidated and need to be fully gutted and rebuilt. In every home that I build, I try to design around the integrity of the neighborhood and the structure itself. Philadelphia is a very old city, which means that much of the real estate in the area has incredibly unique and intricate details that date back one hundred or so years. I do my best to save unique pieces from each home that contribute to the overall character of the environment. I like to preserve the original exposed brick, salvage joists into decorative beams and mantels, refinish original moldings, and save as many interesting pieces that I can.

Someday I'd love to design a boutique hotel. A home is experienced every day, so it usually requires some design restraint. A hotel can be a bit bolder, as it's just for a temporary stay. I think I would really enjoy the opportunity to take some risks and flex my creativity and imagination.

MARGAUX KENT

is a cofounder of Peg and Awl

To do my work, sometimes I have to go around the thief. More about that later.

I never made the decision to be a creator or an artist—I've just always made things. Anything I've made that has any value began with heart and action. When Walter and I started Peg and Awl in 2010, it was no different. At the time, I had been running my small business, the Black Spot Books, for three years, making journals, jewelry, and art. Walter was a painter and cabinet maker. Though it took time to convince him, my heart knew Peg and Awl was something worth starting—even if my brain didn't quite have a plan. I couldn't imagine it *not* working, and that may be precisely what a thing needs to work.

So we started with our not-a-plan and decided—before anything else—to call the business Peg and

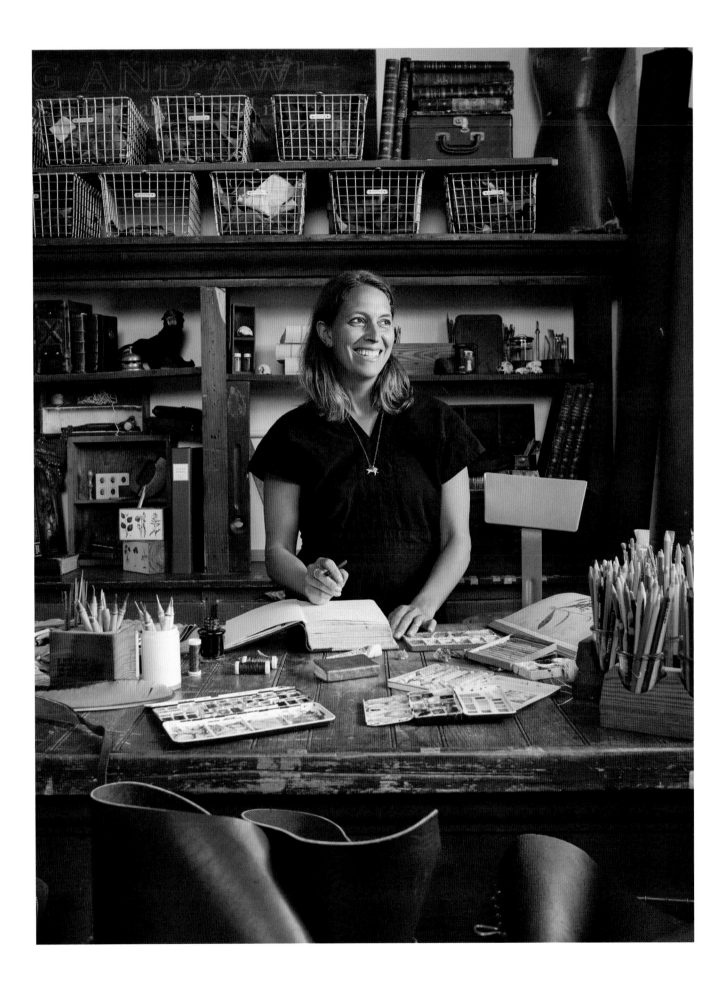

Awl after an old folk song. "So, what should we make . . .?" we asked ourselves. "Shoes!" we haphazardly decided. After searching around some, we found a description of a course in the UK, in the countryside. Søren was a year and a half at the time, and it sounded perfect for all of us. I sent a letter to the instructor and included a little hand-stitched journal. After not hearing back, I emailed and I received an immediate response: "Where I come from, the black spot is a bad omen; your package went straight into the fire!" We took *that* as an omen and decided to start with what we knew: bookbinding, jewelry-making, and woodworking, which led to journals, tub caddies, bags—and the business kept on growing.

We have a team of skilled makers that are up for any challenge. One thing we've discovered is that the more connected to real life a thing is, the more it resonates with the people who love the brand. Peg and Awl has never been about a particular product, though there are favorites. Our customers make return trips because of our blending of exploration, history, and nature. These are the threads that wind through all of our work. We tell stories, and we use reclaimed and sustainable materials as our canvases.

The material gathering began pre-Peg and Awl when my journal was stolen in Amsterdam. (Ah, here's where the thief comes in.) I set out in search of a book bindery and happened upon a reupholster's shop up the street—and thus I made my first book with reclaimed leather. And then I couldn't stop: I found some worn-out leather in a barn in Ecuador, and more in Israel in the corner of an old cobbler's shop. These adventures lead to making journals with reclaimed materials and with an already layered past. I'd grown up going abandoned house-hunting and

flea-marketing with my mom, so the charm of old things and the stories they held always stoked my curiosity.

When Peg and Awl began, Walter and I decided to create using abandoned bits from lives lived. Found material. From a construction site in Philadelphia: wood from the 1800s. From an abandoned barn, guarded by two enormous vultures: a stall filled with leather scraps. The more we looked, the more we found. We were reshaping the past to tell new stories, and our customer adds to this tapestry of time. We continue to make useful objects, but now we are sourcing mostly sustainable materials, as we've used up a lot of our store of found leather and the like—though we still bring in old materials when we can. Walter and I make things as we need them—and then we make them for everybody else! Our goal is to make simple useful objects suited for all.

As an artist and maker, I've always been an outsider, so I've always had a mentality to not let opposition interfere with my path. As a woman in business, I've run into gender inequality in the workplace. But my drive made me stubborn, and I thought: If I can't get through the problem, then I'll try to get around it. I did my best and then some. And I'm not alone. At the Peg and Awl workshop, I've been surrounded by women and stories of women who've forced their way in the world.

I was raised by a strong, independent mom who was determined to find her way out of her small country life on a mountaintop. She was an amazing artist but found her way into the work world via a math scholarship. She is steadfast and lets little get in her way. My dad's mom was also a strong-willed woman. When her husband left in the fifties,

my grandmother raised two boys on her own. It seems natural that I'd follow course. I had a lot to live up to.

As a woman, I am not fighting for a place at the table; I'm fighting to stay at my own table. If we have to go around to get around, we will. That was how Peg and Awl started, after all. Getting around. We get around the stodgy old methods and faux materials by finding our own and giving it a voice. Every woman who works here has a voice and a tale to be heard. Just sometimes you have to get around the thief.

TONYA RHODES

is a casino shift manager

Today I am a casino shift manager at Mandalay Bay Resort and Casino, but I started out as a dealer. When I first moved to Vegas, I was a single mother thinking about applying to the University of Nevada, Las Vegas, to work in a bank ultimately. But I looked at the casino industry and thought, well, that looks like a lot of fun; I could do that while going to school. Here I am thirty-one years later. I fell in love with it, with meeting different people. Every day's the same, but the people are always different. I started out at another place, that we call a break-in house, to get some experience before applying to a place like Mandalay Bay. I started out downtown and went to dealer's school. I learned blackjack, and then I learned all of the others. I moved around and dealt for twelve years, supervised for a few more. I got promoted to pit manager and then after that to assistant shift manager, until I was pro-

moted to my current position of shift manager. Today I manage the day-to-day operations of the casino, especially table games.

Here at Mandalay Bay, I'm the only female shift manager. But MGM Resorts embraces diversity and gives opportunities to women such as myself. I'm an immigrant from Vietnam. I came here not knowing a word of English. I learned as I went, and this country and, yes, this company, gave me a chance. I'm grateful to have this job, to do what I do. I will say there are a lot of Asian women dealers on the floor. I'm hoping that some of them will be inspired to step into supervisor or management, or leadership positions.

I always try not to focus on the negatives. I focus on what I do and what I'm capable of doing. I try to do the best job that I can each and every single day. And honestly? I kill people with kindness. I do. Of course

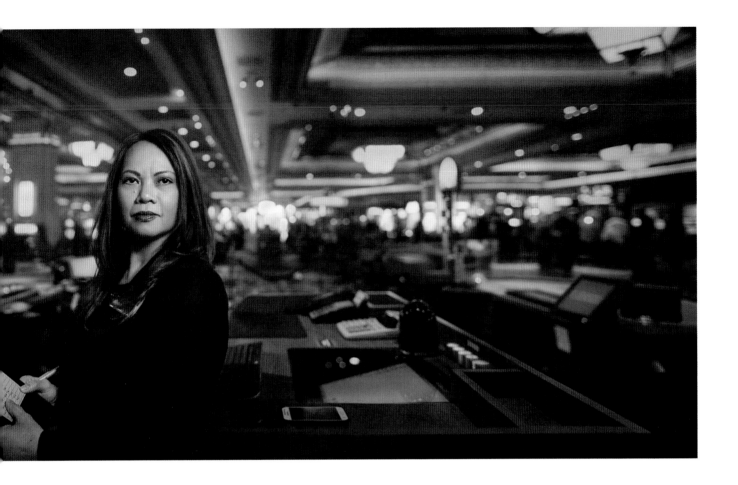

there are situations on the floor where I try to handle a situation with guests, and they'll say, no, they want my boss. I just tell them, "I am in charge of the casino. What can I do for you?" I try not to say I am the boss. I ask what I can do or what I can help them with. So again, you have to kill people with kindness.

I remember back in dealing school, there were three of us that became pretty close friends. There were me, a girl from Mississippi, and a girl from California. We graduated at the same time and all tried to get dealing positions. The counselor looked at the Mississippi girl, a gorgeous redhead, and he said, "You are going to go far with your personality. You're going to do great." He looked at the Californian and said, "And you're good, too." He looked at me and he said, "You know what? You're cute enough. Find yourself a husband. There's way too many Orientals in the business already." I remember thinking: I'm going to prove you wrong.

So I guess my advice to young folks would be: Don't let anybody tell you that you can't do something—in this business or any business, actually. If you find something you want to do, figure out what it takes to get there and do it. Learn as much as you can at school or on the job. Work as hard as you can. But don't ever let anybody tell you that you can't do something. You're capable. You're more than enough.

DESIREE REED-FRANCOIS

is the director of athletics at the University of Nevada, Las Vegas

I am beginning my third year as the director of athletics at the University of Nevada, Las Vegas (UNLV). Prior to starting at UNLV, I spent twenty-five years at institutions large and small, public and private, preparing me to lead in a dynamic, complex, and rewarding environment like college athletics. I come from a family of educators, and I played sports my whole life; college athletics is simply part of my DNA.

But it was not until 2004 that I even considered working as an athletic director. One day, I was sitting in a Marie Callender's restaurant, very pregnant with my son, Jackson, speaking with the former president of the NCAA, Ced Dempsey, who was on our campus doing some consulting work. He asked me what my career goal was, and I told him that I wanted to be the senior woman administrator at UCLA. He asked why I did not want to be an athletic director instead. At the time, there were two female ADs in the entire country (Barbara Hedges at Washington and Debbie Yow at Maryland). Until that conversation, I did not know that it was an option. Ced believed in me, and that made all of the difference in the world.

But even before that, my family provided my foundation; my brother inspired me on a daily basis. I have been fortunate to have been mentored and taught by some of the nation's best, and from them I've learned the importance of building teams, developing real, authentic relationships, and the importance of culture. College athletics is a people business, and we can never lose sight of the humbling responsibility we have to positively impact our student athletes' lives. I'm able to provide an education and incredible experience for the 480 student athletes under my watch.

Of the 130 people at the Football Bowl Subdivision level directing college athletics, there are nine women including myself. I believe that the more we can provide context, mentorship, and opportunities to the next generation, the more we will see an increase in women leading athletic departments. I want to continue the progress we've made towards excellence at UNLV by creating an environment that positively impacts our student athletes. Our athletic culture should serve as a point of pride for our global UNLV community.

To all of the young women, I say: Put your hopes and dreams on paper—and then ask yourself every day: Are your efforts aligned with your expectations?

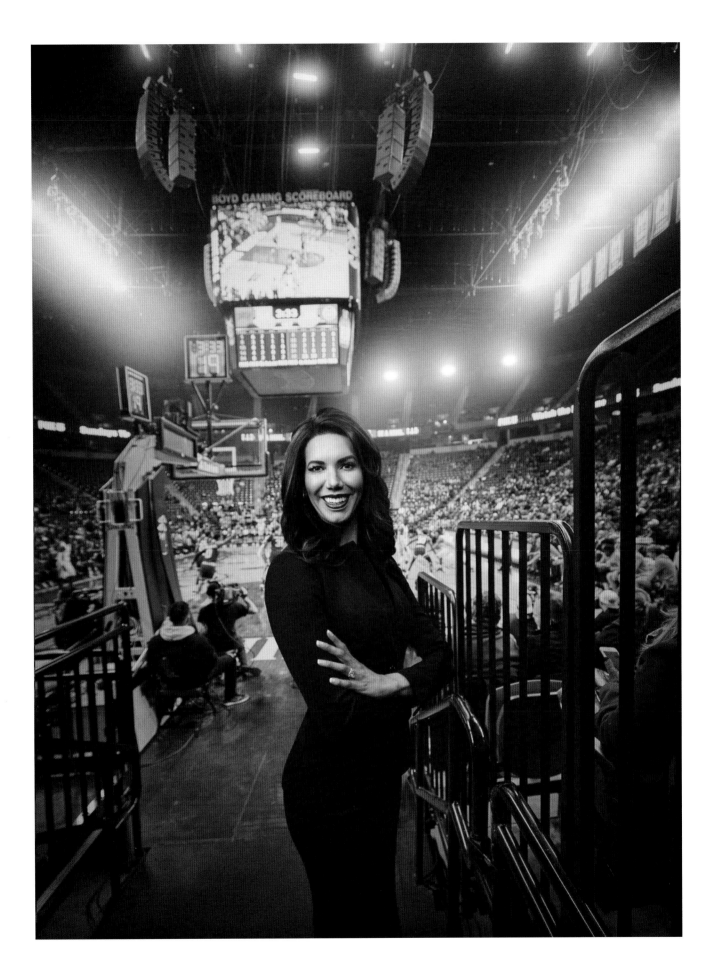

HEATHER PERKIN

is a winemaker

When I decided to go to university for winemaking, I'd had only one week's experience at a winery, during the off-season. I didn't really know any of the daily operations stuff. At school, the first year—I call it the culling year—was just straight science; you don't do any winemaking. I got through that, and I started to take some winemaking classes, which I found interesting. In my fourth year, I had an internship at Domain Chandon winery. I was very nervous that I had spent all of this time and money and could only hope that I was going to like the experience of harvest. Fortunately, I loved it.

I loved the intensity, I loved the camaraderie among the complete strangers that I was thrown in with, working alongside them for twelve-hour shifts, six days a week. I loved the focus. Everyone had the same goal. I finished up my schooling, and then I

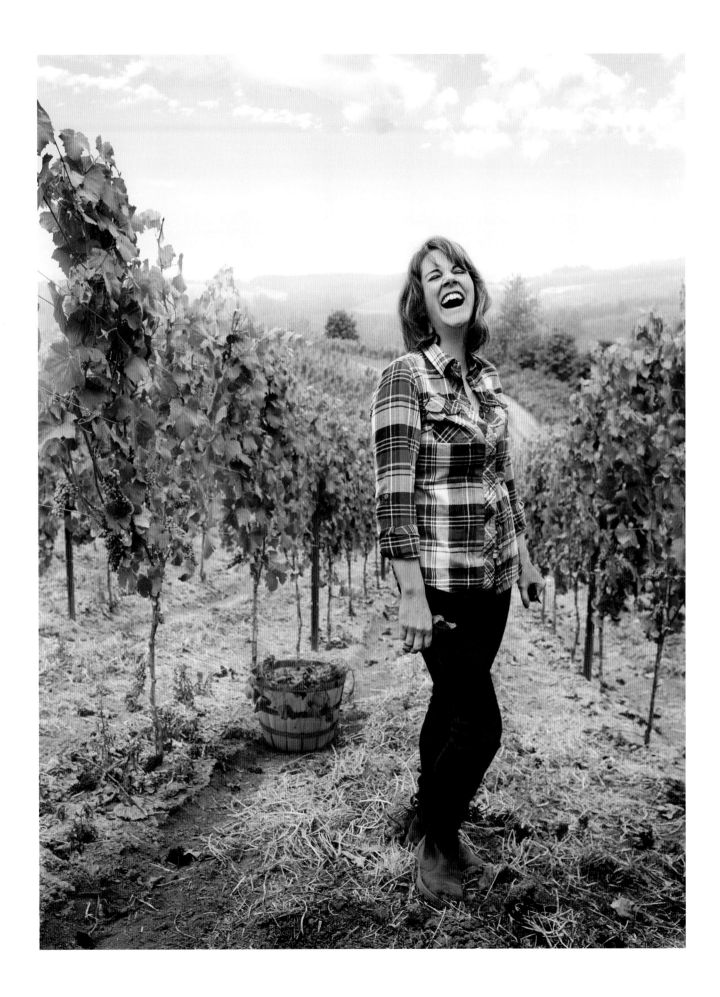

jumped into a harvest in the Barossa Valley in South Australia, at Elderton Wines. I got to work with the reds there; it was pretty intense. It didn't quite have the same cozy camaraderie from the first harvest. But everyone always says the best part of a harvest is the people: the team, the family atmosphere. I guess we're kind of adrenaline junkies where the intensity is concerned. I really, really do enjoy that, even if you can't sustain it for more than three months. I learned a lot at Elderton—not only about wine but about different people's personalities and how far I could push myself.

Since it wasn't a full-time position, I had to move on. I wanted to check out Elk Cove in Oregon, in the northern hemisphere; you have to chase the seasons if you don't have a full-time position. No matter where you are, you are always fighting the weather. This is an agriculture business, so you're up against the weather; you need to consider when disease pressure kicks in or if crazy weather does something bad to the vines; or you can't harvest because it's so muddy. The disease and weather issues in this climate are very different than in Australia, where I grew up. We have rain constantly up here in Oregon; you have to harvest your fruit before it rains too much. And then you only have so many tanks; for reds, fermentation can take anywhere from ten to twenty days. So that tank is occupied for a certain amount of time, but you've got more fruit coming in, so you have to turn your tanks, get them empty, and then refill them.

This is the most work you're going to do, when you're making wine. The rest of the year you're just babysitting. You're letting it mature and develop until it's ready to bottle. But 90 percent of our work happens in that two- or three-month period, climate depending. So you can't screw up the harvest. If you do, you have to chase your tail for the whole year.

I loved Oregon. I was stunned by how green it was, I was stunned by the wines. You can grow everything, every type of pinot noir. But then, of course, it

wasn't a full-time position. So I had to think of my next role, which took me to New Zealand. There I worked at Seresin in the Marlborough District and worked with a lot of sauvignon blanc. The sauvignon blanc is definitely their key variety. While I was there, I was trying to find a full-time job, but that is hard; there are a lot of winemakers, and a lot of qualified winemakers, in New Zealand.

So I came back to Oregon for another harvest with a very different crew. The assistant winemaker who had hired me had actually returned to New Zealand. So we were a little bit short staffed, such that even some of the office staff pitched in. The accountant and his wife came in on the weekends and helped to inoculate. Everyone was always like, "What do you need? We'll do it for you." It was an incredible family and particularly one with a lot of women.

My parents got divorced when I was young, and I'd been living with my dad since I was ten. When I was seventeen, my dad told me I needed to hone in on my subject choices for my final years of school. I was kind of a bit all over the board, and I said to him, "You know what, I think I'd like to be a businesswoman." I was actually thinking about all the nice clothes and the briefcase and the shoes that you get to wear as a businesswoman. He pointed out that I didn't study any business subjects in school. At the time he was connecting with the local winery and going to wine tastings; the region was very new then. I liked that these winemakers were also working collaboratively with the locals. There was just a lot of camaraderie. Everyone seemed so cool and happy, and you could travel. And you needed to travel if you wanted to get the experience, if you didn't land a full-time job. So it seemed like a pretty win-win scenario.

It didn't hurt that Dad had made a hobby of wine. He had grown vines in the Perricoota region on the border of New South Wales and Victoria. My whole family became involved for quite a while. On the weekends, the whole family would plant. I had never

been into gardening, so it was pretty cool to see these sticks turn into vines and fruit. But I never would have thought about winemaking until my dad decided to work on a vineyard.

My mum was super-capable of anything that she put her mind to. She moved from England to Australia when she was twenty-one, so I never felt that there were things women couldn't do. I had a great group of girlfriends at university—we still stay in touch—and among us there was never an attitude of "We couldn't do this." There were by far more male students at uni. But I was always sort of accepted at school. I was a little nervous trying to get jobs, though, I must admit. I really emphasized my physical abilities and experiences, that I'd worked with my dad on the vineyard. While I've only worked at two Australian wineries, I've heard from other people that it feels a bit like an old-boys' club among the winemakers. So in Australia, as a woman, I guess I felt I needed to prove myself more. Whereas in America, I've just been me. I'm not a damsel in distress by any means.

I love my career. I couldn't be a stay-at-home mum. I admire those who can, but I think for the happiness of my kids—and my own happiness—I need to work. You're always going to strive for balance. It's super-daunting trying to figure out your career with that in mind. I think I was really lucky to pick something and just go. But I often think it's a tricky lifestyle to maintain with a family. When you're seventeen or eighteen, you're not really contemplating that balance. I wouldn't want my kids considering that at that age. But you've got to think a little bit without getting too overwhelmed with the choices you make. It doesn't hurt to think a little bit about where you want to be in your thirties and your forties. And is that with kids? And is the career that you're considering viable? Unfortunately, you do need money in this world, and you have to think about how to set up your career to have the lifestyle you want.

So I encourage traveling and trying a lot of fun stuff in your early twenties. But do think about where you're going to want to be. Consider your future and your relationships. You'll have to compromise—you have to consider the other person's goals if you want to be in a relationship with them. And that can change your plans, change your perspective, change your options. I know it can sound scary and daunting, but you can do it, and you can dig deep. Just try and keep a level head, consider the future, but don't get too stuck in thinking about the future. The best advice I can offer is: Have fun, and keep a really good group of buddies around you.

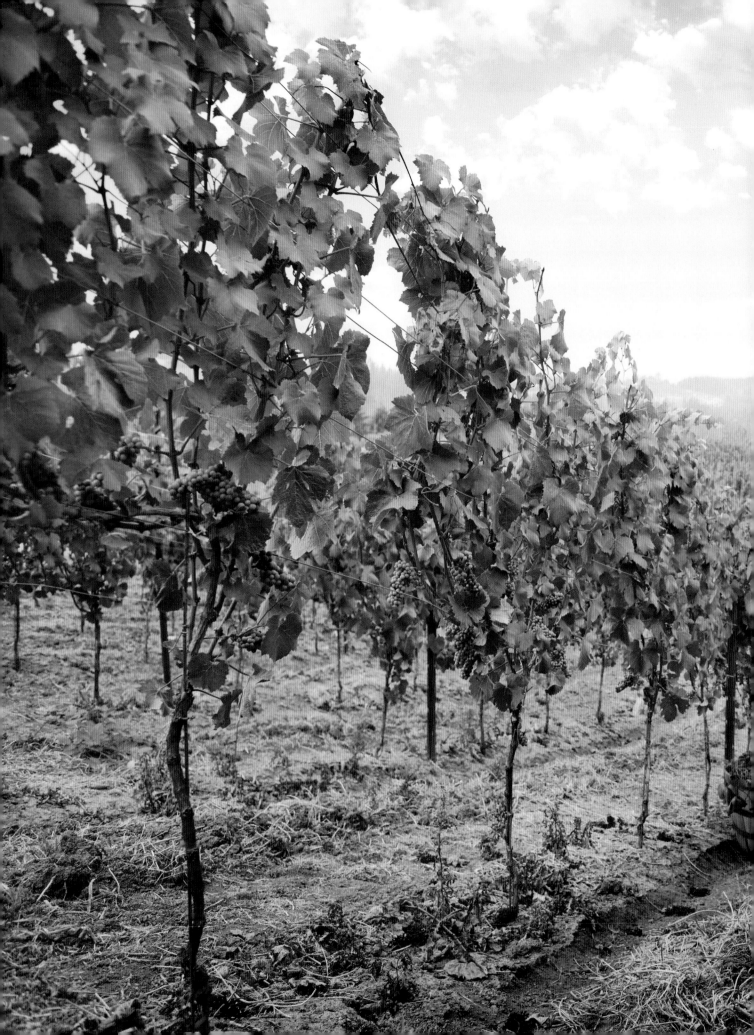

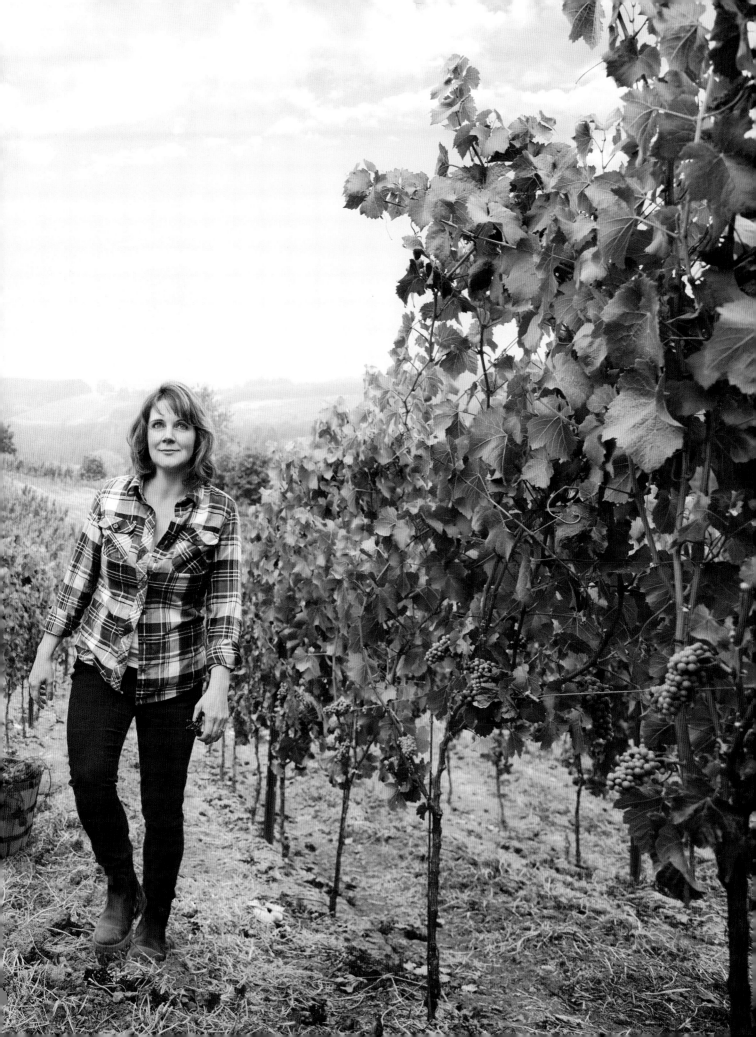

CARLA HALL

is a blacksmith

I started metalworking when I was in college in the mid-nineties. I knew that I loved the processes of metalworking, especially working with steel, within the first few months of exploring metals. I began metalsmithing and welding in my early twenties, and when I was introduced to a local blacksmith shop, I was beyond excited to begin hammering and shaping steel. Once I began smithing, I was hooked. I ultimately left college to explore metal sculpture and blacksmithing, moved to the mountains of North Carolina to train at Penland School of Craft, and then landed on the West Coast to finish college, while working with blacksmiths in Seattle. I then moved to the Bay Area in 2000 to work with professional smiths, developing technical metalworking skills. From there I began working with the Crucible, a nonprofit industrial art school. I established Carla Hall Metal Design in 2005 and began to find clients and worked as an arts educator.

I grew up in a crafting family in North Carolina and in the Appalachian craft culture. My grandfather was a woodworker and mechanic; my grandmothers and mom worked with textiles. My family was self-sufficient and emulated a do-it-yourself culture from a young age. It was our normal and our way of life.

Aside from my family's influence, my early mentors and teachers have led me to where I am now: those who encouraged me to pursue the craft, knowing it was hard physical work and involved many years of training, especially the women smiths who paved the way for me as a young aspiring artist and blacksmith.

Through them I have learned that community and a network are very important. You must build relationships and community, lean on mentors, collaborate, and share ideas to grow as an artist.

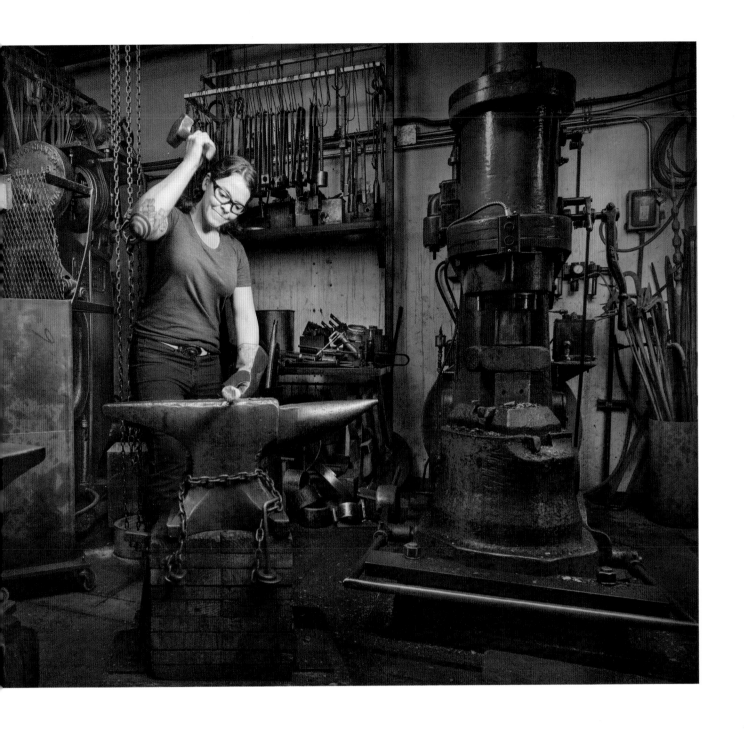

235

More and more, women are becoming metal artists and blacksmiths. With the Maker movement and the resurgence of blacksmithing in sculpture programs in colleges and universities, young people and young women are given greater access to the craft than I had growing up. Social media, especially Instagram, are playing a big role in access to information and idea sharing for artists.

Still, it is less common for women to be in this field. The traditionalists and folks in more conservative areas, especially outside of city centers, still seem surprised to meet female blacksmiths. In the last year since moving to Minnesota, so many people have told me they've never seen a woman blacksmith before or that they didn't know women could be blacksmiths. This reminds me there is more work to be done in terms of access and exposure to the craft, women's abilities, and the many amazing blacksmithing talents around the world.

I work at being open minded and not defensive when people, mostly men, bristle at the sight of me forging. Most people are genuinely interested and have simply never seen a woman smith. They may watch me work for a while and ask questions. I look at it as a conversation between two people who are very different. This exposure, these conversations, help us all grow.

I balance my work in the shop with teaching, designing, and managing my business. Only some days are for forging and metalworking in the shop; other days are for drawing and design, client meetings, business management. I enjoy teaching and sharing my knowledge of the craft, especially with those who don't traditionally have access to it. I have worked with youth, people of color, and women for many years, and this remains my priority. In my opinion there is far too little access, value, and relevance of blacksmithing in poorer communities, communities of color, and for young girls and women. To me a perfect day is firing up the forge, hammering steel, and working alongside other people who are super-excited by the process. I thrive in a creative communal space.

I plan to continue to develop the craft. I am far from a great blacksmith, even after twenty years of practice; there is always room to grow and learn. I want to take on more challenging smith projects and continue to grow as an artist and person. I would like to do a personal exhibition, which would tell my story through blacksmithing.

My advice to young women interested in blacksmithing—or anything—is to follow your heart and find what works for you. Don't let other people discourage you from something you find exciting, especially when it feeds your soul. Making things, being creative, sharing ideas, taking risks, and connecting with other people are a great part of being alive, regardless of your gender, the color of your skin, your culture, how much money your family has or doesn't have.

Happy hammering!

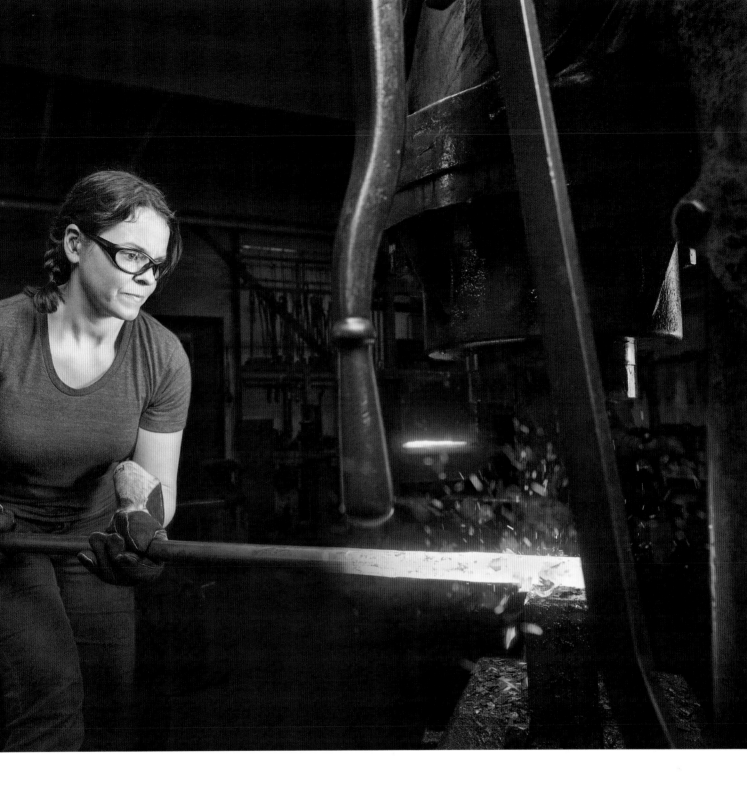

JOURDAN IMANI KEITH

is the founder and director of Urban Wilderness Project

I've been writing poetry since I was a teenager, which is, I guess, a pretty common way to express what seems like it can't be said, especially when you're an adolescent. And my original connection to writing poetry, actually, was because of an outdoor experience I had. The genesis of writing poetry really did begin when I climbed this mountain in Maine with a camp counselor who had made me promise, if I was going to go to the quiet side of the mountain with her, that I "wouldn't bother her." So I had to find my quiet spot, and she would go to the other side. I agreed, but where I sat, there were all of these bugs everywhere. On the West Coast, we're like, "They're insects, and we're one with nature," but I grew up in Philadelphia. So I was like, "There are bugs here." There are bugs. That's what we call them, that's how we feel about them. But I was trying to have this quiet moment, and I'd already promised this counselor that I wouldn't bother her. I couldn't get up. And what was I going to say, that there were bugs? So I just sat there and I closed my eyes, just to give myself some visual peace from everything that was moving on the ground and flying in my face. And when I opened my eyes, a bird flew by at eye level. I was on the side of a kind of mountain on the cliff, and it's not a mountain compared to the mountains that are on the West Coast, but for me, it was like, "What? A bird just flew by at eye level." It blew me away.

I tell that story because I had a natural high, which people make fun of, but I was so exhilarated by the experience, because I closed my eyes, and I opened them and saw that bird. And then, without knowing it, I started doing these sensory exercises that later

on I would teach as an outdoor environmental educator. For example, I'll say, "Well, okay, close your eyes. Now see what you notice after having them open now. And then deprive yourself of hearing. Close your ears, and open and just look." And it was amazing. So coming back from that trip—I was clumsy then, I'm still clumsy now, which is not really what you'd think of as a good trait for an outdoor leader, but it's the truth: I fell down the mountain. I did a forward aerial somersault. No kidding. I tore all the skin off my hand. But I was so exhilarated that I didn't feel it yet. What kept me okay was that natural high. We now advocate for getting out into the wilderness for one's good health. That's what happened to me. And I came back to my cabin after this incredible experience, not even feeling fazed by how much I'd hurt myself, and wrote a poem. I hadn't written poems at that point. I kept a journal, but the fact that for some reason I chose to write a poem as opposed to telling the story about how amazing it was really made me connected to loving the mountain, starting to write poetry, shamelessly showing it to my counselor, etc.

When my students think their poetry is horrible, I say, "I actually have the evidence from my first poem, so do not. The heavens didn't open, and I didn't write this poem that's so amazing. I just wrote down what I felt and what I was excited about." And so that experience, long before I knew I would be a teacher of poetry or lover of the outdoors, influences how I work with young people in my encouraging them to write about whatever they feel exhilarated about. I remember that experience because I wrote it down. And so years later, fast-forward to when I'm teaching middle

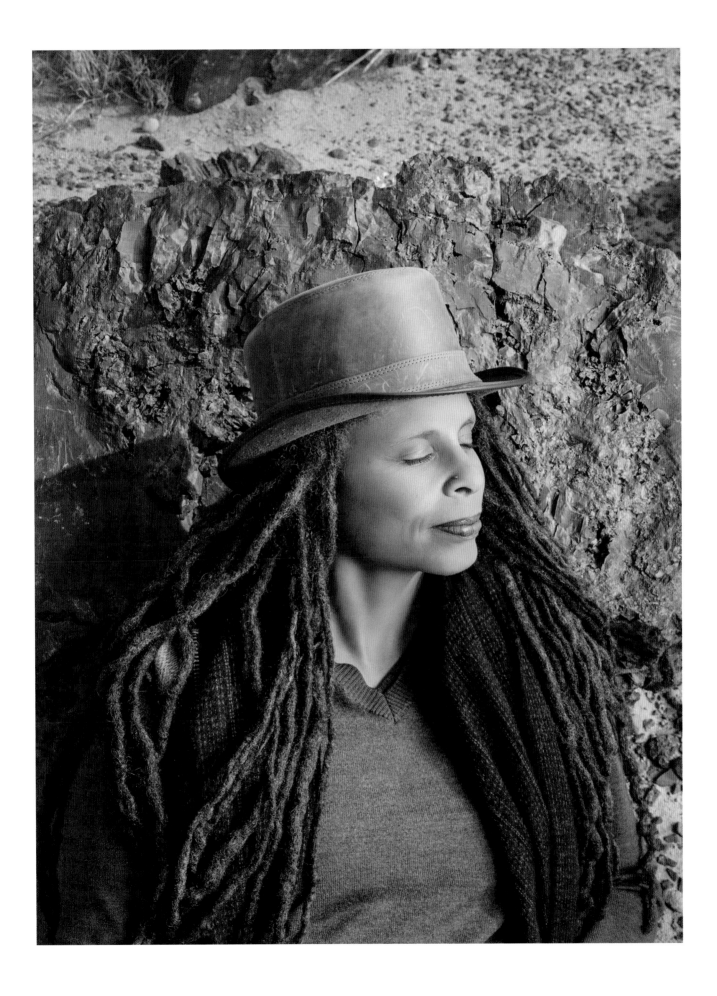

school students about marine ecology and forestry and all that, I started using storytelling because I stumbled into it.

When I first began teaching and I didn't know what was happening, I would tell a story and the students would become quiet and focused. And I tell stories now to high school students and adults, and it's completely different from poetry, the way that people stay with you and follow the journey. I'll sometimes ask students to tell me a story about what I'd been teaching—that day, a microforest. And they told me these stories that showed that they really understood what I'd been teaching for an hour about forest and mycorrhizal fungi and decomposition. And so, as an educator, I fell in love with storytelling and then started using it.

As an individual trying to deal with a lot of the challenges that I face as a woman, as a black woman, as a person who loves other women, storytelling became a way that I could stay rooted in my African storytelling traditions but also a way to aid me in navigating the world. I like to use poetry and storytelling and activism, I guess, to prompt people to notice that we all see the world differently. I think this maybe creates some empathy.

One of my major influences in this has absolutely been Sonia Sanchez. She is the person who taught me about poetry. I was young, and she loved haiku, which is a Japanese form that has developed and changed as it's gone around the world but is very much rooted in the natural world and observation of the natural world. Her approach to haiku is definitely as an activist, definitely as an amazing black woman. She noticed how the Japanese especially, even during internment, had used haiku to survive. She talked about the way it had a connection to the blues, for her. I teach her work now and have written poems about her and about honoring her work. She recently won a lifetime achievement award from the Academy of American Poets. And on September 16, 2018, if Hur-

ricane Florence doesn't keep me from getting there, I plan to read her work at the African American Museum in Philadelphia in her honor. I use haiku the way she taught me to use haiku: to embrace our humanity and our sexuality. Haiku made it very clear that she understood that we are nature. I never heard her use those words, but that certainly is something that, if I have the opportunity and the right audience to talk about, I do.

Another woman who has influenced me is Liz Titus Putnam, who founded the Student Conservation Association at a time when women were not allowed to do that sort of work. I feel fortunate that I met her and I've gotten to know her. While she isn't a day-to-day influence, when I reached out to her and told her that as a black woman, I felt like giving up sometimes because there were so many "invisible" barriers—it's like you're running into a wall that you know is there and other people are telling you isn't there—she really encouraged me. And I appreciate that, and I feel very strongly, if nothing else gets written down, that Liz Titus Putnam needs to have a national park named after her. She has to. She has influenced the entire country and the world to have a youth crew. It was her idea to have young people go out into the wilderness and work. And all these men have parks named after them. Let's not wait until she's dead. She's in her eighties.

When we talk about identifying as a female and being identified as a female, age always factors into our perceived limitations. Always. Whether you want to accept that or not. So a man can be in his late sixties and be doing the same work and no one doubts his ability to hike up and down the mountain. But as for a female just hitting forty, many look for someone younger to do the work.

I'm carrying sixty pounds on my back up and down a mountain, sometimes with cramps, with men half my age, and they whine. Even when I'm told, say, "Oh, we're looking for someone younger who could relate

to the kids this way or that," what they're saying is, they don't see you. They literally, physically don't see you in the field because of the barriers that have existed before. They can't imagine you doing that work because they often haven't seen other people like you doing it.

And so then add to it the layers of assuming that as a black woman, you don't want to be out in the woods. You don't want to be out here in these wild places. You don't want to be far from the city. But that is actually what I do want to do. There was a job interview I had where it became clear they couldn't tell over the phone whether I was black or white or what. Later, the two people who hired me had become my friends and disclosed this to me. They had had a bet going on whether I was black or not. And when the one person met me, she said, "I'm so excited to meet you." I couldn't figure out why until I learned she had lost the bet. So I almost didn't get a job, not because they didn't want to hire a black person but because they assumed that I wouldn't like the job and wouldn't last long. But that's what I'm talking about as an invisible wall. It's not like they didn't want me there; they just didn't know anyone like me. They were only used to a bunch of white people out in the woods.

You have to consider how the history of segregation has played out in all parts of life in the United States, even in the national parks, just like everywhere else. It influences my work as a black woman, very much feeling like access to wilderness is an issue of equity. It really is.

Part of the challenge that I share with people is, I've been doing this work for a while and then I'm very candid because I want my colleagues to understand that we're having a different experience of the same outdoor pre-wilderness trip and post-wilderness trip, we're having a different experience in the town; we are looked at different, we carry a different history. And I feel like it's very important to share that so people can have their eyes open.

I did a staff training for two young white women who were going to lead a trip in my place after a car accident. The group that they were leading was going to be predominantly African American kids. So part of the staff training involved empathy—getting them to see through our eyes and show them that their role was to keep those kids safe in a different way, that risk management wasn't just the trail knowledge. That particular gaze is not something invisible that can't be made visible.

Over the last two years or so, I have been working on transitioning my organization to new leadership for the wilderness programming and continuing the legacy of Urban Wilderness Project through trainings and public speaking. I hope that my writing will be applied to others' work in developing crews of young people and leaders who want to better understand that there is an intersection between gender and ethnicity and the environment. I believe that if one intends to change the landscape of the work that we're doing, one must be mindful of that intersection.

I hope to share my wisdom and advice with other young people interested in this line of work. I have to say, the advice that I'm living right now actually comes from another woman, a deaf jazz singer I just learned about by the name of Mandy Harvey. I felt very encouraged by her words, which were, when you come to the obstacles, you have to figure out how you're going to go around them. I'm paraphrasing. So I'll just say how it rang true for me and how it's opened up doors. You keep your goal in mind, and you measure yourself as you go towards the goal. Because if you look at the goal and you say, "I'm not there," then you'll give up.

It's important to know where you are on your journey toward your goal because you're not going to wake up and be there. Things will get in your way. For example, [in 2003], the year I started the Urban Wilderness Project, I got in a major car accident that was so bad I couldn't pick up my leg to get in the car,

let alone hike up a mountain. I took action. I switched therapists and physical therapists and chiropractor and massage therapists because I needed to find people could get me back to the place where I could lead wilderness trips. I needed to get in shape enough to carry sixty pounds on my back again. Eight years later, I was hit by a car while walking. I had been in a major accident in 2003, which sent me on a path toward healing; the 2011 accident required me to accept that I could not heal in time to lead our seventeen-day summer programs. I had to find another way. At that time, I had to tearfully tell the National Park Service, a partner for many years, that I couldn't pull off the trip that year. But what resulted from that experience was that our organization changed its structure to focus more on eighteen- to twenty-four-year-olds, who desperately needed the program but needed less from me physically. An incredible door opened up that changed our program entirely. And in my recovery, I found a massage therapist who has now been on my advisory board and board of directors; all of her younger children have been in my program, and one of them has become a leader in the program and co-trains me with me at times. So that horrible, horrible you-have-got-to-be-kidding-me obstacle could also lead to a connection that you can't even fathom.

I took action. I switched therapists and physical therapists and chiropractor and massage therapists because I needed to find people who could get me back to the place where I could lead wilderness trips. I needed to get in shape enough to carry sixty pounds on my back again. At that time, I had to tearfully tell the National Park Service, a many-years partner, that I couldn't pull of the trip that year. But what resulted from that was that our organization changed its structure to focus more on eighteen- to twenty-four-year-olds, who desperately needed the program but needed less from me physically. An incredible door opened up that changed our program entirely. And in my recovery, I found a massage therapist who has now been on my advisory board and board of directors; all of her younger children have been in my program; one of them has become a leader in the program and cotrains with me at times. So that horrible, horrible you-have-got-to-be-kidding-me obstacle could also lead to a connection that you can't even fathom.

Just go around the obstacle. Don't try and go through it. You're going to go through it anyway. But don't lose sight of your goal. Just know where you're headed, and give up enough for something else to come true. Give up what you thought was going to happen, but don't lose your goal.

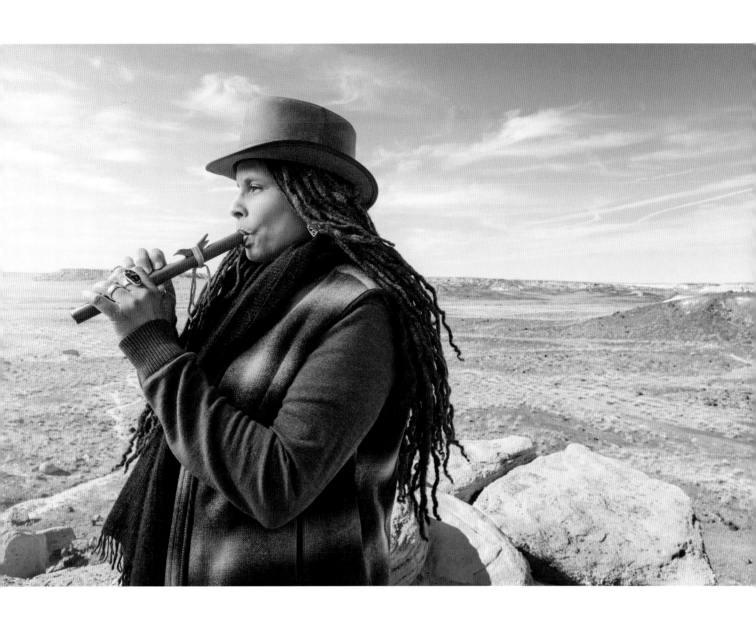

ACKNOWLEDGMENTS

I am grateful to every woman who has gone out on a limb to share her story. It is not always easy to stand up and speak out. Thank you for sharing your voice.

Many others have given time, effort, and resources toward creating this book. The road in bringing this book to life has been long. There is a strong sense of accomplishment around every aspect of this project. For all involved, I hope you feel the same. I don't have the space here to name everyone who has aided in the process, but please know how thankful I am for all the help along the way.

Noel Pattani: I know we didn't make it easy for you, but you somehow made it work. This was an enormous task and you have done so much to keeping the process moving forward. Thank you.

Caroline Tiger: You were crucial to the process and I don't think I would have moved without your talents and wrangling of my disorganized ideas.

Robert Luessen: It's rarely easy, but always entertaining. What an incredible decade, my friend.

George McCardle: We ask for a lot and you always deliver. Thank you for endless hours getting these images finished right.

David Doerrer and Zack Knoll: Thank you for believing in this book and showing me the way through this unique process.

My photography and life mentors, collaborators, and partners: I thank you all for the advice, guidance, companionship, and opportunities. If you are named or not, please know you are appreciated: Redhawk, Tyler, Ed, Ronda, Louise, Toni, Wylie, Melissa, Heather, Lauranne, Bill, Dave, Steven, Gabe, Becky, Andy, Richard, Jason, Shea, Carley, Mike, Lily, Wendy, Bonnie, Dawn, Kate, Heidi, Jared, Jess, Jeff, Ryan, Tye, David, Emily, Taisya, Zack, Mint, John, Amy, Caitlin, Michael, Steve, Andrew, Dahlia, Donna, Susan, Trish, Don, Ali, Dee, Louise, Karen, and Jackie.

MORE ABOUT THE WOMEN

Some of the featured participants have offered the below information for further reading on them and their work.

The Abingdon Co.
Twitter: TheAbingdonCo
Instagram: @theabingdonco
Facebook: The Abingdon Co
LinkedIn: The Abingdon Co
Pinterest: abingdonco

Abingdon Foundation
medium.com/@AbingdonFoundation
Twitter: @AbingdonFdn
Instagram: @abingdonfdn
Facebook: Abingdon Foundation
LinkedIn: Abingdon Foundation
YouTube: www.youtube.com/channel/UCzT79nBF
brJ5U6K_X8cRcNQ

Jordan Ainsworth
Instagram: @jainsworthh

Mia Anstine
MiaAnstine.com
Twitter: @MiaAnstine
Instagram: @MiaAnstine
Facebook: Mia Anstine
Pinterest: Mia Anstine
YouTube: www.youtube.com/user/mialdor

Ayah Bdeir
www.Littlebits.com;
littlebits.com/summer-camp-2019

Beth Beverly
www.Diamondtoothtaxidermy.com
Instagram: @diamondtoothtaxidermy

Christina Bothwell
Christinabothwell.com
Instragam: @christinabothwell

Khalia Braswell
www.khaliabraswell.com
Twitter: @khaliabraswell
Instagram: @digital.diva

Connie Chang
Twitter: @thechanglab
Instagram: @thechanglab

Anna Valer Clark
Cuencalosojos.org

Diane Crump
www.dianecrump.com
Facebook: Diane Crump;
Diane Crump Equine Sales

Sophi Davis
www.TheMontanaCowgirl.com
Blog: ArtoftheCowgirl.com
Instagram: @themontanacowgirl
Facebook: www.facebook.com/themontanacowgirl/

Angela Duckworth
www.Characterlab.org;
bcfg.wharton.upenn.edu;
wpa.wharton.upenn.edu
Twitter: @thecharacterlab & @angeladuckw
LinkedIn: Character Lab

Natalie Egenolf
Natalieegenolf.com
Twitter: @NatalieEgenolf
Instagram: @NatalieEgenolf

Julie Engiles
www.vet.upenn.edu/people/faculty-clinician-search
/JULIEENGILES

Mindy Gabriel
www.firefightermentalhealth.org/peer-supporters;
https://the2020club.wordpress.com/mindy-gabriel-2019/

Alison Goldblum
www.restorationphilly.com
Instagram: @restorationphilly

Doris Kearns Goodwin
DorisKearnsGoodwin.com
Twitter: doriskgoodwin
Instagram: doriskgoodwin
Facebook: doriskgoodwin

Alice Graham
www.thebackbaymission.org

Damyanti Gupta
YouTube: www.youtube.com/watch?v=uG29FuNarzA;
time.com/collection-post/5296993/damyanti-gupta-firsts/

Carla Hall
www.carlahallmetaldesign.com
Instagram: @chmetaldesign

Hilary Hansen
Facebook: www.facebook.com/hansenshorsehauling

Katherine Kallinis Berman &
Sophie Kallinis LaMontagne
www.georgetowncupcake.com
Instagram: @georgetowncupcake

Jourdan Imani Keith
Urbawildernessproject.org
Jourdankeith.wordpress.com

Margaux Kent
www.pegandawlbuilt.com
Instagram: @pegandawl + @thebrotherskent

Lauren Kessler
www.laurenkessler.com
Blog: laurenchronicles.com
Twitter: @laurenjkessler
Instagram: laurenjkess

Patrice Lans
www.oregon.gov/doc/about/pages/prison-locations.aspx

Mary Lata
www.fs.usda.gov/detail/r3/fire-aviation/?cid=STEL
PRD3830542
YouTube: www.youtube.com/watch?v=gmo_NhGh7Mc;
www.youtube.com/watch?v=VnzMdzmlYuo

Magen Lowe
www.odocjobs.com
Instagram: @Magen.Christine

Heidi Moneymaker
www.actionstarworkout.net
Instagram: @Heidimoneymaker

Renae Moneymaker
Instagram: @renaemoneymaker707

Mira Nakashima
www.nakashimawoodworkers.com;
www.nakashimafoundation.org

Indra Nooyi
www.indranooyi.com
Twitter: @indranooyi
Instagram: @indranooyi
LinkedIn: linkedin.com/in/indranooyi/

Danielle Perez
www.thedanielleperez.com
Twitter: @DivaDelux
Instagram: @DivaDelux
Facebook: Thigh Gap Comedy

Nancy Poli
www.strykerfarm.com

Neri Oxman
mediatedmattergroup.com/;
neri.media.mit.edu/;

timesensitive.fm/episode/neri-oxman-extraordinary-visions
-biological-age/
MoMA retrospective (2020): www.moma.org/calendar
/exhibitions/5090
The Mediated Matter Group: Neri Oxman (Director), Becca Bly,
Christoph Bader, Felix Kraemer, Jean Disset, João Costa, Jorge
Duro-Royo, Joseph Kennedy, Kelly Egorova, Michael Stern, Nic
Lee, Nitzan Zilberman, Rachel Soo Hoo Smith, Ramon Weber, Ren
Ri, Sunanda Sharma, Susan Williams, Tilman Bayer

Desiree Reed-Francois
www.UNLVRebels.com;
http://unlvrebels.com/
Twitter: @DRFrancois1
Instagram: UNLVDesiree

Mara Reinstein
MaraMovie.com
Twitter: @marareinstein
Instagram: @maramovies

Dororthy Roberts
www.law.upenn.edu/cf/faculty/roberts1/;
www.ted.com/talks/dorothy_roberts_the_problem_with_race_
based_medicine?language=en
Twitter: @DorothyERoberts

Sadie Samuels
Instagram: @Sadiethesiren; @mustbenicelobsterco
Facebook: Must Be Nice Lobster Co

Pat Summitt
PatSummittLeadership.com
Facebook: Pat Summitt Foundation

Heather Marold Thomason
www.primalsupplymeats.com
Twitter: @primalsupplyphl
Instagram: @primalsupplymeats
Facebook: Primal Supply Meats

Judith von Seldeneck
www.diversifiedsearch.com
Blog: diversifiedsearch.com/insights/blog/
Twitter: @divsearch
LinkedIn: Diversified Search

Sam White
www.shakespeareindetroit.com
Twitter: @ShakesintheD
Instagram: @shakespeareindetroit
Facebook: Shakespeare in Detroit

Christy Wilhelmi
www.gardenerd.com
Book: *400+ tips for Organic Gardening Success*
Twitter: @gardenerd1
Instagram: @gargenerd1Facebook: Gardenerd
YouTube: youtube.com/user/gardenerd1/
Podcast: gardenerd tip of the week

Meejin Yoon
www.howeleryoon.com/
Instagram: @howeleryoonarchitecture

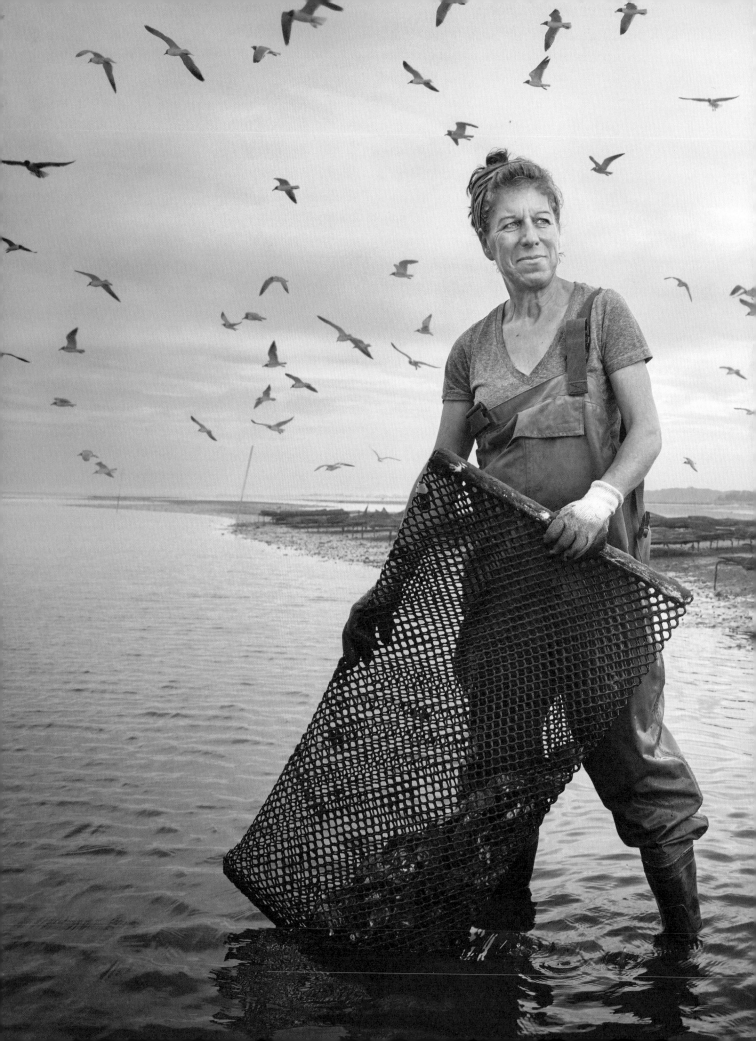